KU-544-027

The Burden of Representation

Essays on Photographies and Histories

John Tagg

University of Minnesota Press
Minneapolis

Published 1993 by the University of Minnesota Press
111 Third Avenue South, Suite 290,
Minneapolis, MN 55401–2520

Copyright © John Tagg 1988

All rights reserved. No part of this publication may be reproduced,
stored in a retrieval system, or transmitted, in any form or by any
means, electronic, mechanical, photocopying, recording, or
otherwise, without the prior written permission of the publisher.

Published in Great Britian by
MACMILLAN PRESS LTD

ISBN 0–8166–2405–4

The University of Minnesota is an
equal-opportunity educator and employer

Sixth Printing, 2005

In memory of my mother,
Ethel Tagg, born 1922, died 1980

Acknowledgements

Looking back over a period of ten years in which these essays were produced, it would be impossible to acknowledge all the individuals to whom this work is indebted. I want, however, to thank especially the following, without whose conversations and support one or other of the chapters which follow would have been the poorer: Stevie Bezencenet, Victor Burgin, Tim Clark, Sande Cohen, James Donald, Andrea Fisher, Stephen Hopwood, Vanessa Jackson, Steve Kennedy, Maureen Lea, Sarah McCarthy, Nicky Road, Jo Spence, Tom Steele, Gabrielle Syme, Kate Walker, Tricia Ziff, and Shirley Moreno, whose recent untimely death is still mourned.

Research for these essays was begun with the aid of a Fellowship jointly funded by the Arts Council of Great Britain and the Polytechnic of Central London. I remain grateful to both institutions, as I am to the many students at the University of Leeds and the University of California at Los Angeles who listened so patiently and responded so encouragingly to my efforts to clarify the concerns of this book.

The introductory essay and Chapter 5, 'God's Sanitary Law', appear here for the first time. Other chapters have been previously published as follows: Chapter 1 was based on a script prepared for the Open University *Popular Culture* course, and published in revised form as 'Portraits, Power and Production', in *Ten:8* No. 13, 1984; Chapter 2 appeared as 'The Burden of Representation: Photography and the Growth of the State', in *Ten:8*, No. 14, 1984; Chapter 3 as 'Power and Photography – Part I, A Means of Surveillance: The Photograph as Evidence in Law', in *Screen Education*, No. 36, Autumn 1980; Chapter 4 as 'Power and Photography – Part II, A Legal Reality: The Photograph as Property in Law', in *Screen Education*, No. 37, Winter 1981; Chapter

6 as 'The Currency of the Photograph' in *Screen Education*, No. 28, Autumn 1978; and Chapter 7 under the same title in T. Dennett and J. Spence (eds) *Photography/Politics: One*, Photography Workshop, London, 1979.

The author and publishers wish to acknowledge, with thanks, the following photographic sources: Barnardo Photographic Archive; Cambridgeshire County Constabulary; Collectors' Editions, New York; International Museum of Photography at George Eastman House; Gernsheim Collection, Harry Ransom Humanities Research Center, University of Texas at Austin; Kodak Museum; Leeds City Libraries; University of Leeds, Brotherton Library; Library of Congress, Washington; The Mansell Collection; National Archives, Washington; National Portrait Gallery, London; Museum of the City of New York; The City of Oakland, the Oakland Museum, California; Graham Ovenden; Public Record Office, London (ref: PCOM 2/291); Royal Society of Medicine; The Trustees of the Science Museum, London; Stockport Library, Local History Department; Syndication International; The Board of Trustees of the Victoria and Albert Museum, London. The publishers have made every effort to trace the copyright-holders, but if any have been inadvertently overlooked, they will be pleased to make the necessary arrangement at the first opportunity.

Los Angeles *John Tagg*

Introduction

I

In his posthumously published book, *Camera Lucida*, Roland
Barthes, against his apparent interpreters, leaves us with a poignant
reassertion of the realist position. The camera is an instrument of
evidence. Beyond any encoding of the photograph, there is an
existential connection between 'the *necessarily* real thing which has
been placed before the lens' and the photographic image: 'every
photograph is somehow co-natural with its referent'. What the
photograph asserts is the overwhelming truth that 'the thing has
been there': this was a reality which once existed, though it is 'a
reality one can no longer touch'.[1]

The quiet passion of Barthes's reassertion of a retrospective
photographic realism, whose unconscious signified must always be
the presence of death, has to be read against the death of his own
mother, his reawakened sense of unsupportable loss, and his search
for 'a just image' and not 'just an image' of her.[2] His demand for
realism is a demand, if not to have her back, then to know she was
here: the consolation of a truth in the past which cannot be
questioned. This is what the photograph will guarantee:

> The important thing is that the photograph possesses an
> evidential force, and that its testimony bears not on the object
> but on time. From a phenomenological viewpoint, in the
> Photograph, the power of authentication exceeds the power of
> representation.[3]

The image which is brought to mind is that of the photograph as
death-mask. But this same image serves to remind us that

1

photography is not unique in its alleged phenomenological basis. The death-mask signifies the same 'that-has-been-and-is-no-more' by mechanically substituting volumes of plaster or bronze for the convexities and concavities of recently dead flesh. Yet it is entirely questionable whether a death-mask could conjure up the piercing, lost reality which Barthes wanted to experience in his grief. The same may be said for the engraved images produced by the physionotrace – the briefly fashionable device for tracing profiles which was, in a sense, the ideological precursor of photography in that the mechanical basis and reproducibility of its images not only ensured their relative cheapness and availability, but were also seen at the time, the end of the eighteenth and beginning of the nineteenth century, as the source of a truth not possessed by conventional images.

I need not point out, of course, that the existence of a photograph is no guarantee of a corresponding pre-photographic existent. The notorious and retrospectively clumsy montage which showed US Senator Millard Tydings in earnest conversation with Earl Browder, appearing to implicate him in communist sympathies and losing him his seat in Congress during the McCarthy period, made that crude and costly deception only too clear – with the benefit of hindsight, laughably clear, perhaps. But such wisdom after the fact always runs the risk of making montage a special case: a case of manipulation of otherwise truthful photographic elements. On a more subtle level, however, we have to see that *every* photograph is the result of specific and, in every sense, significant distortions which render its relation to any prior reality deeply problematic and raise the question of the determining level of the material apparatus and of the social practices within which photography takes place. The optically 'corrected' legal record of a building façade is no less a construction than the montage, and no less artificial than the expressively 'transformed' experimental photographs of Lois Ducos du Hauron or, in a different context, those of Bill Brandt. The legal record is, in much the same way though for different purposes, an image produced according to certain institutionalised formal rules and technical procedures which define legitimate manipulations and permissible distortions in such a way that, in certain contexts, more or less skilled and suitably trained and validated interpreters may draw inferences from them, on the basis of historically established conventions. It is

only in this institutional framework that otherwise disputable meanings carry weight and can be enforced.

The indexical nature of the photograph – the causative link between the pre-photographic referent and the sign – is therefore highly complex, irreversible, and can guarantee nothing at the level of meaning. What makes the link is a discriminatory technical, cultural and historical process in which particular optical and chemical devices are set to work to organise experience and desire and produce a new reality – the paper image which, through yet further processes, may become meaningful in all sorts of ways. The procedure is familiar enough. Reflected light is gathered by a static, monocular lens of particular construction, set at a particular distance from the objects in its field of view. The projected image of these objects is focused, cropped and distorted by the flat, rectangular plate of the camera which owes its structure not to the model of the eye, but to a particular theoretical conception of the problems of representing space in two dimensions. Upon this plane, the multicoloured play of light is then fixed as a granular, chemical discolouration on a translucent support which, by a comparable method, may be made to yield a positive paper print.

How could all this be reduced to a phenomenological guarantee? At every stage, chance effects, purposeful interventions, choices and variations produce meaning, whatever skill is applied and whatever division of labour the process is subject to. This is not the inflection of a prior (though irretrievable) reality, as Barthes would have us believe, but the production of a new and specific reality, the photograph, which becomes meaningful in certain transactions and has real effects, but which cannot refer or be referred to a pre-photographic reality as to a truth. The photograph is not a magical 'emanation' but a material product of a material apparatus set to work in specific contexts, by specific forces, for more or less defined purposes. It requires, therefore, not an alchemy but a history, outside which the existential essence of photography is empty and cannot deliver what Barthes desires: the confirmation of an existence; the mark of a past presence; the repossession of his mother's body.

We could go further. Even if we were confronted by the actual existent about whose (past) existence the photograph is supposed to assure us, we could not have the authentic encounter Barthes wants. We could not extract some existential absolute from the

conscious and unconscious, cultural, psychological and perceptual codes and processes which constitute our experience of the world and make it meaningful – just as they invest meaning in a paltry piece of chemically discoloured paper. Neither experience nor reality can be separated from the languages, representations, psychological structures and practices in which they are articulated and which they disrupt. The trauma of Barthes's mother's death throws Barthes back on a sense of loss which produces in him a longing for a pre-linguistic certainty and unity – a nostalgic and regressive phantasy, transcending loss, on which he founds his idea of photographic realism: to make present what is abent or, more exactly, to make it retrospectively real – a poignant 'reality one can no longer touch'. What exceeds representation, however, cannot, by definition, be articulated. More than this, it is an effect of the production of the subject in and through representation to give rise to the phantasy of this something more. We have no choice but to work with the reality we have: the reality of the paper print, the material item.

But what is also real is what makes the print more than paper – what makes it meaningful. For this, however, we must look not to some 'magic' of the medium, but to the conscious and unconscious processes, the practices and institutions through which the photograph can incite a phantasy, take on meaning, and exercise an effect. What is real is not just the material item but also the discursive system of which the image it bears is part. It is to the reality not of the past, but of present meanings and of changing discursive systems that we must therefore turn our attention. That a photograph can come to stand as *evidence*, for example, rests not on a natural or existential fact, but on a social, semiotic process, though this is not to suggest that evidential value is embedded in the print, in an abstract apparatus, or in a particular signifying strategy. It will be a central argument of this book that what Barthes calls 'evidential force' is a complex historical outcome and is exercised by photographs only within certain institutional practices and within particular historical relations, the investigation of which will take us far from an aesthetic or phenomenological context. The very idea of what constitutes evidence has a history – a history which has escaped Barthes, as it has so many labourist and social historians too. It is a history which implies definite techniques and procedures, concrete institutions, and specific social

relations – that is, relations of power. It is into this more extensive field that we must insert the history of photographic evidence. The problem is historical, not existential. To conjure up something of what it involves today, I suggest in the text that you ask yourself, and not just rhetorically, under what conditions would a photograph of the Loch Ness Monster (of which there are many) be acceptable?

II

What I go on to argue is that the coupling of evidence and photography in the second half of the nineteenth century was bound up with the emergence of new institutions and new practices of observation and record-keeping: that is, those new techniques of representation and regulation which were so central to the restructuring of the local and national state in industrialised societies at that time and to the development of a network of disciplinary institutions – the police, prisons, asylums, hospitals, departments of public health, schools, and even the modern factory system itself. The new techniques of surveillance and record harboured by such institutions bore directly on the social body in new ways. They enabled, at a time of rapid social change and instability, an unprecedented extension and integration of social administration, amounting – even before Alphonse Bertillon's systematisation of criminal records in the 1880s – to a new strategy of governance.[4]

At the same time, the emergence and official recognition of instrumental photography was caught up with more general and dispersed transformations in society and in ways of thinking about it, representing it, and seeking to act on it. The development of new regulatory and disciplinary apparatuses was closely linked, throughout the nineteenth century, to the formation of new social and anthropological sciences – criminology, certainly, but also psychiatry, comparative anatomy, germ theory, sanitation, and so on – and the new kinds of professionalisms associated with them, which took both the body and its environment as their field, their domain of expertise, redefining the social as the object of their technical interventions. On a profound level, indeed, the two developments could not be separated, for, as Foucault's work has shown, the production of new knowledges released new effects of

power, just as new forms of the exercise of power yielded new knowledges of the social body which was to be transformed.[5] Power and meaning thus have a reciprocal relation described in the coupled concepts of the regime of power and the regime of sense. What characterised the regime in which photographic evidence emerged, therefore, was a complex administrative and discursive restructuring, turning on a social division between the power and / privilege of *producing* and *possessing* and the burden of *being* meaning. / In the context of this historical shift in power and sense, photographic documentation and evidence took form; not all at once, of course, for the photograph's status as evidence and record (like its status as Art) had to be produced and negotiated to be established.

Yet it is important to reiterate that this status cannot be understood solely in the context of archival practices and new discourses centring on the body. First, there are real dangers in separating late nineteenth-century discourses which specify the body from discourses of the social environment which they came to supplement but not supplant; indeed, as the Quarry Hill albums discussed below show, photographic evidence has to be tracked across both domains. Second, the changing status of photography must also be pursued through courts of law, Select Committee hearings, governmental inquiries, commissioners' reports, and debates in legislative bodies where the determinants of evidence and proof were defined and redefined. This will mean not only investigating the legislation and judicial practices which laid down, in various police, prison and criminal justice Acts, where and when photographic records were required to be made and the terms under which they could function as evidence. It will also mean, as I argue in Chapter 4, looking at the photograph's second court appearance, not as the instrument of criminal law but as the object of copyright laws which defined the status of creative properties and thus contributed to that separation and stratification of photographic production into the amateur and professional, instrumental and artistic domains which was laid out in the last decades of the nineteenth century.

In both cases, whether pursuing the photograph as instrument or object of legal practices, we shall have to take full account of significant national differences, between Britain, France, the United States, and so on. And, while we are being cautious, we might also

add a number of other reservations that must qualify attempts to extend Foucault's metaphor of Panopticism and his concept of a new technology of power/knowledge to the photographic domain. First, the chronology of change, which is unclear in Foucault, cannot be taken to point to a single and final reversal of the political axis of representation or to mark a definite periodicity. Nor can national differences and inconsistencies be suppressed. For example, if the 1880s in France were a period of rationalisation in police photography, with the introduction of Bertillon's 'signaletic' identity card system, this does not mesh easily and conveniently with developments elsewhere. In Britain, local police forces had been using photography since the 1860s, but, even after the 1870 Act requiring county and borough prisons to photograph convicted prisoners, the value of such records for detection continued to be questioned. A parliamentary report of 1873 summarising returns from county and borough prisons showed that, of 43,634 photographs taken in England and Wales under the 1870 Act up to December 31, 1872, only 156 had been useful in cases of detection. This had to be set against a total cost of £2,948 18*s* 3*d*.[6] Thus, the police in Britain, like other governmental offices, did not obtain their own photographic specialists until after 1901, following the introduction not of an anthropometric system like Bertillon's, but of Sir Edward Henry's fingerprinting system. Even then, the format of acceptable record photographs was still under debate in the late 1930s.

Second, certain exaggerated readings of Foucault – of which the essays that follow are not innocent – face the problems of older versions of the thesis of social control: they run the risk of overlooking more mundane, material constraints on the lives of the dominated classes and of overstating the triumph of control, while clinging to notions of a thwarted but revolutionary class. As the historian Gareth Stedman Jones has insisted, Benthamites and evangelicals in Britain, for example, were no more successful than radicals and Chartists in moulding a working class in their own image; from the 1850s on, a working-class culture was gradually established which, however conservative and defensive, proved virtually impervious to external attempts to determine its character or direction.[7] Yet, having said this as a partial corrective to some of what follows, the force of the argument is clear, that the emergence of photographic documentation and what Barthes sees as the

photograph's 'evidential force' were bound up with new discursive
and institutional forms, subject to but also exercising real effects of
power, and developing in a complex historical process that is all
but obliterated by the idea of a continuous 'documentary tradition'
which takes the status of photographic evidence as neutral and
given.

III

'Documentary' as such was a later development belonging both to
a different phase in the history of the capitalist state and to a
different stage of struggle around the articulation, deployment and
status of realist rhetorics. Taking its name from a usage coined by
the film critic John Grierson in 1926, documentary came to denote
a discursive formation which was wider by far than photography
alone, but which appropriated photographic technology to a central
and privileged place within its rhetoric of immediacy and truth.[8]
Claiming only to 'put the facts' directly or vicariously, through the
report of 'first hand experience', the discourse of documentary
constituted a complex strategic response to a particular moment of
crisis in Western Europe and the USA – a moment of crisis not
only of social and economic relations and social identities but,
crucially, of representation itself: of the means of making the sense
we call social experience. Outside this crisis, the specificity and
effectivity of documentary cannot be grasped. Focused in specific
institutional sites and articulated across a range of intertextual
practices, it was entirely bound up with a particular social strategy:
a liberal, corporatist plan to negotiate economic, political and
cultural crisis through a limited programme of structural reforms,
relief measures, and a cultural intervention aimed at restructuring
the order of discourse, appropriating dissent, and resecuring the
threatened bonds of social consent.

Integral to such a venture, therefore, was a discursive strategy
whose realisation was to give the documentary mode – which, by
contrast, remained oppositional in Britain in the 1930s – a central
place in Franklin Roosevelt's reformist 'New Deal' programme. By
mobilising documentary practices across a whole series of New
Deal agencies, Roosevelt's administration did more than assemble

propaganda for its policies. It deployed a rhetoric with larger claims than this: with claims to retrieve the status of Truth in discourse, a status threatened by crisis but whose renegotiation was essential if social relations of meaning were to be sustained and national and social identities resecured, while demand for reform was contained within the limits of monopoly capitalist relations.

Certainly documentary traded on realist modes and practices of documentation which had longer histories in the growth and struggles of urban, industrialised societies. Such histories implicated documentary, too, in the development and deployment I have described of new discourses on society, new ways of scrutinising it, representing it, and seeking to transform it. The process was, as I have already argued, bound up with the emergence of institutions, practices and professionalisms bearing directly on the social body in a new fashion, through novel techniques of surveillance, record, discipline, training and reform. Intersecting with older practices and discourses of philanthropy, these new institutionalised techniques articulated with and extended the sphere of influence of a restructured state apparatus in ways which integrated social regulation in an unprecedented manner, devolving it systematically to domains of life never before subject to such intervention. The documentary movement of the paternalistic New Deal state belonged to this history of centralising, corporatist reform which, from the mid-nineteenth century on, through health, housing, sanitation, education, the prevention of crime, and a strategy of seemingly benevolent social provision, had sought to represent, reform and reconstitute the social body in new ways.

Social welfare was thus wedded to a mode of governance whose instigation did not pass unresisted, whether actively or passively, yet which sought to establish its rule not primarily through coercion and authoritarian control, as under fascism, but through relations of dependence and consent. Central to it, therefore, was an emergent formation of institutions, practices and representations which furnished means for training and surveilling bodies in great numbers, while seeking to instil in them a self-regulating discipline and to position them as dependent in relation to supervisory apparatuses through which the interventions of the state appeared both benevolent and disinterested. In the context of this modern strategy of power, we can safely dismiss the view that the reversal of the political axis of representation in late nineteenth- and early

twentieth-century documentation and the subsequent amassing of a systematic archive of subordinated class, racial and sexual subjects can be looked at as 'progressive' phenomena or as signs of a democratisation of pictorial culture.

If there is a continuity, then, it is that of developing systems of production, administration and power, not of a 'documentary tradition' resting on the supposed inherent qualities of the photographic medium, reflecting a progressive engagement with reality, or responding to popular demand. Yet even at this level, the continuity is one of uneven and sporadic development. In changing historical circumstances, at moments of recurrent crisis or rapid transformation, systems of governance could not survive unchanged and had to be renegotiated in ways crucially focused on the logics of social meaning and systems of representation which they sustained and which, in turn, served as their supports.

The photographs examined by the essays in this study are patterned across such shifts and crises in the discursive order. The years in which the Quarry Hill area of Leeds was systematically surveyed and photographed, for instance, marked the close of a period of instability in Britain – of high unemployment, social unrest, threatened epidemics, and immigration – which called forth new social stratagems, new techniques of representation and administration, through which, it was hoped, a specific kind of attention to the material needs of the poor would provide the means of their regulation and reformation. It was in such a context that the institutions, practices and discourses of social welfare came to be articulated in the space of the local state. Crisis was averted and a new phase of development was prepared by a social restructuring negotiated through local apparatuses deploying new powers and new modes of representation. Just as in the USA in the 1930s, in the midst of an even more profound economic, political and cultural upheaval, social unity was recast and a new relation between corporate capital and the state was worked out at a national level, in which welfare structures and documentary practices played a crucial role in securing social regulation and consent within a social democratic framework. The 'Depression' years and the temporising response of liberal democracy, as I have argued, provided the setting in which documentary rhetoric as such emerged. But it was half a century earlier that, in the most developed capitalist countries, the local structures of the welfare

state were prepared. Integral to them was a new regime of representation.

IV

This last phrase, however, runs the risk of remaining only a provocative historical hypothesis. To stop here would leave us in danger not only of eliding significant national differences but also of running together a complex and discontinuous history. Between the involvement of photography in the welfarism of the last quarter of the nineteenth century and the emergence of the liberal, democratic documentary mode of the 1930s, important changes have yet to be analysed. In the nineteenth century, for example, we are dealing with the instrumental deployment of photography in privileged/administrative practices/ and the professionalised discourses of new/social sciences/ – anthropology, criminology, medical anatomy, psychiatry, public health, urban planning, sanitation, and so on – all of them domains of expertise in which arguments and evidence were addressed to qualified peers and circulated only in certain limited institutional contexts, such as courts of law, parliamentary committees, professional journals, departments of local government, Royal Societies and academic circles. /In the terms of such discourses, the working classes, colonised peoples, the criminal, poor, ill-housed, sick or insane were constituted as the passive – or, in this structure, 'feminised' – objects of knowledge./Subjected to a scrutinising gaze, forced to emit signs, yet cut off from command of meaning, such groups were represented as, and wishfully rendered, incapable of speaking, acting or organising for themselves. The rhetoric of photographic documentation at this period, whether attached to the environmentalist arguments of public health and housing or focused on the alleged pathologies of the body isolated in medical and criminological discourse, is therefore one of precision, measurement, calculation and proof, separating out its objects of knowledge, shunning emotional appeal and dramatisation, and hanging its status on technical rules and protocols whose institutionalisation had to be negotiated. As a strategy of control, its success has been greatly exaggerated; but as a strategy of representation, its claims and their consequences seem to have gone largely unchallenged.

By contrast with the last quarter of the nineteenth century, the economic, political and cultural crises of the 1920s and 1930s occurred in more developed capitalist democracies in which, while the technical and instrumental use of photography continued and was greatly systematised and extended, a wider negotiation of social consensus was also demanded. A crucial inflection of the discourse of documentation therefore took place. Mobilising new means of mass reproduction, the documentary practices of the 1930s, though equally the province of a developing *photographic* profession, were addressed not only to experts but also to specific sectors of a broader lay audience, in a concerted effort to recruit them to the discourse of paternalistic, state-directed reform. Documentary photography traded on the status of the official document as proof and inscribed relations of power in representation which were structured like those of earlier practices of photo-documentation: both speaking to those with relative power about those positioned as lacking, as the 'feminised' Other, as passive but pathetic objects capable only of offering themselves up to a benevolent, transcendent gaze – the gaze of the camera and the gaze of the paternal state. But in its mode of address, documentary transformed the flat rhetoric of evidence into an emotionalised drama of experience that worked to effect an imaginary identification of viewer and image, reader and representation, which would suppress difference and seal them into the paternalistic relations of domination and subordination on which documentary's truth effects depended. At the same time, and in keeping with a reasserted environmentalism which displaced again the geneticism of nineteenth-century anthropometric sciences, it transposed the static separation of bodies and space characteristic of earlier photographic records into an ethnographic theatre in which the supposed authenticity and interrelationships of gesture, behaviour and location were essential to the 'documentary' value of the representation. The comparative measurement of specimen subjects and spaces in isolation gave place to what the Farm Security Administration photographer, John Collier Jr, called 'visual anthropology'.[9]

One notable, if partial, exception to this might come to mind in the work of Walker Evans. But if, for photographers like Evans, an older archival mode of documentation remained available as a rhetorical resource to mark out a difference both from documentary

defined, opposed or reconciled by a privileged criticism and gathered in the transcendent space of the Museum, typified the strategic attempt to impose a corporatist hegemony in a reasserted cultural hierarchy. But whatever sense or necessity such a critical appropriation of the term 'documentary' might have had at the time, its earlier currency was strained to the point of breaking. The unlikely and paradoxical mixture of social and psychological 'truths', exotic voyeurism, fetishised artistic subjectivity, and formalist claims to universality, which may once have appeared mutually enhancing, was contradictory and inherently unstable. For all the critical élan with which a modish tradition was constructed that could appear, by turns, modernist and realist, universal and American, objectively true and subjectively expressive, profoundly human and obsessively privatistic, its effectivity was short-lived. The assimilation of photographic practices to 'Fine Art' models was fraught with difficulties, and that precarious generalisation Photography did not sit well in the modern museum of Art. The history of photography stands in relation to the history of Art as a history of writing would to the history of Literature. It cannot be reduced to a unity and assimilated to the very canon it has, practically and theoretically, called into question. The idea of a modernist photographic lineage has no more status than the notion of a popular documentary tradition to which it has been counterposed and which it has regrettably served to re-incite.

V

To say this about the dominant representations of photographic practice in the United States in the 1960s and 1970s is also to say something about the context in Britain in which the research for these essays was begun. There, too, a variety of residual documentary practices were posed as the popular, humanistic, or even radical left alternatives to recently imported versions of mystical or formalist aestheticism, though both were set against the nostalgic conservatism of the Royal Photographic Society and the technicism and stereotypical exaggerations of commercial photography, advertising and photojournalism. The institutional, practical, but also theoretical means to challenge this continual re-enactment of the terms of a nineteenth-century debate on the

nature of photography, by developing new forms of intervention
and provoking a radical realignment, had hardly begun to emerge.
Or perhaps it is more accurate to say that, if many of the necessary
resources were present outside the spaces of photography – in the
fragmentation of post-conceptualist art and the impetus to cultural
activism, in the trickle of translated post-structuralist theory, in a
revitalised Marxist debate, and in a resurgent, theoretically
articulate women's movement – they were far indeed from beginning
to disrupt photographic practice, education, or curatorial and
administrative policy.

Before passing on to a consideration of how these issues shaped
the essays which follow, I want to look first at an apparent conflict
in the argument put forward in the early chapters of the book. Is
there not a contradiction between the claim that the development
of photography as a technology of surveillance and record entailed
a radical reversal of the political axis of representation, and the
recognition of the opposite movement in the dispersal and seeming
'democratisation' of photography, following the introduction of
equipment and services accessible to a wide amateur market?

Clearly there is a contradiction – one that must be engaged with,
one rooted not in the argument but in the process of historical
development and symptomatic, at a deep level, of contradictions
central to a capitalist mode of production which must place its
means of production in the hands of those it expropriates and in
which there is an inherent antagonism between the socialisation of
production and consumption and of the mechanisms of discipline
and desire, and the private appropriation of surplus value. At the
same time, this contradiction in the deployment of photographic
technology also has to do with conflicts inherent in the longer
historical development of reproductive means of cultural production
which, as well as raising levels of production and consumption and
seeming to disperse cultural activity in ways difficult to control,
have also had the opposite effect of facilitating the imposition of
cultural homogeneity, while simultaneously creating new divisions
of power both between the possessors and controllers of the means
of cultural production and the dispossessed, and between those
who are and those who are not literate in the appropriate cultural
languages. Within the space of these contradictions there is
undoubtedly room for cultural resistance, dissent and opposition.
Yet this dissent rarely develops. More particularly, the emergence

of a mass amateur base or, perhaps more accurately, the production of a new consumer body for photography did not represent a challenge to the existing power relations of cultural practice. In fact, it may have furthered their solidification. Why?

In the first case, photography only passed into popular hands in the crudest sense of the term. The development of popular amateur photography was entirely dependent on the large-scale production of equipment and materials, mechanised servicing, and a highly organised marketing structure, which together made possible a second phase of industrialisation of photography and the emergence of multinational, monopolistic corporations such as that pioneered by George Eastman. For the new class of amateurs and even for certain professionals, large parts of the photographic process were entirely reliant on and in the control of this photographic industry whose privately or corporately owned means of production were highly concentrated and necessitated elaborate divisions of labour and knowledge – both developments opposed to democratic dispersal. In consequence, too, at the level both of equipment and servicing, much of the process made available was highly mechanised or tailored to the needs of mechanisation and standardisation. The instrument that was handed over was, of this necessity, very limited, and the kinds of images it could produce were therefore severely restricted on the technical plane alone.

More significantly, perhaps, if a piece of equipment was made available, then the necessary knowledges were not. Technical knowledge about the camera was not dispersed but remained in the hands of specialist technicians, themselves dependent on means of production they did not own or control. Knowledge of the mechanics of picture-making was equally specialised and constituted an increasingly professionalised skill, usually calling for much more elaborate training and equipment than that available to the amateur and installing a difference so marked that, for photography with pretentions to a higher status, the explicit connotators of Art characteristic of late nineteenth-century Pictorialism proved entirely dispensable. By contrast, popular photography operated within a technically constrained field of signifying possibilities and a narrowly restricted range of codes, and in modes – such as the head-on portrait pose – already connoting cultural subordination. Accorded a lesser legal status than either commercial or so-called artistic photography and, by definition, positioned as inferior in an

increasingly stratified arena of cultural production, /amateur
photographic practice was also largely confined to the narrow
spaces of the family and commoditised leisure which imposed their
own constraints by tying it to consumption, incorporating it in a
familial division of labour, and reducing it to a stultified repertoire
of legitimated subjects and stereotypes. /

All this must be weighed before we can even begin to talk about
'democratisation' or criticise the alleged poverty of popular
photography. If amateur photography operates in an exceedingly
limited institutional space and signifying range, then it is hemmed
in on all sides by divisive barriers to technical and cultural
knowledge, ownership and control. But beyond this, even if
variation, innovation and dissent were exhibited by amateur
photographic practice, it would not carry the weight of cultural
significance, because, by definition, its space of signification is not
culturally privileged. Any success in shifting the parameters of
signification – one definition of inventiveness and imagination –
would therefore be outweighed by the social hierarchy of registers
of meaning. Thus dissent or innovation in popular photography is
rarely seen as transforming signifying possibilities or contesting
orders of practice (as, for example, in Jo Spence's professional,
institutionally promoted reworking of the family album). Rather
what it involves, if it is to be visible at all, is a change of level,
moving upwards in the hierarchy, ceasing to be 'amateur'
photography in evaluative terms, graduating to another space: the
space of professional, technical or, more usually, Art photography.
(Witness the migration of the work of Lewis Carroll, Lartigue or
Mike Disfarmer, among others.)

This is what calls into question wholesale and normative
condemnations of amateur photography. There can be no totalising
definitions of originality or imagination spanning the complexly
demarcated spheres of modern cultural practice. The field of
portraiture, for instance, dominating as it does so much of amateur
photography, is divided, over its entire range, into a number of
zones defined by different forms of practice, different economies,
technical bases, semiotic resources and cultural statuses. No
absolute set of criteria crosses these zones. Nor can their separation
be seen as a ready-made basis for evaluation. Rather, we must try
to grasp their historically produced relations not only as levels in
the market, but as levels in a hierarchy of practices whose most

privileged strata, increasingly sustained by post-market institutions, are called 'Art', whose middle ground ranges from 'commercial art' to 'craft', and whose lower registers are designated 'kitsch', 'vernacular', 'amateur' or 'popular culture'.[14] These are distinctions articulated within a particular historical cultural formation and lent substance by the particular historiographies it sustains. Their hierarchical ordering is a function of the tensions and conflicts of the development of cultural production under the political and economic relations of capitalism and the dissonant drives of market expansion and social reproduction. It is these tensions and conflicts, especially between the colonisation of new markets and the reproduction of social values, that necessitate a stratified culture in which a conspicuous and selectively supported 'High Art' more visibly sustaining normative social mores is articulated in and through a mutually defining difference both from 'commercial' and from 'popular' culture. The difference, then, is one that is institutionally produced and internal to the system, not one founded on an essential opposition, as conservative cultural critics from Matthew Arnold to Clement Greenberg have claimed.

As in the general cultural sphere, the hierarchisation of photographic practices rested on the historical development of distinct economies, institutional bases and secondary supportive structures. But it also needed to be secured at the legal and political levels. As we have seen, popular amateur photography would not have been possible without the development of a large-scale photographic industry, fostering the emergence and domination of international corporations such as Eastman Kodak. The corporate stage of production was both the condition of existence of popular photography and its limit. It was new technical, organisational and marketing methods which laid the basis first for the enormously profitable mass production of photographic images, and then, in the second phase of capitalisation, for the even more lucrative industrialised production both of photo-mechanical reproductions and of equipment and materials. Unscrupulous competition and the high investment costs of such developments inevitably raised demands for statutory protection and controls, registered in legislation and legal disputes on censorship and copyright through which, in part, the contradictions between cultural privilege and control and the potentiality of the new means of cultural production were negotiated.

What emerged from such legal and legislative interventions was a series of distinctions – between the licit and the illicit, between property and non-property – overwritten both on the emergent hierarchy of photographic practices and on new legal and institutional definitions of instrumental and non-instrumental representations. The result was a structure of differences – between amateur and professional, instrumental and artistic – which was to become relatively fixed and in which popular practice was allotted a particular, subordinate place. It was a stratification as characteristic of photography's development in England as in France, even allowing for different juridical conceptions of copyright. Whether or not a notion of the subject was brought into play, photographic law was still overdetermined by pre-emptive ideas of property, meaning and cultural value so that, while protection and status were given to 'artistic conception' and capital investment, the actual 'operatives' and makers of photographic images, like print workers and studio technicians today, might be denied any legal claim to their control. Hence the close relation between the setting in place of a hierarchical order of practices and the emergence, at every level, of a hierarchy of practitioners – from the amateurs and disenfranchised 'proletariat of creation', up to the professional stratum of artists, editors, journalists and others empowered to intervene in the production of meaning and the whole range of experts, from art critics to criminologists, privileged to adjudicate on its results.[15]

The concentration of power, status and control characteristic of the structure of which amateur photography was a subordinate part lends little support to interpretations of the advent of mass photographic practice either as a triumph of democracy or as proof of the poverty of popular imagination. What it rather suggests is a pattern of institutional organisation and a structure of relations of domination and subordination which precisely echo those in which photography was mobilised as an instrument of administrative and disciplinary power. The contradictory moments of photographic development turn on the same process of social hierarchisation. At work in them is an institutional order, a professionalised structure of control, and a political economy of discursive production which, so far from being an expressive unity, have no need of consistency but attempt only to sustain their effectivity by orchestrating a

range of different and even contradictory discourses and theories of discourse and the play of their power effects.

VI

Power, then, is what is centrally at issue here: the forms and relations of power which are brought to bear on practices of representation or constitute their conditions of existence, but also the power effects which representational practices themselves engender – the interlacing of these power fields, but also their interference patterns, their differences, their irreducibility one to another. Here, a determinate space is opened up as the effect of recent theoretical debates for which power can no longer be seen as a general form, emanating from one privileged site, uniform in its operations, and unified in its determinate effects. The space is crucial, since it exposes a rift in the causal sequences of deterministic theories of cultural practice and in the general conceptions of representation on which they rest. Its consequences are, therefore, far-reaching for all attempts to theorise cultural politics and history, even including the more than reluctant discipline of art history and those varied belated critiques which have gone, once again, under the name of the social history of art.

It would be encouraging to think that this connection of art history and the field of cultural theory might no longer appear unlikely or odd – or, at least, less so than at the time these essays were begun. The weight of established authority at the institutional level and at the level of the dominant discourses of art history may still insist that the two be kept apart, but new forms of critical and historical theory, exemplified in the work of T. J. Clark, have made decisive inroads since the early 1970s.[16] These developments may not have been as visible or as influential as those in film theory in the same period, but they have gathered momentum and, at last, by force of attrition, unfixed the ritual patterns of art historical debate.

Though originally presented in spaces pointedly 'outside' the discipline of art history, the essays here are, from one point of view, to be read as a response to this context and especially to Clark's innovatory attempt to synthesise historical analyses with his

readings of recent French Marxism, semiotics and psychoanalysis.[17] Clark's rethinking of the issues of realism, urbanisation and representation, the relations of class to culture, and the conditions of production and reception of specific works of art, provided important points of contact with the themes of this book. What gave focus to these concerns, however, was the central belief, shared by a number of approaches at that time, that the problems of art history were at root *methodological* and that what the subject needed was 'theory', something which could only be imagined as coming from outside – outside the discipline and even, in Britain at least, outside what was thought to compose the national intellectual culture.[18]

The dominant methodological focus and questionable belief in methodological solutions were to leave new approaches vulnerable in crucial ways to a decade of political, educational and intellectual change.[19] Yet, at the beginning, they provided an essential impetus to work which tried to break with established art historical modes and engage with new forms of critical, analytical and political theory which were then entirely transforming the concept of cultural studies. Written over a period of ten years, the arguments and interventions of the essays in this book, with all their revisions, reversals and hesitations, are plotted on this process of engagement. Their point of departure was an attempt to shift the debate about realism and representation by piecing together the outlines of a historical account of the development of documentary evidence as a function of social administration, but the intention was also to assemble the elements of a theory, in the belief not only that these elements could be eclectically reconciled but that they could be welded into a systematic method. For example, the earliest essay, 'The Currency of the Photograph', set out to bring a semiotic analysis of photographic codes into conjunction with an Althusserian account of 'Ideological State Apparatuses' and to hold them in place by a Foucauldian emphasis on the power effects of discursive practices. The purpose was to avoid the reductive, expressive models that had prevailed in the social history of art, from Antal and Schapiro even to Clark himself. The problems of this 'solution', however, soon became evident.

VII

As the essay itself wants to show, a classical semiotic account of immanent systems and codes of meaning cannot specify the institutional nature of signifying practices, their patterns of circulation in social practice, or their dependence on specific modes of cultural production. What is missing, however, cannot be supplied by grafting on a Marxist account of the hierarchical instances of the social formation. The reflectionist concept of representation on which such accounts must inevitably depend runs entirely counter to a semiotic conception of language as a conventional system of differentiations already containing and in effect party to the constitution of social relations. This is a view which precludes the notion of a determinant, pre-linguistic realm of the social or the treatment of language as a simple medium through which a primal social experience finds expression and thus recognition in the answering experience of similarly positioned social subjects. It follows, then, that we cannot think of abstracting experience from the signifying systems in which it is structured, or of decoding cultural languages to reach a given and determinant level of material interest, since it is the discursive structures and material processes of these languages that articulate interest and define sociality in the first place.

The object, however, is not to replace a 'social' explanation with a discursive analysis, but rather to trace the relation between the two; to map out the productivity and effectivity of successive, coexistent, contradictory or conflictual languages; to plot the limits governing what they can articulate and how far they can remain convincing by recruiting the identification of their speakers and channelling the convictions of those they address. A discursive analysis such as this does not pretend to be final or exhaustive. Discourses have conditions of existence which they do not determine and, in any case, comprise more than languages alone. Moreover, any analysis of their effects cannot be other than a conditional calculation framed by the context, perspective and form of practice within which it is itself made.

To reject the idea that cultural practices and systems of meaning constitute a level of representation determined in its meanings and effects by some more basic material reality is not, therefore, to posit an autonomous discursive realm. Equally, what is not discourse

cannot be held to constitute a unified, distinct and counterposed domain: an ontologically prior unity of being to which discourse may be referred. (The argument is crucial here for cultural theory, as it was earlier for grasping the nature of photographic representation.) What is denied is not the 'non-discursive' but the conception of it as a unitary category with general attributes, knowable through a non-discursive 'experience', yielding general criteria of epistemological validity. The non-discursive, the real, is diversely constituted in different discourses and practices and cannot be imagined as a universal, common or necessary referent, existing autonomously, yet somehow available through a non-discursive representation to serve as a measure of truth. Just as there is no object of knowledge or process of knowledge in general, outside specific discursive systems, so there can be no general test. Particular bodies of discourse and practice can and do develop their own appropriate criteria of adequacy and effectivity, specific to their objectives and to the technologies they deploy, but not valid beyond their domains. As bases for disputes and tests, such criteria may be radically different, but their efficacy is sufficiently established in the context of the determinate purposes and circumstances of the discourses and practices to which they relate. There is no necessity to posit a general measure and certainly no basis to the idea of measuring their relative degrees of openness to an imagined authentic experience of an original reality.

The difficulties this puts in the way of the kind of analysis which simply wants to view signifying systems as encoding and decoding practices and to locate them within what Althusser called 'Ideological State Apparatuses', cannot now be avoided.[20] Althusser's decisive advance was to treat 'ideology' as social relations, displacing notions of ideas or consciousness which had hitherto reduced ideology to a (mis)representation of the social in thought. 'Ideology' now appeared as the effect of definite institutions, practices and forms of subjection, as an indispensable mode of organisation and conduct of social relations. What Althusser continued to insist on, however, was the general and unified character of these relations and of the institutional processes by which they were produced and held in place. By subsuming all 'ideological' social relations under the mechanism of the 'Ideological State Apparatuses', Althusser elided differences between the institutions he named, inflated the concept of the state to a point of

analytical redundancy, and condemned his model to a circularity in which the Ideological State Apparatuses were bound to perform in unison a function procured for them in advance by the power and unity of purpose and ideology of an already ruling class. The model had to assume what it set out to explain. The discourses, practices and institutional structures of the Ideological State Apparatuses could secure nothing in themselves but only function as the reflex of an already inscribed power and repetitively re-enact or *re-present* what was already ordained at the level of the relations of production, into which a complex diversity of irreducible social relations were now collapsed.

For all Althusser's intentions of breaking with expressive, historicist readings of Marxism, his retention of the idea of unified levels or instances performing functions set for them by their positions in a structured totality returned his theory to the same linear separation and functionalist reduction of social practices and the same hierarchy of causality that characterised the base-superstructure model.[21] When the concepts of pre-given unities and the transparency of representation are rejected, this model is decomposed, and with it goes the function of reproduction: the idea that the cultural institutions and practices of a particular society must exhibit a necessary unity of character and ideological effect. The conditions of capitalist production are, for example, complex, flexible and compatible with a wide range of familial, managerial, educational, administrative and cultural forms, and even these may not be allowed to stand in the way of the colonisation of new markets. The political, economic and cultural fields are not, therefore, unities constituting definite sectors or instances, governed by their place in an architectonic totality.

Rejecting the architectural model of floors or levels does not, however, mean asserting that cultural institutions, practices and formations are either autonomous or inconsequential. Nor is it to deny that cultural practices and relations can be changed, challenged or reformed through institutional interventions, political practices or state actions, or that such interventions will have effects on wider social relations. It is rather to insist that these effects are not given in advance and that change in one cultural institution will not set off an inexorable chain of echoing repercussions in all the others. It is also to acknowledge that the complex conditions of cultural institutions cannot be specified in a

general concept, nor their mode of operation and consequences predicted by a general model. The effect is to remove all analytical guarantees but not to grind any process of deconstruction to a halt, since analysing forms of conditionality and the connection between cultural, political and economic social relations does not require a general theory of causality or evolution, any more than it needs a general mechanism of individual incorporation – whether in the form of a theory of alienation or a theory of the 'interpellation of the subject'.

The same complaint, it needs to be said, can also be made against recent attempts to supplement the theory of ideology by a psychoanalytical account of the production of 'the subject' in which, as in Althusser's own account, the abstractness and universality of the theoretical mechanism invoked are in constant tension with the historicalness of the apparatuses in which this mechanism is supposedly enacted. It is one of the purposes of the essays which follow to suggest that the historical relations of representation and subjection are much more complex and overdetermined than they appear in generalised and historically unspecific accounts such as Laura Mulvey's seminal analysis of spectatorial relations of power in 'classical Hollywood cinema',[22] or Elizabeth Cowie's equally influential essay 'Woman As Sign'. Operating as the latter does in a timeless space between anthropology and semiology, it is not attuned to grasp the crucial processes of historical and institutional negotiation or yield anything but a schematically abstracted diagram of power and a mythological periodisation.

The problems clearly go beyond solution by supplement. What has become vulnerable is the very concept of ideology which acquired a novel centrality in Marxist theorising only in the 1960s, as the struggles and problems of modern capitalist societies compelled the recognition of complex fields of social relations not adequately grasped by classical Marxist models. As a means to index certain beliefs, experiences, or forms of consciousness, seen as necessarily representing and organising the actions of unwitting social subjects, to a conception of material class position or interest, the category proved, in the words of one social historian, 'inert and unilluminatingly reductive'.[23] Even in Althusser's penetrating and innovatory analysis (and certainly in most defences of 'left' documentary photography), it could not be disentangled from

notions of essential class identities, the transparency of representation, and of a transgressed but knowable truth.

If 'class analysis' was to survive in cultural theory, it could not do so through a concept of ideology in the form of a return to origins or a theory of expression. There are no given and essential class relations from which cultural representations of class derive and against which they have to be measured. Nor can the multiple and diverse relations of domination and subordination bearing on and generated by cultural practices be collapsed into relations of class alone. Rather, the complex articulations and discourses of class specific to particular historical moments must be explained from the order, organisation and effectivity of representational practices and sited within a wider play of power. Across this field, the notion of 'class struggle' can only denote a dispersed, aggregative and non-unitary outcome, cut across by other forms of conflict, and not the inevitably evolving expression of homogeneous and irreconcilable identities called into being at a more fundamental level. Nor can attempts to gauge such an outcome claim any privileged exterior vantage. Far removed from the absolute judgements of historicist narration, they must rather be seen as involving specific limited forms of political calculation, dependent on determinate historical means and particular, challengeable political perspectives which have to be constructed and are not given.

VIII

All this is a deal more circumspect than the ambitions of traditional Marxist cultural theory (even as they are reflected in the earlier of the essays which follow). Circumspection of this sort, however, does not imply political disengagement, and if the relation that is posited between theory and practice is changed, it is not abandoned. To offer a cultural analysis as a conditional calculation of the power effects of specific forms of practice under determinate conditions may lack the glamour of a master knowledge, but it may come closer to promoting departures in cultural practice by furnishing criteria to characterise specific situations of action, without having the effects of pre-emptive theory and while remaining sensitive to the continual adjustments necessary to

effective intervention. By contrast, for all the supposed mobilising value of traditional Marxism's simplifying schema and claims to scientificness, its conception of an objective historical process has more often had a disabling effect on active struggle, while its fixed modes of calculation and inflexibly reductive patterns of explanation have proved inadequate to the demands of new forms of cultural practice and insensitive to the possibilities of new arenas of conflict in present-day capitalist societies consequent on the growth and dispersal of new kinds of welfare, administrative, educational and cultural institutions and their articulation of new modalities of power.

It was precisely for this reason that Althusser's theory of Ideological State Apparatuses appealed so widely to those whose struggles – especially against racism and the subordination of women – lay, most immediately, outside accepted political domains and were inhibited or marginalised by the workerism, economism and essentialism of existing Marxist and socialist theories. Hence, too, its popularity on the left as a basis for fostering cultural activism and legitimising cultural struggle: struggle not only through, but *in* and *on* the institution of photography, for example. Yet, paradoxically, Althusser's model served simultaneously to disarm the very struggles it seemed to have validated. By locating such struggles, as we have seen, in what he defined as *state* apparatuses, Althusser ensured that they remained tied to and limited by conditions of struggle originating outside their sphere and governing the entire supposed social totality. In the terms of such an analysis, specific and local institutional interventions had to pave the way for revolution or else be condemned as reformist measures, liable to collapse back or merely reinfuse 'the system'. What seemed to open new possibilities of action in a whole range of cultural, familial and educational sites turned out, in effect, to obstruct innovatory practices by reinforcing traditional notions of revolutionary struggle, with all their accompanying exaggerations of the role of the theoretically informed activist.

But Althusserianism was not alone in feeding this process. While Foucault's work seemed to offer a much more effective conception of a 'microphysics' of power and of local struggles against its 'capillary forms',[24] the monumentalising of his institutional histories into a general metaphor for the 'disciplinary archipelago' had the same debilitating effects on action. Robbed of its historical

particularity and theoretical restraints, Foucault's panoptic regime was turned into the mirror equivalent of Althusser's machinery of repression and consent, the pessimistic darkness of the one contrasting with the revolutionary light of the other, like a cold war image of a world divided, with only the choice between this way or that: the internalised repression of the society of surveillance or the imaginary freedom of ideological self-subjection. The prospect of productive day-to-day struggles and successful specific interventions was always receding in such totalising systems, which are open to nothing but equally total change. Faced with a task out of all proportion to existing capabilities, arousal to action gave way to post-structural depression.

IX

If some of the arguments developed below veer too far, at times, in the direction of these totalising tendencies, the general tack on which they are set is headed the opposite way. This, as I have stressed, is not a course which means abandoning cultural political analysis or suggesting that cultural practices are autonomous, unconditional or trivial. What develops across the articles, read in the order in which they were written, is rather an attempt to break from ahistorical modes of textual analysis without falling into a reductive account of the relation of cultural practices to economic and political social relations and the state. The issue of the state remains central to the themes of this book. To reject Althusser's theory of Ideological State Apparatuses is not to deny the historical importance of significant changes in the nature of the state in developed industrial societies, to underestimate this state's capacity for proliferating interventions, or to question its strategic importance for struggle as the institutional concentration and condensation of political power and representation. It is equally crucial, however, not to be led into reading every play of power relations as the product of the overt or covert actions or structure of the state, any more than as the reflex of some immanent disciplinary will. We have to be able to develop an account of social relations, the state and governmentality in which, theoretically and historically, it makes sense to talk of cultural politics and cultural interventions and yet it is possible to conceive of a variety of non-reflectionist practices.

The importance of this to cultural political analysis is manifest since, without it, such analysis would have no status at all.

The historical analyses gathered here rest on the view that cultural practices have significance – and, in turn, constitute a site of struggle – precisely because of their place in that non-unitary complex of social practices and systems of representation which do not express, but construct, inflect, maintain or subvert the relations of domination and subordination in which heterogeneous social identities are produced. Such practices belong, therefore, to a field of power effects in which they are articulated with economic and political practices, representations and relations, without presupposing any unified outcome. They also depend on specific, historically developed means and modes of production and other conditions of existence which they do not determine; but they cannot be evaluated by reference to these conditions as to a source or origin. The problem for analysis is to calculate the specific conjunctural effects of cultural practices in relation to their conditionality. But these effects cannot be established outside such historical calculations. There are no necessary and binding rules of connection between conditions of existence and modes of production and effects at the level of signification – no incontrovertible laws of relation, for example, between 'mass media', corporate ownership, and trivialisation and depoliticisation of meaning. Or, to put it another way, the commodity status of certain cultural products in capitalist societies cannot be equated with their sign status, as in the theory of fetishism and, on a more facile level, as in so many attacks on the production of saleable art objects in 'left' cultural criticism of the 1970s.

There are no laws of equivalence, then, between the conditions and effects of signification, only specific sets of relations to be pursued. There is no mechanism of expression, linking holistic classes to their supposed outlooks and cultures, only a complex of processes of production of meanings going on under definite historical constraints and involving the selective and motivated mobilisation of determinate means and relations of production in institutional frameworks whose structures take particular historical forms. There is no meaning outside these formations, but they are not monolithic. The institutions, practices and relations which compose them offer multiple points of entry and spaces for contestation – and not just on their margins. There is no space,

therefore, that can be condemned in advance as necessarily a site of incorporation or privileged as the proper site of cultural action – the gallery or the streets; privileging one space over another, however, may be a function of a particular discourse and/or institutional order. The potentialities of action depend on an accumulation of conditions, the nature of the site, the means of cultural production involved, the means of intervention, the mode of calculation deployed, and so on. But the sites and the discursive practices they support are never isolated. Their interrelations and hierarchies – 'Art', 'craft', 'mass communications', 'popular culture', 'folk art', 'subcultural styles' – also constitute levels of intervention demanding their own specific forms of practice.

The consequences all this has for cultural practice and for mapping out the grounds for cultural struggles are clear, though these consequences cut against what traditional aesthetics and criticism assume can be taken for granted. The dramatic unities are gone. There can be no one place or stage for action, whether thought of in institutional terms or as the abstract, mythological space of the avant-garde and certain operatic versions of art history as class struggle. Then, too, no one strategy can be adequate for the diversity of sites and confrontations; there are no recipes for action, social commands, or artists' mandates here, no prospect of socialism in one work of art. Nor can only one agent or kind of agency be thought to be involved. The specialness of the artist and traditional intellectual can no longer serve even as a mobilising myth. Cultural institutions require a whole range of functionaries and technicians who contribute their skills to or service cultural production at a whole series of points, in a whole variety of ways. Any adequate cultural mobilisation must therefore be as highly stratified and collective as the dominant mode of production: as collective as the film industry, television, architecture or, indeed, the artist–dealer–critic–museum circuit; as collective and complex as the skills, practices, codes, technical rules, procedures, protocols, knowledges, habits, divisions of labour and distinctions of rank which make up the institutional base.

But if, in this, practice is stripped of universality and robbed of guarantees, the argument also turns on critical theory. Theory can offer argued calculations of the effects of particular practices in specific conditions, or provide criteria for characterising situations and modes of action, but it cannot lay down the lines of an

objective process or prescribe necessary directions. Neither can it operate from anything but an implicated internal perspective, a political position that has to be constructed, a basis in its own conditionality as itself a cultural practice. If this opens the way for a specific practice, it effectively explodes the privilege that criticism, across the political spectrum, has claimed for itself since the Enlightenment.[25]

It also suggests the limits of a methodological debate which was, for over a decade, the dominant focus for opposition to traditional approaches in art history, as in film and photographic theory. The problems of such a focus proved to be not only the theoretical ones of the reductivism, eclecticism and metaphysical essentialism of the various versions of the belief in methodological finalities. The greatest dangers lay in the way new critical and historical practices for the most part bracketed out questions of their own institutional limits, power relations, and fields of intervention. In this, advocates of social history were as guilty as the most abstract structuralists. For all the concern with 'dominant representations', real opportunities for analysis, organisation and engagement were missed: if the majority, for example, encountered 'dominant art history' through tourism and leisure consumption, the strategic importance of work in these areas, outside museums, was never seriously grasped; nor did new curricula effectively equip students to intervene in these fields. The arena of confrontation was never so diversified. Concentrated in certain limited spaces, predominantly in higher education, and seemingly content if not secure in its all but complete academicisation, the methodological challenge was staged and significant ground was gained. But the very terms of this academic success were to contribute to its serious vulnerability in the face of catastrophic political change, state intercessions, economic cutbacks, redundancies and unemployment. Ironically, the very issues that had begun to come to the fore in theory now threatened to overtake a theoretical movement which had begun in very different conditions, in the educational expansion and upheavals of the 1960s.

At this point, left till last of course, it has to be said that I am talking about my own work, as well as that of others; talking, indeed, about this book and the conditions which disrupted its writing and delayed its completion. It is more than theoretical second thoughts which separate its point of departure from its

moment of completion, and the very processes of power and institutional struggle with which it wanted to deal are written on it more deeply perhaps than they are written in it. If this was to lead, however, to no more than a defeatist view of the theoretical project of which this book is part, there would be no point in finishing the sentence. But the argument returns: critical writing – this book – cannot pre-empt or argue away the conditions which frame its intervention, but neither is it exhausted by them. What it can do is shift the discursive structures in which these conditions can be grasped and lines of resistance drawn out. That is not enough and that is not an end to it. But the point is neither to throw away the book, nor imagine it ever complete. The problem now lies in developing the strategies, practices, discourses, institutions and mobilisations which might be able to change how and where it can speak and to write it again to some effect.

Chapter 1

A Democracy of the Image: Photographic Portraiture and Commodity Production

A foul society has flung itself, like Narcissus, to gaze at its trivial image on metal. (Baudelaire, *Salon of 1859*)

I

It is a commonplace now to say that we could not go through a day without seeing a photograph. We are surrounded by advertising hoardings, newsphotos, magazine covers, window displays and posters of all kinds. But amongst all these there is a special kind of photograph, more pressing and more intimate. These are the photographs we carry in our wallets, set on our sideboards and mantelpieces, collect in albums, and stick in our passports, bus passes or student cards. They are images of ourselves, our family, our friends; portraits whose meaning and value lie in countless social exchanges and rituals which would now seem incomplete without photography. A wedding, the committal of a prisoner to gaol, a response to a lonely-hearts advertisement, an application to a university, a sporting victory, a departure for war: all these are sealed by the making and exchanging of a photograph – a portrait.[1] Wrench them from their contexts and put them together and you have the 'family album' in which we make one kind of sense of our lives. A childhood studio portrait, a school photo, a wedding group, a passport photograph, an identity pic, a holiday snapshot: we all have them. You could probably put together a similar selection.

But what do such pictures do for us? What uses do they have? Why does it seem natural to have kept them? And how has it come about that, for most people, photography is primarily a means of obtaining pictures of faces they know?

In some ways, all the pictures I shall discuss in this chapter seem to form an album, connecting our own portraits to the past: a family of faces spanning the entire history of photography. But can the fragile daguerreotype image in its red plush case be equated with the coarse newspaper print which was looked at once, then thrown away? Does the blurred cameo effect and wistful expression of the prison record photograph make this early mug shot comparable with an imposing and expensive studio portrait by Nadar? Or with the stiff figures of the cigarette-card sized pictures in the album of celebrities? Each of these images belongs to a distinct moment; each owes its qualities to particular conditions of production and its meaning to conventions and institutions which we may no longer readily understand. The transparency of the photograph is its most powerful rhetorical device. But this rhetoric also has a history, and we must distance ourselves from it, question the naturalness of portraiture and probe the obviousness of each image. As we begin to do this, they must appear strange, often incompatible one with another. Comfortable notions of the history of photography and sentimentalities about the Family of Man must be left behind.

Look at the plates reproduced in this chapter. Notice how repetitious they are. Heads and shoulders, as if those parts of our bodies were our truth. We hardly question the theories of physiognomy on which such sedimented notions rest. But such theories came powerfully into play in our society only in the nineteenth century. Almost all the poses are three-quarter views tending to frontality, except for one. To a great extent, the pose of this image was determined by the device which produced it – the mechanism of the Physionotrace, which traced the profile of the sitter and engraved it via an armature on to a copper plate. Clearly such a method would not produce recognisable results by tracing a frontal outline. Photography, however, was not bound by such limitations; yet the change from a profile representation to a full-face involved more than expediency and taste. It summoned up a complex historical iconography and elaborate codes of pose and posture readily understood within the societies in which such

portrait images had currency. The head-on stare, so characteristic of simple portrait photography, was a pose which would have been read in contrast to the cultivated asymmetries of aristocratic posture so confidently assumed by Nadar's *Portrait of Rossini*. Rigid frontality signified the bluntness and 'naturalness' of a culturally unsophisticated class and had a history which predated photography. Hogarth and Daumier satirised it in the *Marriage Contract* scene from *Marriage à la Mode* of 1745 and in the *Croquis Parisiens* of 1853, which set the 'pose de l'homme de la nature' against the 'pose de l'homme civilisé'. Their target was the emerging middle class but, in the course of the nineteenth century, the burden of frontality was passed on down the social hierarchy, as the middle classes secured their cultural hegemony. The bourgeois figures in mid-nineteenth-century polyphoto images aped the mannerisms of eighteenth-century painted portraits and coveted their prestige. By the 1880s,

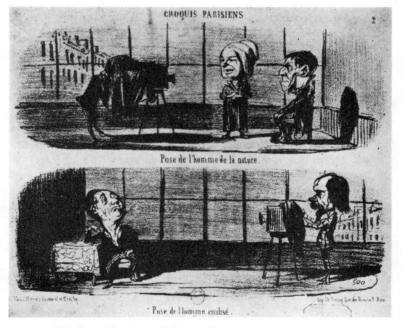

Plate 1. Honoré Daumier, *Pose de l'homme de la nature* and *Pose de l'homme civilisé* from *Croquis Parisiens*, 1853. (Bibliothèque Nationale, Paris)

the head-on view had become the accepted format of the popular amateur snapshop, but also of photographic documents like prison records and social surveys in which this code of social inferiority framed the meaning of representations of the objects of supervision or reform.

II

The portrait is therefore a sign whose purpose is both the description of an individual and the inscription of social identity. But at the same time, it is also a commodity, a luxury, an adornment, ownership of which itself confers status. The aura of the precious miniature passes over into the early daguerreotype. The same sense of possession also pervades the elaborately mounted collections of *cartes-de-visite* of public figures. The production of portraits is, at once, the production of significations in which contending social classes claim presence in representation, and the production of *things* which may be possessed and for which there is a socially defined demand. The history of photography is, above all, the history of an industry catering to such a demand: a history of needs alternatively manufactured and satisfied by an unlimited flow of commodities; a model of capitalist growth in the nineteenth century. Nowhere is this more evident than in the rise of the photographic portrait which belongs to a particular stage of social evolution: the rise of the middle and lower-middle classes towards greater social, economic and political importance.

It was the rise of these classes which had produced throughout the late eighteenth century that demand for reproductions in great quantities which spurred both manufacturers and inventors to seek new ways in which it might be satisfied. The market for pictures expanded as fast as it could be supplied. What had for centuries been the privilege of the few was pressed as a democratic right by the new middle classes of Britain, France and America even before the period of the French Revolution. And nowhere was their demand more insistent than in portraiture. To 'have one's portrait done' was one of the symbolic acts by which individuals from the rising social classes made their ascent visible to themselves and others and classed themselves among those who enjoyed social status. As rapidly as the market grew, so new forms and techniques

were developed to supply it, transforming the craft production of portraits as more and more mechanical means of image-making removed the need either for training or for skill.

In this transitional period, the emerging middle-class market for portraits had not yet spurred the development of novel artistic modes but, rather, saw the adoption of artistic conceptions and forms of representation from the displaced nobility – modes which were modified according to new needs. What was demanded of portraits was, on the one hand, that they incorporated the signifiers of aristocratic portraiture and, on the other hand, that they be produced at a price within the resources of the middle-class patrons. The fashionable miniature became one of the first portrait forms to be adapted to the needs of a new clientèle in this way. The

Plate 2. Mme Pierre-Paul Darbois, *Mr Henry Rosales*, painted miniature, 1843. (Trustees of the Victoria and Albert Museum)

Portrait of Mr Henry Rosales typifies the plain type of product which dominated the markets of the early years of the nineteenth century and competed with the earliest photographs. Large numbers of miniaturists producing thirty to fifty portraits a year at a modest price earned their living by this trade, until the advent of photography in the mid nineteenth century took away their livelihood with alarming rapidity and, at the same time, secured an enormous leap in production. In Marseilles around 1850, for example, about four or five miniaturists made a modest living producing, at most, around fifty portraits in a year. Some years later, there were forty to fifty photographers working in the town, mostly as portraitists, each producing on average 1,200 plates a year for fifteen francs a piece, giving them an annual turnover of 18,000 francs each, or just under a million francs in Marseilles as a whole.[2]

As in the general tendency of manufacture in this period, the expansion of the market, with growing demand from larger and larger numbers, necessitated the mechanisation of the process of production and the replacement of expensive hand-made luxuries such as painted portraits by cheaper mechanical imitations. Even before the invention of photography, this had been evident in the crazes for silhouettes and the profile engravings mechanically transcribed by the Physionotrace. Invented in 1786 by Gilles Louis Chrétien, the Physionotrace combined the two current modes of cheap and available portraiture: the cut-out silhouette and the engraving. Seated in Chrétien's apparatus, customers had their profiles traced on glass by a stylus connected through a system of levers to an engraving tool which recorded the movements of the stylus at a reduced scale on miniature copper plates. From these plates multiple copies could then be printed. What had required of the miniaturist some artistic skill and from the silhouettist at least some manual dexterity, now became a mechanical operation. A single sitting of less than one minute sufficed to produce a small but exact map of the features which could be reproduced again and again. The value and fascination of such mechanically produced portraits seemed to lie in their unprecedented accuracy. The mechanisation of production guaranteed not only their cheapness and ready availability, but also, so it seemed, their authenticity. In this sense, although it was an apparatus which could not be developed further, the Physionotrace was the precursor not only of

Plate 3. Physionotrace engraving by Gilles-Louis Chrétien, 1793. (The Kodak Collection, National Museum of Photography, Film and Television)

the potential of photography as a system of multiple reproduction, but also of its claims to offer a mechanically transcribed truth.

III

The experimental initiatives which resulted in the invention of photography itself were situated at the point of convergence of a variety of scientific disciplines, involving optics, the chemistry of light-sensitive salts, the design of lenses, and the precision engineering of instruments. Their pursuit depended, in turn, on a liberal conception of scientific research and a definite degree of development of the apparatuses in which it was to be carried out and tested. The incentive to develop the existing scientific and technical knowledge as a means of fixing the image of the camera

obscura came, however, from the unprecedented demand for images among the newly dominant middle classes, at a stage of economic growth in Britain and France when organised industry was displacing traditional patterns of manufacture and laying the basis for a new social order. In 1839, when Daguerre made public his photographic process, what he stressed was its potential accessibility to a wide public and its automatic nature – two factors which were seen as inseparable from the imagined objectivity of the technique. 'Anyone', he claimed, 'can take the most detailed views in a few minutes' by 'a chemical and physical process which gives nature the ability to reproduce herself.'[3] The ideological conception of the photograph as a direct and 'natural' cast of reality was present from the very beginning and, almost immediately, its appeal was exploited in portraiture.

Commercial and colonial competitors, however, were not to be so easily convinced. The *Leipzig City Advertiser* denounced the process as sacriligious, especially where it involved the representation of the human face:

> To try to catch transient reflected images is not merely something that is impossible but, as a thorough German investigation has shown, the very desire to do so is blasphemy. Man is created in the image of God and God's image cannot be captured by any human machine. Only the divine artist, divinely inspired, may be allowed, in a moment of solemnity, at the higher call of his genius, to dare to reproduce the divine-human features, but never by means of a mechanical aid.[4]

But such pious chauvinism was powerless to stop the momentum of the daguerreotype. 'Within fifteen days after the publication of the process of M. Daguerre in Paris', recorded one of Daguerre's overenthusiastic pupils, 'people in every quarter were making portraits.'

Yet the difficulties of making photographic portraits were not few. Even after Daguerre learned how to develop the latent image on the metal plate and thereby reduced the required exposure time, these exposures remained long, often more than half an hour in the beginning. Sittings were drawn out and uncomfortable. The face was powdered white and the head held rigid in a clamp. Sitters also had to close their eyes against the harsh sunlight required to expose the plate, and the necessity of keeping still invariably

resulted in rigid expressions. Even then the process was hazardous, and the result from the expensive equipment might well be failure. The silvery surface of the picture produced was extremely fragile. It had to be protected in a case like jewellery and did not allow for retouching, except for delicate stippled colouring. As a direct positive, each daguerreotype plate was also unique and could not be easily duplicated, except by unsatisfactory means of hand engraving, copying in the camera, or etching by the electrotype process. Thus, Daguerre's technique did not at first fulfil the public's demand for portraits.

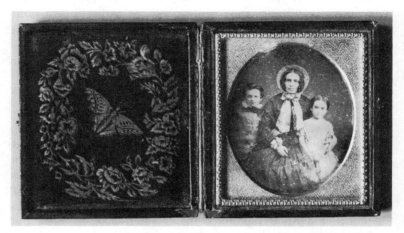

Plate 4. Unknown photographer, daguerreotype portrait in its case. (Trustees of the Victoria and Albert Museum)

Even so, the interest of the public, the attraction of the daguerreotype's ability to record in previously unimaginable detail, and the economic importance of the technique, ensured that experiments would continue. In March 1840, what the *New York Sun* called 'the first daguerreotype gallery for portraits' was opened in New York. It soon had its imitators in Philadelphia, London and, by the following year, in most major cities in Europe and America. By that time, too, substantial technical advances had been made. Improved lenses forming an image many times more brilliant than Daguerre's had been constructed in Vienna, and the first practical method for increasing the light sensitivity of the plate

had been published in London. By 1842, exposure times had been reduced to between forty and twenty seconds, and portrait studios began to open everywhere. It is estimated that more than ninety per cent of all daguerreotypes ever taken were portraits. In a 'daguerreotypemania', the middling people flocked to have photographs made, soon outnumbering the factory owners, statesmen, scholars, and intellectuals amongst whom photographic portraiture was first established. Shopkeepers, lesser functionaries, officials and small traders of all kinds – these were the sectors of the middle class which found in photography a new means of representation commensurate with their economic and ideological conditions. By their numbers, they created for the first time an economic base on which a form of portraiture could develop that was accessible to a mass public.

For the early entrepreneurs, the rewards this brought were great. Beard of London, who controlled daguerreotype patents in Britain, netted £30,000 in his second year, mostly from portraits on which he often worked to a profit margin of ninety per cent. In all the countries of Europe, the daguerreotype was a success, but nowhere did it give rise to a more flourishing commerce than in America. Here it was adopted with the utmost enthusiasm after exhibitions organised by Daguerre's representative Francois Gouraud in New York, Boston and Providence in the winter of 1839. Within a decade, there were already two thousand daguerreotypists in the country, and Americans were spending between eight and twelve million dollars a year on portraits, which made up ninety-five per cent of photographic production.[5] By 1853, three million daguerreotypes were being made annually and there were eighty-six portrait galleries in New York City alone, many of them magnificently fitted out with stained glass, statuary, drapery, pictures, caged songbirds and mirrors, in a palace-like splendour. A visit to such a gallery was a social event, as the client was put at ease before the difficult procedure. As mechanical improvements were made to the imported technique and the processes of production, such as buffing and coating, were mechanised, daguerreotypes became so cheap that almost all classes could afford to sit for them. With short-cut methods and intense competition, the price had been reduced to two for twenty-five cents; yet this was still much more than the new paper prints which began to eclipse the daguerreotype in the 1850s. It was not until their

possibilities for reproduction were developed that the conditions existed for a real portrait industry which would rapidly overwhelm traditional artistic methods and bring in its train the great expansion of the chemical, glass and paper-making industries.

IV

Photographic prints had their origin in the calotype or talbotype process invented, independently of French discoveries, by the Englishman William Henry Fox Talbot in the 1830s. In the final form of Fox Talbot's process, the latent image formed by the exposure of sensitised paper in the camera was 'developed' by subsequent chemical treatment, fixed, and then recopied so as to produce what Sir John Herschel called a 'positive' from the 'negative' produced in the camera. The illustrations show that the image quality of such prints was poorer than that of the daguerreotype, but the negative-positive process gave Fox Talbot's system the crucial advantage over Daguerre's in that it produced multiple copies, making mass printing and publication theoretically possible – especially after the invention of highly sensitive albumen paper in 1850.

The exploitation of Fox Talbot's invention was relatively slow. Unlike Daguerre, who sold his invention to the French state which

Plate 5. W. H. Fox Talbot, *Gentleman Seated*, calotype, 1842. (Trustees of the Science Museum, London)

in turn made it public, Fox Talbot received no official recognition, patented his calotype process in 1841, and doggedly prosecuted those who infringed his copyright. Even after relinquishing certain controls in 1852, he kept to himself the right to license the taking of portraits for profit which remained the most lucrative use of photography. Only in Scotland did these patents not apply, and it was in Scotland that the only extended success with calotype portraiture was achieved by the painter David Hill and his assistant Robert Adamson. Their ambitions for the medium went far beyond those of the high-street shop. All kinds of sitters came to their studio in Edinburgh or were photographed outdoors in the seclusion of a nearby cemetery. With a camera like that of Daguerre and a lens which produced only a dim image – no doubt considered more artistic – the two men made several thousand portraits, strongly influenced by Hill's knowledge of portrait painting. Exposures often minutes long were taken in strong sunlight softened by reflected light from a concave mirror; but the results ceased to seem contrived. Hill's skill at lighting and composition and Adamson's technical ability combined to produce spare portraits in which the hardness and grain of the paper, peculiar to the calotype, gave an atmospheric unity to the total image, searing it with a poignancy at once monumental and transient. The calotype portrait of Hill himself shows a control over the play of light, a sense of design and an inwardness of expression which refer back to a tradition of Dutch painting that Hill never so successfully deployed in his own stilted oils – though he continued to consider photography as subordinate to the practice of painting.

Hill and Adamson's large-scaled, artistically posed and suggestively blurred portraits were to receive an honourable mention at the Great Exhibition of 1851. But the public, used to the high quality of the French process, did not take to the graininess of the paper print, and few seem to have been able to sustain a practice of calotype portraiture. Calotypes were used rather for recording architecture and landscapes. The daguerreotype remained supreme in the sphere of stock portraiture because it required shorter exposure times and could be better adapted to rapid production methods. Moreover, as you can see even in the reproductions, where its expressive qualities were not used, the calotype could not be compared with the brilliant and precisely defined miniature image of the daguerreotype. In 1851, however,

Plate 6. D. O. Hill & R. Adamson, *Portrait of D. O. Hill*, **calotype, c.1845. (Trustees of the Victoria and Albert Museum)**

Plate 7. Unknown photographer, *Portrait of a Man with a Tall Hat*, **collodion glass negative, c.1860. (Trustees of the Science Museum, London)**

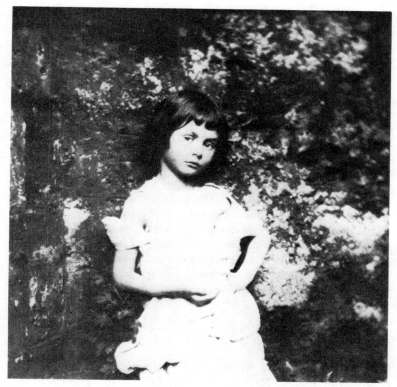

Plate 8. Charles Lutwidge Dodgson (Lewis Carroll), *Alice Liddell,*
albumen print from a collodion negative, c.1858. (Graham Ovenden)

both techniques were rapidly overhauled by the introduction of
another process which was a negative-positive process like the
calotype, but which required much shorter exposures for its finely
grained glass plates.

The collodion or wet-plate process was made available at a time
when the demand for pictures had escalated and a price war had
cut the cost of daguerreotypes to a minimum for images made two
at a time with a double lens camera. In picture factories, the
division of labour was so developed that production reached a
thousand a day: the 'operator' never left the camera; the polisher
and coater prepared the plate; the exposed plate was passed on to

the mercuraliser who developed it, the gilder who coated it, and the painter who tinted it. In fifteen minutes, the customer, waiting in a queue, had the finished likeness in hand. Even in these conditions, the daguerreotype's dominance of the commercial studio was shaken by the new invention. The wet-plate technique brought prices even lower and raised quantities even higher. Its fast emulsion revolutionised photography, especially portraiture, and an albumen print from a collodion negative could be said to embody the fine qualities of the metal plate with the reproducibility of the paper print. The glass plate of the collodion process could also be presented as a positive by backing it with black material. The disadvantage of this in making the product unique was outweighed by its speed: the sitter could take the likeness away immediately. At the same time, the wet-plate process proved more accessible to amateurs prepared to master the tricky techniques involved. As much as it stimulated a burgeoning picture industry, it also fostered the private activities of those, like Lewis Carroll and Julia Margaret Cameron, who pursued their idiosyncratic interests far beyond the pale of public imagery.

V

Yet the daguerreotype survived, at least until the introduction of *carte-de-visite* photographs, patented by Disdéri in France in 1854. *Carte-de-visite* photographs were paper prints from glass negatives, mounted on card and produced by use of a special camera with several lenses and a moving plate holder. With such a camera, eight or more images could be taken on one plate and the prints from it cut up to size. Since unskilled labour could be used for many of the operations involved, the productivity of the operator and printer could be increased virtually eightfold. The basis was laid for a mass production system in which the actual photographer was no more than a labourer.

In the period of prosperity for French commerce and industry which followed the *coup d'état* of Louis Bonaparte in 1852, Disdéri, the opportunist and showman, made this mass-production system world famous, never failing to exploit an opportunity for publicity such as that offered by the patronage of Emperor Napoleon III. For the most part, however, Disdéri's clients came either from the

aspiring bourgeoisie, enriched by financial speculations and the unbridled expansion of capitalist enterprise, or from the swollen ranks of petty officials and functionaries of the Second Empire. The unparalleled growth of Disdéri's business in France followed the Grand Exhibition of Industry of 1855 in which photography was made known for the first time to a wider public, just as it had been in England at the Great Exhibition of 1851. But whereas the photographs this public crowded to see were large in scale, unretouched, and explicit in their connotations of artistic status, what satisfied them as customers were images no more than six by nine centimetres in size, showing figures with stock props in a repetitive set of conventional poses, and costing twenty francs a dozen.

Plate 9. Pages from an album of cartes-de-visite of *Prominent French Figures*. (Trustees of the Victoria and Albert Museum)

By radically altering the format and price of his portraits and by skilful promotion, Disdéri opened his doors to a whole class of middling people eager to measure themselves against the image of their social superiors. His studio in the centre of Paris became known as the 'Temple of Photography', a place unrivalled in its luxury and elegance; but behind this facade was a factory whose turnover from portrait revenue and the sale of pictures of celebrities

approached 4,000 francs a day. Disdéri's entrepreneurial methods were subsequently taken up on an international scale by photographers who were no more than skilled technicians; yet their efforts engendered a veritable 'cardomania' in France, America and England, where Mayall sold 100,000 copies of his Royal Family set and where 70,000 portraits of the Prince Consort were sold in the week following his death. Photography had become a great industry resting on the base of a vast new clientèle and ruled by their taste and their acceptance of the conventional devices and genres of official art.

Carte-de-visite photographs were made to a formula. Posing was standardised and quick, and the figures in the resultant pictures were so small that their faces could not be studied. A New York daguerreotypist remembered his first reaction to such a novelty:

> It was a little thing, a man standing by a fluted column, full length, the head about twice the size of a pin. I laughed at that, little thinking I should, at a day not far distant, be making them at a rate of a thousand a day.[6]

However, although elaborate albums were produced to hold such *carte-de-visite* photographs of friends and celebrities, prestige portraiture continued to use a larger format which distinguished its wealthy and cultured patrons from the cheaper end of the trade.[7] To this area were recruited many of the artists whose means of existence had been taken over so rapidly by photography. The very Bohemian factions who had attacked photography as an instrument 'without soul or spirit' were constrained by economic necessity to adopt it as a better means of subsistence than their former professions; but their artistic pretensions also served to raise the status of their photographic production. Typical of this group was the former writer and caricaturist Gaspard Félix Tournachon, known as Nadar, whose painstakingly lit and subtly posed *Portrait of Rossini* contrasts with the empty formula of Disdéri's picture of *Marshal Vinoy*.

Nadar's conception of portraiture belonged to an already threatened tradition. Disdéri's style of portrait gallery, to which clients would come as to a shop, was indicative of a changed relationship between image maker and sitter. The direct and personal connection between artist and employer, which had tended to disappear under the social relations of capitalism and new forms

Plate 10. André Adolphe Disdéri, *Carte-de-visite Portrait of Marshal Vinoy*, albumen print. (Trustees of the Victoria and Albert Museum)

Plate 11. Gaspard-Félix Tournachon (Nadar), *Gioacchino Rossini,*
albumen print. (National Portrait Gallery, London)

of organisation of artistic production, was eroded all the faster by
such promotion of photography. By contrast, when Nadar opened
his studio in Paris in 1853, he cultivated a sympathy with his
clients more closely resembling the traditional interrelationship of
artist and patron. His sitters were drawn from liberal and
progressive circles in art, literature and politics, and from the
fashionable and scandalous élite of Bohemia with whom he could
identify and who were more than willing to submit to and even
collaborate with his novel technique. Without retouching, without
contrivance and with the simplest of means, Nadar presented the
faces of those to whom he could intimately respond. He argued
that:

The theory of photography can be learnt in an hour and the elements of practising it in a day . . . What cannot be learnt is the sense of light, an artistic feeling for the effects of varying luminosity and combinations of it, the application of this or that effect to the features, which confront the artist in you.

What can be learnt even less is the moral grasp of the subject – that instant understanding which puts you in touch with the model, helps you to sum him up, guides you to his habits, his ideas and his character and enables you to produce not an indifferent reproduction, a matter of routine or accident such as any laboratory assistant could achieve, but a really convincing and sympathetic likeness, an intimate portrait.

VI

At all levels of the market, however, the demand for a more convenient process than the wet-plate technique Nadar used led to many experiments in the latter half of the century which were once again to transform the practice of portraiture. In 1864, a collodion dry plate was developed which could be manufactured and used by the photographer ready-made. But the convenience of its use was paid for by a great loss in sensitivity, since the exposures required were three times those of wet plates. By 1878, however, Charles Harper Bennett had developed a gelatin rather than a collodion dry plate on which exposures could be made in as little as one twenty-fifth of a second, that is, at snapshot speeds. At a time when the entrepreneurial exploitation of photographic portraiture had reached its limit, an economically decisive shift was made. Manufacturers soon took over the production of gelatin dry plates, which released the photographer from the marked limitation of always having to have a darkroom on hand where plates could be prepared and processed while still wet. Plates could now be given to others to develop, and the foundations of a photo-finishing industry were laid. The speed of the new materials also made the tripod dispensable so that, for the first time, the camera could be held in the hand. A bewildering array of hand-held cameras appeared on the market in the 1880s, including 'detective cameras' and cameras loaded with several plates so that a dozen or more exposures could be made without reloading. The most famous of

these was introduced in 1888 by George Eastman, a Rochester dry-plate manufacturer. The name he chose for his camera was one he judged to be easily remembered and pronounceable in any language. It was the 'Kodak'.

The technical invention of flexible film and winder used in the Kodak was important enough, but its impact would have been as nothing if it had not coincided with an even more radical change in the conception of marketing photographic products. Realising that the professional and keen amateur market was saturated with novelties and technical aids which made little appeal to the serious photographer, Eastman decided to aim his sales promotion at a whole stratum of people who had never before taken a photograph.

Plate 12. Pages from an album of Kodak snapshots, 1893–1894. (Trustees of the Science Museum, London)

Eastman originated not only a camera but also a radical reconception of the boundaries of photographic practice, and an industrial system and machinery for producing standardised materials in sufficient quantities to support it. With the slogan 'You Press the Button and We Do the Rest', the Kodak brought photography to millions through a fully industrialised process of production. Instead of going to a professional portraitist, people without training or skill now took pictures of themselves and kept the intimate, informal or ill-composed results in family albums.

The portraitists who had displaced engravers and miniaturists themselves went out of business or were forced to supplement their income by opening photographic stores catering to the amateur market.

This period in which photography underwent its second technical revolution – with dry plates, flexible film, faster lenses and hand-held cameras – was also the time when the problem of reproducing photographs on an ordinary letter-set press was solved. This

Plate 13. Front page of *The Daily Mirror*, 22 April 1912, half-tone plate. (Mirror Group Newspapers Ltd)

Even less transformed

transformed the status of the photograph and thereby all the traditional forms of pictorial representation as dramatically as had the invention of the paper negative by Fox Talbot. With the introduction of half-tone plates in the 1880s, the entire economy of image production was recast. Unlike the photogravures and Woodburytypes which preceded them, half-tone plates at last enabled the economical and limitless reproduction of photographs in books, magazines, advertisements, and especially newspapers. First used in the *New York Daily Graphic* in 1880, they rapidly displaced illustrations which required the intervention of artist or engraver and, by 1897, were in regular use in the *New York Tribune*. By the turn of the century, the public had begun to expect to have the faces and news of the day in photographs in their newspapers and, when a method was devised for sending photographs by wire transmitter, there were no further obstacles to the publication of papers like the *Daily Mirror*, which was the first to be illustrated exclusively with photographic plates. The example I have chosen (Plate 13) is a bizarre one in which a private image, not dissimilar to others we have looked at, was given a new currency ten years later in an attempt – so characteristic of the *Mirror* to this day – to anchor a dramatic event in a representation of its 'human face'. What it also shows is that, just as the Kodak had transformed informal and family portraiture, so the illustrated papers ended the trade in reproductions of portraits of topical or celebrated public figures. No longer would it seem remarkable to possess an image of someone well-known or powerful. The era of throwaway images had begun.

What Walter Benjamin called the 'cult' value of the picture was effectively abolished when photographs became so common as to be unremarkable; when they were items of passing interest with no residual value, to be consumed and thrown away. This was to provoke a reaction among late nineteenth-century Pictorialists who sought, by recourse to special printing techniques imitating the effects of drawing or etching, to reinstate the 'aura' of the image and distinguish their work aesthetically from that of commercial and amateur photographers. But their efforts were of little avail. It was not that self-consciously artistic images like *Primavera* contravened some essential truth of the medium, but that, in claiming the status of autonomous Art for their photography, the Pictorialists were a crew rowing out to join a sinking ship. As

- brilliantly *mprovmetine* about the *Camera*

Plate 14. Robert Demachy, *Primavera*, gum print, from *Photographie est-elle un art?*, 1899. (Gernsheim Collection, Harry Ransom Humanities Research Center, University of Texas at Austin)

Walter Benjamin was to argue: 'When the age of mechanical
reproduction separated art from its base in cult, the semblance of
its autonomy disappeared forever.'[8]

It was not on the exalted heights of autonomous Art that
photographic portraiture made its lasting place, but in a profane
industry which furnished the cosier spaces of the bourgeois home.
And not only there. Such photographs also found a place in files –
in police stations, hospitals, school rooms and prisons – and in
official papers of all kinds. While the Pictorialists were blurring

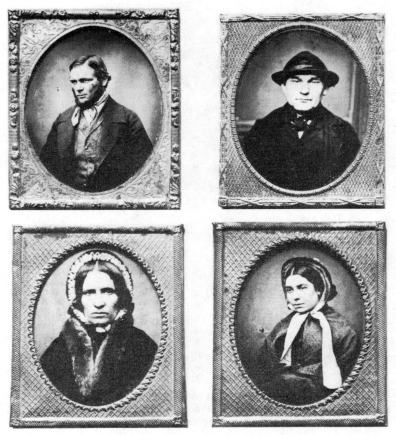

**Plate 15. Unknown photographer, *Birmingham Prisoners*,
ambrotypes, 1860–1862. (West Midlands Police)**

their outlines and smudging their tones, a more far-reaching pictorial revolution had taken place: the political axis of representation had been entirely reversed. It was no longer a privilege to be pictured but the burden of a new class of the surveilled. It is another history of portraiture to which the last image in this chapter (Plate 15) leads us – one which has less to do with commodity production than with its essential precondition: the exercise of a new kind of power on the social body, generating new kinds of knowledge and newly refined means of control.[9]

Chapter 2

Evidence, Truth and Order: Photographic Records and the Growth of the State[1]

At the end of the previous chapter, I argued that, in the last quarter of the nineteenth century, the photographic industries of France, Britain and America, in common with other sectors of the capitalist economy, underwent a second technical revolution which laid the basis for a major transition towards a structure dominated by large-scale corporate monopolies. The development of faster dry plates and flexible film and the mass production of simple and convenient photographic equipment opened up new consumer markets and accelerated the growth of an advanced industrial organisation. At the same time, the invention of means of cheap and unlimited photomechanical reproduction transformed the status and economy of image-making methods as dramatically as had the invention of the paper negative by Fox Talbot half a century earlier. In the context of generally changing patterns of production and consumption, photography was poised for a new phase of expansion into advertising, journalism, and the domestic market. It was also open to a whole range of scientific and technical applications and supplied a ready instrumentation to a number of reformed or emerging medical, legal and municipal apparatuses in which photographs functioned as a means of record and a source of evidence. Understanding the role of photography in the documentary practices of these institutions means retracing the history of a far from self-evident set of beliefs and assertions about the nature and status of the photograph, and of signification generally, which were articulated into a wider range of techniques and procedures for

extracting and evaluating 'truth' in discourse. Such techniques were themselves evolved and embodied in institutional practices central to the governmental strategy of capitalist states whose consolidation demanded the establishment of a new 'regime of truth' and a new 'regime of sense'. What gave photography its power to evoke a truth was not only the privilege attached to mechanical means in industrial societies, but also its mobilisation within the emerging apparatuses of a new and more penetrating form of the state.

At the very time of photography's technical development, the functions of the state were expanding and diversifying in forms that were both more visible and more rigorous. The historical roots of this process, however, go back fifty years across a period which coincides exactly with the development and dispersal of photographic technology, especially in Britain and France. Here, the reconstruction of social order in the period following the economic crises and revolutionary upheavals of the late 1840s depended, in different ways, on a bolstering of state power which in turn rested on a condensation of social forces. At the expense of an exclusive political rule which they could not sustain, the economically dominant industrial and financial middle classes of both countries entered into a system of political alliances with older, contending class fractions which stabilised the social conflicts that had threatened to destroy the conditions in which capitalist production could expand and diversify. These increasingly integrated, though continually modified, governing blocs dominated national political life and thus the expanding machinery of the centralised state. This great bureaucratic and military machine may have appeared to stand to one side, but it secured capitalism's conditions of existence, not only by intervention but precisely by displacing the antagonisms of contending class fractions and appearing to float above sectional concerns and represent the general or national interest.

At the local level, however, and especially within the expanding industrialised urban areas, the dominance of industrial capital and its allied mercantile and intellectual strata was more explicit and less subject to compromise. Here, too, an increasingly secure middle-class cultural domination was cashed at the level of more diffuse practices and institutions which were nonetheless crucial to the reproduction and reconstruction of social relations. This more general hegemony was, by stages, secured and made effective

through a constellation of regulatory and disciplinary apparatuses, staffed by newly professionalised functionaries, and subjected to a centralised municipal control. The pressing problem, locally and generally, was how to train and mobilise a diversified workforce while instilling docility and practices of social obedience within the dangerously large urban concentrations which advanced industrialisation necessitated. The problem was solved by more and more extensive interventions in the daily life of the working class within and without the workplace, through a growing complex of medical, educational, sanitary, and engineering departments which subsumed older institutions and began to take over the work of private and philanthropic agencies. Force was not, of course, absent. Local police forces and the administrative arms of the Poor Law were of central importance to the emerging local state, but even these could not operate by coercion alone. They depended on a more general organisation of consent, on disciplinary techniques and a moral supervision which, at a highly localised and domestic level, secured the complex social relations of domination and subordination on which the reproduction of capital depended. In a tightening knot, the local state pulled together the instrumentalities of repression and surveillance, the scientific claims of social engineering, and the humanistic rhetoric of social reform.

By the closing decades of the century, bourgeois hegemony in the economic, political and cultural spheres seemed beyond all challenge. In the midst of economic depression, the break up of liberalism, and the revival of independent working-class movements, the apparatuses of the extended state provided the means of containing and negotiating change within the limits of democratic constitutionalism, even while the state itself took on an increasingly monolithic and intrusive form, liable to panic and periodic relapse into directly repressive measures. But such relapses cannot belie the important fact that a crucial shift had taken place. In the course of a profound economic and social transformation, the exercise of power in advanced capitalist societies had been radically restructured. The explicit, dramatic and total power of the absolute monarch had given place to what Michel Foucault has called a diffuse and pervasive 'microphysics of power', operating unremarked in the smallest duties and gestures of everyday life. The seat of this capillary power was a new 'technology': that constellation of institutions – including the hospital, the asylum, the school, the

prison, the police force – whose disciplinary methods and techniques of regulated examination produced, trained and positioned a hierarchy of docile social subjects in the form required by the capitalist division of labour for the orderly conduct of social and economic life. At the same time, the power transmitted in the unremitting surveillance of these new, disciplinary institutions generated a new kind of knowledge of the very subjects they produced; a knowledge which, in turn, engendered new effects of power and which was preserved in a proliferating system of documentation – of which photographic records were only a part.

The conditions were in play for a striking *rendezvous* – the consequences of which we are still living – between a novel form of the state and a new and developing technology of knowledge. A key to this technology from the 1870s on was photography, and it is into the workings of the expanded state complex that we must pursue it, if we are to understand the power that began to accrue to photography in the last quarter of the nineteenth century. It is in the emergence, too, of new institutions of knowledge that we must seek the mechanism which could enable photography to function, in certain contexts, as a kind of proof, even while an ideological contradiction was negotiated so that a burgeoning photographic industry could be divided between the domain of artistic property, whose privilege, resting on copyright protection, was a function of its lack of power, and the scientifico-technical domain, whose power was a function of its renunciation of privilege. What we begin to see is the emergence of a modern photographic economy in which the so-called medium of photography has no meaning outside its historical specifications. What alone unites the diversity of sites in which photography operates is the social formation itself: the specific historical spaces for representation and practice which it constitutes. Photography as such as no identity. Its status as a technology varies with the power relations which invest it. Its nature as a practice depends on the institutions and agents which define it and set it to work. Its function as a mode of cultural production is tied to definite conditions of existence, and its products are meaningful and legible only within the particular currencies they have. Its history has no unity. It is a flickering across a field of institutional spaces. It is this field we must study, not photography as such.

Like the state, the camera is never neutral. The representations

it produces are highly coded, and the power it wields is never its
own. As a means of record, it arrives on the scene vested with a
particular authority to arrest, picture and transform daily life; a
power to see and record; a power of surveillance that effects a
complete reversal of the political axis of representation which has
confused so many labourist historians. This is not the power of the
camera but the power of the apparatuses of the local state which
deploy it and guarantee the authority of the images it constructs to
stand as evidence or register a truth. If, in the last decades of the
nineteenth century, the squalid slum displaces the country seat and
the 'abnormal' physiognomies of patient and prisoner displace the
pedigreed features of the aristocracy, then their presence in
representation is no longer a mark of celebration but a burden of
subjection. A vast and repetitive archive of images is accumulated
in which the smallest deviations may be noted, classified and filed.
The format varies hardly at all. There are bodies and spaces. The
bodies – workers, vagrants, criminals, patients, the insane, the
poor, the colonised races – are taken one by one: isolated in a
shallow, contained space; turned full face and subjected to an
unreturnable gaze; illuminated, focused, measured, numbered and
named; forced to yield to the minutest scrutiny of gestures and
features. Each device is the trace of a wordless power, replicated in
countless images, whenever the photographer prepares an exposure,
in police cell, prison, mission house, hospital, asylum, or school.
The spaces, too – uncharted territories, frontier lands, urban
ghettos, working-class slums, scenes of crime – are confronted with
the same frontality and measured against an ideal space: a clear
space, a healthy space, a space of unobstructed lines of sight, open
to vision and supervision; a desirable space in which bodies will be
changed into disease-free, orderly, docile and disciplined subjects; a
space, in Foucault's sense, of a new strategy of power-knowledge.
For this is what is at stake in missionary explorations, in urban
clearance, sanitary reform and health supervision, in constant,
regularised policing – and in the photography which furnished
them from the start with so central a technique.

 These are the strands of a ravelled history tying photography to
the state. They have to do not with the 'externals' of photography,
as modernists would have us believe, but with the very conditions
which furnish the materials, codes and strategies of photographic
images, the terms of their legibility, and the range and limits of

their effectiveness. Histories are not backdrops to set off the performance of images. They are scored into the paltry paper signs, in what they do and do not do, in what they encompass and exclude, in the ways they open on to or resist a repertoire of uses in which they can be meaningful and productive. Photographs are never 'evidence' of history; they are themselves the historical. From this point of view, exhibitions such as *The British Worker* must appear not only incoherent but entirely misleading in their purpose, eliding as they do the complex differences between the images they assemble – between their contrasting purposes and uses, between the diverse institutions within which they were made and set to work, between their different currencies which must be plotted and mapped. The notion of evidence on which *The British Worker* rests can never be taken as given. It has itself a history. And the ways in which photography has been historically implicated in the technology of power-knowledge, of which the procedures of evidence are part, must themselves be the object of study.

Chapter 3

A Means of Surveillance: The Photograph as Evidence in Law

In the decades of the 1880s and the 1890s, as we have seen, photography underwent a double technical revolution, enabling, on the one hand, the mass production of cheaply printed half-tone blocks and, on the other hand, the mass production of simple and convenient photographic equipment, such as the hand-held Kodak camera.[1] At the very moment when certain professional photographers were seeking, in reaction, to exhibit their status as artists in all kinds of refinement of printing technique, this double revolution stripped the image of what Walter Benjamin called its 'aura' by flooding the market with cheap and disposable photo-mechanical reproductions and by giving untrained masses the means to picture themselves. While aesthetes and pictorial photographers sought to salvage some prestige by preserving superseded techniques and arguing for the autonomy of photography as an art, an unabating technical development ensured the vast expansion of photography in the far from autonomous realms of advertising, of the family as a reconstructed unit of consumption, and of a whole range of scientific, technical, medical, legal and political apparatuses in which photography functioned as a means of record and a source of 'evidence'.

It is into the workings of these institutions that we must pursue photography if we are to understand the *power* that began to accrue to it in the latter half of the nineteenth century. It is in the

emergence, too, of new institutions of knowledge that we must seek for the mechanism which could enable photography to function, in certain contexts, as a kind of *proof*, even while an ideological contradiction was negotiated so that photographic practice could be divided between the domain of art, whose privilege is a function of its lack of power, and the scientifico-technical domain, whose power is a function of its renunciation of privilege.

This analysis of power and photography will take us far beyond the boundaries of conventional art history into the institutional spaces of the modern state. Our starting point must be power itself and the attempts that have been made to theorise its functionings. In rough and ready terms, I shall raise two questions: where and how do we find power working; how may this power be opposed and how does it produce its own resistance? Clearly, the answers, however sketchy and provisional, will have definite consequences both for the history and practice of photography. We must know more about power to discover where and how it touches photography. We must know more about the nature of resistance and struggle if we are to understand how photographic practice might be invested in them. And this is surely what we need to know, now more urgently than ever.

II

Power in the West, Foucault says, is what displays itself most and hides itself best.[2] 'Political life', with its carefully staged debates, provides a little theatre of power – an image – but it is not there that power lies; nor is that how it functions. The relations of power are among the best hidden things in the social body, which may be why they are among the least studied.

On the left, the dominant tradition, following an orthodox and reductive Marxism, has tended to neglect relations of elementary power in its concentration on the determining effectivity of the economy. It has also tended to see power only in the form of state power, wielded in the apparatus of the state, and has thus participated in the very *ideology of power* which conceals its pervasive workings.

The state, Nietzsche said, is 'organised immorality – *internally*: as police, penal law, classes, commerce, family; *externally*: as will to

power, to war, to conquest, to revenge'.[3] In the classic texts of Marx and Lenin, too, the state is conceived as an explicitly repressive apparatus, a machine of repression which guarantees the domination and subjection of the working classes by the ruling class. It consists of specialised apparatuses such as the police, the law courts and the prisons, but also the army and, above this ensemble, the head of state, the government and the administration. All these apparatuses execute their functions and intervene according to 'the interests of the ruling class' in a class war conducted by the ruling class and its allies against the dominated working classes. Whatever the value of this description in casting light on all the direct and indirect forms of exploitation and domination through which is exercised what Marx, and later Lenin, rhetorically called 'the dictatorship of the bourgeoisie', it also prevents us seeing certain highly pertinent features – features it has become imperative to understand in highly developed modern states and in the historical aftermath of those twin aberrations of power: Fascism and Stalinism.

The theoretical development of the classic Marxist view of the state, in keeping with these demands, received new impetus in the analyses of the French Marxist philosopher Louis Althusser, who took up the relatively unsystematised distinction made in the *Prison Notebooks* of the Italian Communist leader Antonio Gramsci, between the institutions of civil society – the Church, the schools, the trade unions, and so on – and those of the state apparatus proper.[4] Gramsci saw that the state had undergone a crucial change of function in Western bourgeois democracies, so that its real strength could no longer be understood only as the apparatus of government, the politico-juridicial organisation, but demanded attention to the 'private' apparatuses of 'hegemony' or civil society through which the bourgeois class sought to assimilate the entire society to its own cultural and economic level. In his more rigid theoretical framework, Althusser divided the state into two domains or kinds of apparatus: that which functioned primarily and predominantly by 'physical force', and that which functioned primarily and predominantly 'by ideology'. It is the state apparatuses which, principally by force, procure the political conditions for the action of the 'Ideological State Apparatuses' – the educational, religious, family, political, trade-union, communications and 'cultural' apparatuses – which, acting behind

a 'shield', largely secure the reproduction of the relations of production. The Ideological State Apparatuses are 'on the side of the repressive State Apparatus', but they must not be confused with it. They are distinct, specialised and 'relatively autonomous' institutions which constitute a plurality, much of which lies outside the public domain as defined in bourgeois law, but which owe their unity to their functioning 'beneath the ruling ideology', that is, beneath the ideology of the ruling class. 'No class', Althusser says, 'can hold state power over a long period without at the same time exercising its hegemony over and in the State Ideological Apparatuses.'[5]

There is still in Althusser's theoretical amplification something of an idea of power as a privilege to be captured and then exercised; a kind of 'fluid' which may be 'poured' into an apparatus as into a vessel. We shall come on to further difficulties which arise from his attempt to maintain a strict distinction between the State Apparatuses and the Ideological State Apparatuses on the basis of their respective primary functioning by force and ideology. Above all, the anomalies in Althusser's account arise from his conception of preconstituted class identities, in possession of preformed ideologies, which contend for control of the Ideological State Apparatuses which are merely instruments for propounding and enforcing the ruling ideology. Too often, Althusser sees the Ideological State Apparatuses as the *stake*, rather than the *site* of class struggle, though he has to acknowledge that the Ideological State Apparatuses are fraught with contradictions originating both in the residues of former ruling classes and in the resistances of the exploited classes. What he does not show is that it is in the representational practices of these apparatuses themselves that the ideological level is constituted, of necessity including that positionality which constitutes class identity.

This said, a decisive step has been taken towards seeing power – a power still conceived as 'state' power – in more than its repressive functions; towards a total explanation which incorporates those apparently peripheral and independent institutions such as the family, the school and the communications media, in the reproduction of the social relations within which production takes place; and towards the most important realisation that, if these apparatuses function 'by ideology', by interpellating individual subjects in the positions created for them by the socio-technical

division of labour, then 'an ideology always exists in an apparatus, and its practice, or practices. This existence is material.'[6]

Part of the value of Althusser's account resides, therefore, in the way it opens on an extensive prospect of concrete historical work. It has been the French historian Michel Foucault who has done most to elaborate this materialist analysis in the concrete domain of real history; who has set out, in his own words,[7] 'to investigate what might be most hidden in the relations of power; to anchor them in the economic infrastructures; to trace them not only in their governmental forms but also in the infra-governmental or para-governmental ones; to discover them in their material play'. Foucault has made what he calls 'the technology of power' the very principle, the central matrix, from which the particular processes of the present scientifico-juridical formation derive. It is within this 'technology of power' that he has studied the genealogy of a cluster of institutions which, born of the profound reorganisation of social relations in European societies in the late eighteenth and early nineteenth centuries, have secreted new and strategically connected discourses about and within them; discourses which themselves function as formidable tools of control and power, producing a new realm of objects both as their targets and as instrumentalities.

It is in the context of the development of such a discursive formation that Foucault has seen the pathologising of the female body, in the eighteenth century, as the object of an immense medical attention; the reconstitution of homosexuality as illness in the new medical and psychiatric analyses of the 1870s; the 'discovery' of 'mental illness' in the workings of the asylum; the generation of delinquency in the new apparatus of the prison and the evolution of the new pseudo-discourses of criminology. All these are products of a determinate range of instruments – the hospital, the asylum, the prison, the school, the barracks – exercising a new range of techniques and acting with precision on their newly constituted and individuated subjects. In his studies of the 'birth' of this constellation of institutions in the eighteenth and nineteenth centuries, Foucault opens up a new territory that is neither violence nor ideology, coercion nor consent; that bears directly and physically upon the body – like the camera's gaze – yet is also a knowledge. This knowledge and this mastery constitute what he calls the political technology of the body: a diffuse and multiform instrumentation which cannot be localised in a particular type of

institution or state apparatus but is situated at a different level, that of a 'micro-physics' of power, between the great functionings and the bodies themselves, decipherable only in a network of relations in constant tension which go right down into the depths of society.[8]

Power, in this new type of society, has drained deeply into the gestures, actions, discourses and practical knowledge of everyday lives. The body itself is invested by power relations through which it is situated in a certain 'political economy', trained, supervised, tortured if necessary, forced to carry out tasks, to perform ceremonies, to emit signs. Power is exercised in, and not just on, the social body because, since the eighteenth century, power has taken on a 'capillary existence'. The great political upheaval which brought the bourgeoisie to power and established its hegemony across the social order was effected not only in the readjustment of those centralised institutions which constitute the political régime, but in an insistent and insidious modification of the everyday forms of the exercise of power. What this amounted to was the constitution of a new type of régime discovered in the eighteenth century, that is, a scientifico-legal complex impregnated with a new technology of power.

'If the economic take-off the West began with the techniques that made possible the accumulation of capital', Foucault argues, 'it might perhaps be said that the methods for administering the accumulation of men made possible a political take-off in relation to the traditional, ritual, costly, violent forms of power, which soon fell into disuse and were superseded by a subtle, calculated technology of subjection'.[9] What was new in the late eighteenth century was that, by being combined and generalised, the techniques which made up this technology attained a level at which the formation of knowledge and the increase of power regularly reinforced one another in a circular process. It was a process with two movements: an epistemological thaw through a refinement of power relations; and a multiplication of the effects of power through the formation and accumulation of new forms of knowledge.

III

The development of the police force was integral to this process of change which began in the eighteenth century and effected, in the

era of capitalism, a decisive shift from the total power of the monarch to the infinitely small exercise of power necessary to the discipline and productive exploitation of bodies accumulated in large numbers. In order to be effective, this new strategy of power needed an instrument of permanent, exhaustive, omnipresent surveillance, capable of making all visible, as long as it could itself remain invisible. The institution of the police offered just such a means of control which could be present in the very midst of the working population, under the alibi of a criminal threat itself manufactured across a set of new apparatuses ranging from the penitentiary to crime reporting and the crime novel. In England, it was in the latter half of the eighteenth century and the early nineteenth century that pressure grew to replace with a more rigorously organised force the inefficient system of unpaid constables and watchmen which had failed to control crime and disorder in towns swollen by great concentrations of factory workers. The common law conception of a socialised responsibility for keeping the peace dispersed throughout the community was no longer functioning in the urban industrial centres, in the new architecture of life and work, amidst the break-up of old social patterns and demands for new kinds of order regimented to meet the needs of regulation and production. In the atmosphere of panic following the French Revolution of 1789, investigators such as the magistrate Patrick Colquhoun gave lurid colour to their advocacy of a more effective police force by publishing the results of their criminological research in sensational form in which statistics – such as they were – were marshalled for pejorative purpose. Manufacturers pressed for greater discipline in work and leisure in the factory towns. Methodists and 'humanitarians' called for order, submissiveness and the suppression of vice. Reformers argued that a more effective preventive police was absolutely necessary to guard over property. From the founding of Henry Fielding's Bow Street Foot and Horse Patrol in London in 1748 till the middle years of the next century, the case was pressed and pressed again for a full-time, uniformed police force.

All kinds of official and semi-official forces grew up in the cities, especially around the ports, canals and navigable rivers where property was at stake. Yet there was still a concerted opposition, and not alone from the radical sections of the populace who always saw the police as an 'engine of oppression'. In 1812, the idea of a

centralised force was still seen by one commentator as 'a system of tyranny; an organised army of spies and informers, for the destruction of all public liberty, and the disturbance of all private happiness'.[10] A parliamentary committee of 1818 saw in Jeremy Bentham's proposals for a Ministry of Police 'a plan which would make every servant of every house a spy on the actions of his master, and all classes of society spies on each other'.[11] There was no guarantee that the gaze of surveillance would be fixed in one direction. Merchants and industrialists still feared any powers of inspection which might lead to searches of the houses and premises of those suspected of evading regulations. Older vested interests were also threatened by the new pervasive mechanisms of power. Tories feared an overriding of parochial and chartered rights. Whigs feared an increase in the power of central government. In 1822, a Select Committee of the House of Commons under the chairmanship of Sir Robert Peel once more rejected the idea of a police as being inconsistent with political freedom.

Yet it was this same Robert Peel who, as Home Secretary, was largely responsible for setting up the Metropolitan Police Force by Act of Parliament of 1829. Under the Act, 3,000 blue-uniformed men, in seventeen divisions under a hierarchy of superintendents, inspectors and sergeants, controlled by a commissioner and ultimately responsible to the Home Secretary, were given jurisdiction over the area of a seven-mile radius around Charing Cross. Despite continued agitation for its abolition, the force was bolstered by the appointment of the first special constables in 1831, and systematically extended, first to all urban areas of England and Wales by the Municipal Corporations Act of 1835, and then to the counties and rural areas by Act of Parliament in 1856. By this same Act of 1856, central government undertook to provide one quarter of the cost of pay and equipment, and a regular inspectorate was set up to report on the state of efficiency of the widely dispersed constabularies. In this way, the powers and duties of the constable which derived from the ancient common law of England were subsumed but also transformed in the new police constable, who was a member of a disciplined force, subject to strict codes and a hierarchy of inspection and supervision.

The control which such a force could exert was entirely bound up with the real need of capitalist industrial society to protect a wealth – in the form of the means of production – which was no

longer in the hands of those who owned it, but of those whose labour set it to work and enabled a profit to be drawn from it. Linked to a series of similarly restructured mechanisms of power, it was the police which installed the new power-knowledge nexus in the very heart of working-class life, extending the emerging techniques of observation-domination beyond the walls of the new disciplinary and reformatory institutions such as prisons and penitentiaries. This special kind of observation which the police brought to bear had to be accumulated somehow. It began, therefore, to be assembled in a growing series of reports and registers. From the eighteenth and nineteenth centuries onward, an immense police text came increasingly to cover society by means of a complex documentary organisation. But this documentation differed markedly from the traditional methods of judicial or administrative writing. What was registered in it were forms of conduct, attitudes, possibilities, suspicions: a permanent account of individuals' behaviour.

IV

Now is perhaps the moment to turn to the complicity of photography in this spreading network of power. The early years of the development of the photographic process coincided approximately with the period of the introduction of the police service into this country, and for more than a hundred years the two have progressed together. As photographic processes and equipment have been evolved and refined, so have police forces expanded and become more efficient.

The value of photographs for the purposes of identification was realised by the police at a very early stage. Though successful portraiture only became possible with the introduction of faster Petzval lenses and more sensitive Daguerreotype processes by 1841, the police employed civilian photographers from the 1840s onwards. The West Midlands Police Museum has a file of twenty-three ambrotypes of Birmingham prisoners taken by an unknown photographer in the 1850s and 1860s. The poses are simple and plain, but the delicate glass plates are each mounted in an ornamental frame, as if they were destined for the mantelpiece. Other forces possess similarly early records, though it is most likely

that at this time the work was carried out by professional photographers who were not yet members of the police force itself. The great growth of specialised police photographers followed the successful development of Sir Edward Henry's system of identification by means of fingerprints, introduced at New Scotland Yard in 1901. It soon became apparent that the only way to record

Plate 16. Unknown photographer, *Wandsworth Prison Records*, 1873. (Public Records Office, London, PCOM 2/291)

finger impressions found at the scene of criminal activities was to photograph them, and increasing numbers of police photographers were engaged to make best use of the specialised techniques.

Many thousands of identification pictures are now taken each year and the prints filed, together with the prisoner's fingerprints, at the Central Criminal Record Office and at Regional Record Centres. The police in this country have no authority to photograph an accused person who objects, but if necessary an application for a remand in custody enables the prison governor to take the prisoner's photograph under an authority granted by Section 16 of the Prison Act of 1952. Governors of prisons, remand centres, detention centres and Borstal institutes are themselves required by the Criminal Justice Act of 1948 to register and photograph all persons convicted of crime, but these powers go back to 1870. Act 17, Section 3 of the Alien Order Act of 1920 also empowered police officers to order the photographing of any alien. The photographs required, however, were to be full-face, with head uncovered. They did not yet have to follow the standardised format of full-length, full-face and profile, laid down by the Committee on Crime Detection Report of 1938, which endeavoured to improve the quality of prisoners' photographs, going so far as to describe the system of lighting and equipment to be used. What we have in this standardised image is more than a picture of a supposed criminal. It is a portrait of the product of the disciplinary method: the body made object; divided and studied; enclosed in a cellular structure of space whose architecture is the file-index; made docile and forced to yield up its truth; separated and individuated; subjected and made subject. When accumulated, such images amount to a new representation of society.

The use of photography here, as a process which enables accurate records to be made quickly and cheaply, is clearly underpinned by a whole set of assumptions about the reality of the photograph and the real 'in' the photograph which we shall have to examine more closely. For the moment, let us accept that, given this conception of photography, it could be and has been extended to most aspects of police work until, today, almost every photographic process and technique is in use; though the still image may be rapidly overhauled by more accessible video techniques and even the use of holograms. The production of photographs for court evidence is

now standard practice. Photographs are used to assist in the control of traffic and in the prosecution of traffic offences; to record evidence of bad driving from mobile police patrol cars; to help assess and apportion blame in fatal accident cases before the coroner's court; to provide accurate records of the scenes of crime and of clues found there; to demonstrate the photo-micrographic analysis of forensic evidence; to present visual evidence to juries in the court room of wounding, injuries or damage; to record and deter offences against property; to identify thieves and other intruders; to detect forgeries and questionable documents and to elucidate the method employed to produce them; to observe unruly behaviour at football matches and other places of assembly; to survey road junctions and public spaces from overlooking buildings, nominally for the purposes of planning traffic flow but also to observe the movements of crowds and demonstrations; to catalogue the activities of suspected persons who are under observation; to prove adultery or cohabitation in divorce or social security proceedings. The list is not exhaustive.

However, it is not only the police and the prisons who have found photography such a convenient tool for their new strategies of power. If we examine any of the other institutions whose genealogy Foucault traces, we find photography seated calmly within them. From the mid-nineteenth century on, photography had its role to play in the workings of the factory, the hospital, the asylum, the reformatory and the school, as it did in the army, the family and the press, in the Improvement Trust, the Ordnance Survey and the expeditionary force.

In 1856, Dr Hugh Welch Diamond, founder member of the Royal Photographic Society and resident superintendent of the Female Department of the Surrey County Lunatic Asylum, read a paper to the Royal Society 'On the Application of Photography to the Physiognomic and Mental Phenomena of Insanity'.[12] In it, he expounded his theories on 'the peculiar application of photography to the delineation of insanity', and he illustrated his arguments with photographs he had taken, at his own expense, in the Surrey Asylum. Dr Diamond proposed that clinical photography had three important functions in the psychiatric practices of the day. First, it acted as an aid to treatment. Photographic portraits had a value 'in the effect which they produce upon the patient themselves':

In very many cases they are examined with much pleasure and
interest, but more particularly in those which mark the progress
and cure of a severe attack of Mental Aberration.[13]

Secondly, these portraits furnished a permanent record for medical
guidance and physiognomic analysis:

the Photographer secures with unerring accuracy the external
phenomena of each passion, as the really certain indication of
internal derangement, and exhibits to the eye the well-known
sympathy which exists between the diseased brain and the
organs and features of the body . . . The Photographer catches in
a moment the permanent cloud, or the passing storm or sunshine
of the soul, and thus enables the metaphysician to witness and
trace out the connexion between the visible and the invisible in
one important branch of his researches into the Philosophy of the
humand mind.[14]

Central to Diamond's conception of photography as a method of
procuring a new kind of knowledge was the idea expressed in the
Lancet that: 'Photography is so essentially the Art of Truth – and
the representative of Truth in Art – that it would seem to be the
essential means of reproducing all forms and structures of which
science seeks for delineation.'[15] The links of the chain are truth,
knowledge, observation, description, representation, record. The
value of the camera was extolled because the optical and chemical
processes of photography were taken to designate a scientifically
exploited but 'natural' mechanism producing 'natural' images
whose truth was guaranteed. Photography presented 'a perfect and
faithful record, free altogether from the painful caricaturing which
so disfigures almost all the published portraits of the insane as to
render them nearly valueless either for purposes of art or of
science'.[16] It was free, too, from the imprecisions of verbal language:

The Photographer needs in many cases no aid from any language
of his own, but prefers to listen, with the picture before him, to
the silent but telling language of nature . . . the picture speaks
for itself with the most marked precision and indicates the exact
point which has been reached in the scale of unhappiness
between the first sensation and its utmost height.[17]

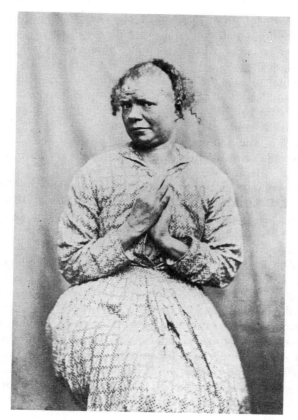

Plate 17. Dr H. W. Diamond, *Inmate of the Surrey County Asylum* from an album entitled *Portraits of Insanity*, **albumen print, 1852–1856. (Royal Society of Medicine)**

The science of the insane could now go beyond the prosaic descriptions of psychiatrists such as Esquirol or Heinroth:

> Photography, as is evident from the portraits which illustrate this paper, confirms and extends this description, and that to such a degree as warrants the conclusion that the permanent records thus furnished are at once the most concise and the most comprehensive.[18]

What is 'evident' from Diamond's photographs, however, is that their naturalness and concision were the products of a complexly coded intertextuality. As in early police photographs, the props and devices were those of a simple studio, the backgrounds plain, the poses frontal or near frontal, and attention was directed towards the face and hands of the sitter. In conception and organisation, Diamond's pictures depended from Philippe Pinel's categorisation of the insane and the earlier typologies of eighteenth-century physiognomy and phrenology. In their pictorial realisation, they drew not only on the conventions of contemporary portraiture but also on the already developed codes of medical and psychiatric illustration found in the line drawings and engravings of works such as J. E. D. Esquirol's *Des Maladies Mentales* of 1838 or the *Physiognomy of Mental Diseases* published in the same year by Sir Alexander Morrison, Diamond's predecessor at the Surrey Asylum. What was remarkable in Diamond's work – for it was not unique, but typified a whole tendency in nineteenth-century photographic practice – was its constitution at the point where discourses of psychiatry, physiognomy, photographic science and aesthetics coincided and overlapped. But the site where they could work together and on each other was a regulated space, a political space, a space in the new institutional order. Here, the knowledge and truth of which photography became the guardian were inseparable from the power and control which they engendered.

The point was not lost on Dr Diamond. His last argument for clinical photography was that it functioned as a means of rapid identification:

> It is well known that the portraits of those who are congregated in prisons for punishment have often times been of much value in recapturing some who have escaped, or in proving with little expense, and with certainty a previous conviction; and similarly the portraits of the insane who are received into Asylums for protection, give to the eye so clear a representation of their case that on their readmission after temporary absence and cure – I have found the previous portrait of more value in calling to my mind the case and treatment, than any verbal description I may have placed on record.[19]

The methods of the new police force are not far away. Commenting

on Diamond's paper, T. N. Brushfield, superintendent of the Chester County Lunatic Asylum, confirmed his view:

> In the case of *criminal* lunatics, it is frequently of great importance that a portrait should be obtained, as many of them being originally of criminal disposition and education, if they do escape from the asylum are doubly dangerous to the community at large, and they may frequently be traced by sending their photographs to the police authorities (into whose hands they are very likely to fall) from some act of depredation they are likely to commit; the photographs would thus cause them to be identified, and secure their safe return to the asylum.[20]

Here, in the tentative photographic practice of Dr Diamond and like-minded superintendents of asylums, is the nexus Foucault describes: the very coincidence of an ever more intimate observation and an ever more subtle control; an ever more refined institutional order and an ever more encompassing discourse; an ever more passive subjection and an ever more dominant benevolent gaze. There are other examples. Henry Hering photographed patients in the Bethlem Hospital in the mid-1850s. In 1860, Charles Le Nègre was ordered to compile a photographic report on the condition of inmates in the Imperial Asylum at Vincennes. Photographs of mentally retarded children were reproduced in *The Mind Unveiled* in 1858. B. A. Morel's *Traité des dégénérescences physiques, intellectuelles et morales de l'espèce humaine et des causes que produisent ses variétés maladises*, published in Paris in 1857, included illustrative photographs taken by Baillarger at the Salpêtrière, where, in the 1880s, Charcot and Richer were to open a Photographic Department to aid their preparation of the *Nouvelle Iconographie de la Salpêtrière*. Whereas, before the invention of photography, clinical records had been confined to spectacular or freakish cases, with the camera, extensive collections and indexes were compiled. The first paper on medical photography had been published in Austria in 1855.[21] The first journal devoted to the subject, the *Internationale medizinisch-photographische Monatschrift* appeared in Leipzig in 1894. It was not a development to be stopped by complaints that the unbridled use of photography in medical practice had gone beyond discretion and ethics.[22]

Such uses of photography were not, however, confined to medicine. In the 1860s, the Stockport Ragged and Industrial

School commissioned a local photographer to assemble an album of pictures of each of the teachers and children in the school. Similar records were kept in the Greenwich Hospital School. The next decade, the 1870s, saw a great expansion in the use of photographic documentation. The main prisons, such as Wandsworth and Millbank Prisons and Pentonville Penitentiary, set up their own studios employing staff photographers. Local authorities

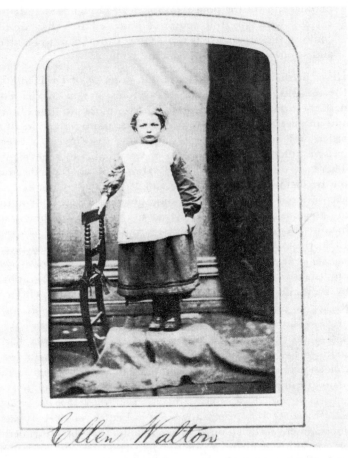

Plate 18. Unknown photographer, *Stockport Ragged and Industrial School*, albumen print, c.1865. (Metropolitan Borough of Stockport, Local Studies Library)

commissioned photographic surveys of housing and living conditions in working-class areas, and private societies, such as the Society for Photographing Relics of Old London, were founded. Children's Homes and Homes for 'Waifs and Strays' also followed the pattern of development, initially employing local portrait photographers, then taking photographers on to their staff. In May 1874, Thomas John Barnardo opened his first Photographic Department in the 'Home for Destitute Lads' which he had founded at Stepney Causeway in 1871. In its first year, the studio and salaries of photographer and assistant absorbed more than £250 out of an annual budget of £11,571, and photography remained thereafter an important item of expenditure. Between 1874 and 1905, Thomas Barnes and his successor, Roderick Johnstone, produced 55,000 photographs for Barnardo, mostly systematic records of the children as they entered and left the institution. The uses of the photographs were familiar by now:

> to obtain and retain an exact likeness of each child and enable them, when it is attached to his history, to trace the child's career.[23]

> To make the recognition easy of boys and girls guilty of criminal acts, such as theft, burglary or arson, and who may, under false pretences, gain admission to our Homes. Many such instances have occurred in which the possession of these photographs has enabled us to communicate with the police, or with former employers, and thus led to the discovery of offenders. By means of these likenesses children absconding from our Homes are often recovered and brought back, and in not a few instances, juveniles who have been stolen from their parents or guardians or were tempted by evil companions to leave home, and at last, after wandering for a while on the streets, found their way to our Institution, have been recognised by parents or friends and finally restored to their care.[24]

Chronological reference albums were kept by the photographers, in which the albumen prints were pasted twelve to a page, with the names and dates of the children written under each photograph. Barnardo himself kept smaller versions, with three photographs to a page, for his own use and to show visitors, parents and police. Photographs were also mounted on personal history sheets on

which were filed printed details of each child's background –
sometimes including the child's own statement – statistics of
colouring, age, height, and subsequent reports and photographs
recording the child's progress.

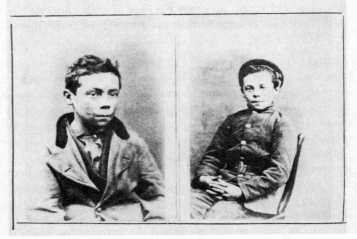

Admitted January 5th, 1876.

Aged 16 Years.

Height, 4-ft. 11-in.

Color of { Hair, Dark Brown.
 { Eyes, Brown.

Complexion, Dark.

Marks on body—None.

If Vaccinated—Right Arm.

If ever been in a Reformatory or Industrial School ? No.

**Plate 19. Thomas Barnes & Roderick Johnstone, *Personal History of
a Child at Dr Barnardo's Home*, albumen prints, 1874–1883. (The
Barnardo Photographic Archive)**

Since Barnardo's Homes were neither 'voting charities' nor
sponsored by any of the churches, their need for funds was always
acute. This induced Barnardo to launch an extensive publicity and
advertising campaign which exploited the methods of the successful

American revivalist churches. Such methods were controversial. In particular, it was Barnardo's use of photography 'to aid in advocating the claims of our institution' which brought him, in 1877, before a court of arbitration on several accounts of dishonesty and misconduct arising from allegations by the Reverend George Reynolds and the Charity Organisation. Specifically, it was charged that:

> The system of taking, and making capital of, the children's photographs is not only dishonest, but has a tendency to destroy the better feelings of the children . . . He is not satisfied with taking them as they really are, but he tears their clothes, so as to make them appear worse than they really are. They are also taken in purely fictitious positions.[25]

From 1870, Barnardo had commissioned 'before-and-after' photographs, purporting to show the children as they arrived at the Home and then, scrubbed and clean, busy in the workshops. It was one such comparative pairing that the court ruled to have been an 'artistic fiction'. More than eighty such pictures were published, however. Some appeared in pamphlets telling a story of rescue from the iniquities of a previous life and of a happy life in the Home. Others were pasted on to complementary cards of the 'once a little vagrant – now a little workman' type, which also gave details of the work of the Home and sold in packs of twenty for five shillings or singly for sixpence. To the theme of observation-domination was added that of advertising and the body as commodity.

We have begun to see a repetitive pattern: the body isolated; the narrow space; the subjection to an unreturnable gaze; the scrutiny of gestures, faces and features; the clarity of illumination and sharpness of focus; the names and number boards. These are the traces of power, repeated countless times, whenever the photographer prepared an exposure, in police cell, prison, consultation room, asylum, Home or school. Foucault's metaphor for the new social order which was inscribed in these smallest exchanges is that of the 'Panopticon' – Jeremy Bentham's plan for a model institution in which each space and level would be exposed to the view of another, establishing a perpetual chain of observations which culminated in the central tower, itself open to constant public scrutiny.[26] This is the same Jeremy Bentham who advocated a

HUNTINGDON COUNTY GAOL.

5*th* January 18 72

Particulars of Persons convicted of an offence specified in the First Schedule of Habitual Criminals' Act, 1869, and who will be liberated from this Gaol within seven days from date hereof, either on expiration of sentence, or on Licence from Secretary of State.

Name *Julia Osgothorpe*
and
Aliases

Photograph of Prisoner.

Description when liberated.

Age (on discharge) *11*

Height *4 ft.*

Hair *L'Brown*

Eyes *Grey*

Complexion *Fresh*

Where born *Nottingham*

Married or single

Trade or occupation

Any other distinguishing mark

Address at time of apprehension *Grantham*

Whether summarily disposed of or tried by a Jury. *Summarily*

Place and date of conviction *Huntingdon 27 Jany 1872*

Offence for which convicted *Stealing Bread*

Plate 20. Unknown photographer, *Huntingdon County Gaol Records*, 1872. (Cambridgeshire County Constabulary)

Ministry of Police but, with the development of photography, his utopian structure was to become redundant. Bentham's 'Panopticon' was the culmination and concrete embodiment of a disciplinary technique already elaborated across a range of institutions – barracks, schools, monasteries, reformatories, prisons – in which a temporal-spatial technology, with its enclosed architectural spaces, cellular organisation, minutely graded hierarchical arrangements, and precise divisions of time, was set to work to drill, train, classify and survey bodies in one and the same movement. Foucault took this as a metaphor for that continual process of proliferating local tactics and techniques which operated in society on a micro level, seeking to procure the maximum effect from the minimum effort and manufacturing docile and utilisable bodies. Yet by the end of the nineteenth century, it could be argued, the new will to power, founded on a fateful threefold unity of knowledge, control and utility, could find a new metaphor in the unobtrusive cells of the photographic frame; in its ever more minute division of time and motion; in its ever finer scrutiny of bodies in stringent laboratory conditions. It is a world for which the exhaustive catalogue of bodily movements in Muybridge's images stands as an ominous sign.

V

To reiterate the point, it should be clear that when Foucault examines power he is not just examining a negative force operating through a series of prohibitions. Even where prohibitions can be shown to operate, they do so not only through edicts or laws but in the reality of institutions and practices where they are part of an elaborate economy including all kinds of incitements, manifestations and evaluations – in short, an entire complex, outside which prohibitions cannot be understood. We must cease once and for all to describe the effects of power in negative terms – as exclusion, repression, censorship, concealment, eradication. In fact, power produces. It produces reality. It produces domains of objects, institutions of language, rituals of truth.

The interdiction, the refusal, the prohibition, far from being essential forms of power, are only its limits, power in its frustrated

or extreme forms. The relations of power are, above all, productive.[27]

We might remember, for example, that Marx did not explain the misery of workers, as Proudhon did, as the effect of a concerted theft. He saw that the positive functioning of capitalist production – capitalism's *raison d'être* – was not directed towards starving the workers, but that it could not develop without doing so. Marx replaced a negative, moralistic analysis with a positive one: the analysis of production. So Foucault, in examining the 'birth' of the prison, looks for the possible positive effects of punitive mechanisms rather than their repressive effects alone. He sees the development of penal institutions as a political tactic in a more general field of ways of exercising power. Similarly, in studying the genesis of the asylum, he asks: how did the power exerted in insanity produce psychiatry's 'true' discourse? When he turns to sexuality, he is concerned to discover why it has been the central object of examination, surveillance, avowal and transformation into discourse in Christian societies. What, he asks, are the positive mechanisms which, producing sexuality in this or that fashion, result in misery?

Crucial to the development of his thematic has been Foucault's rejection of the idea that knowledge and power are somehow counterposed, antithetical or even separable. If power, in its detailed strategies and complex mechanisms, has not been studied, the relation between power and knowledge has been studied even less. For Foucault, power produces knowledge. Power and knowledge directly imply one another. The exercise of power itself creates and causes to emerge new objects of knowledge and accumulates new bodies of information. Diffused and entrenched, the exercise of power is perpetually creating knowledge and, conversely, knowledge constantly induces effects of power. There is no power relation without the correlative constitution of a field of knowledge, nor any knowledge that does not presuppose and constitute, at the same time, power relations.

Foucault's aim, therefore, is not to write the social history of prohibitions but to trace the political history of the production of 'humanity' as an object of knowledge for a discourse with the status of 'science', the status of 'truth'. As a prerequisite for such a study, he offers us a new set of concepts – a new vocabulary – which must compel us to work over again Gramsci's conception of hegemony

and Althusser's conceptions of Ideological State Apparatuses and 'scientific' knowledge. More than this, it must direct our attention to a new and distinct level: that of mechanisms which cannot be reduced to theories, though they overlap them; which cannot be identified with apparatuses or institutions, though they are based on them; and which cannot be derived from moral choices, though they find their justification in morality. These are the modalities according to which power is exercised: the technologies of power.[28]

In analysing these 'technologies', Foucault uncovers a stratum of materials which have so far remained below the threshold of historical visibility. His discoveries have importance both for new and old themes in the history of photography. For example, with the growth of the technology of control and reform, observation and training, a new curiosity arose about the individuals it was intended to transform. It was a curiosity which had been entirely unknown at the beginning of the eighteenth century. In the function of courts at this time, for instance, there had been no need to understand the prisoner or the conditions of the crime. Once guilt had been established, a set of penalties was automatically brought into play that were proportionate and fixed. Yet by the early nineteenth century, in France, Britain and the USA, judges, doctors and criminologists were seeking new techniques to gain a knowledge newly necessary to the administration of power. Prisoners were encouraged to write down their life stories. Dossiers and case histories were compiled. The simple technique of the examination was brought into play, evoking its use on soldiers and children, on the sick and insane. Who, Foucault asks, will write:

> the more general, more fluid, but also more determinant history of the 'examination' – its rituals, its methods, it characters and their roles, its play of questions and answers, its system of marking and classification? For in this slender technique are to be found a whole domain of knowledge, a whole type of power.[29]

The emergence of the 'documentary' as evidence of an individual 'case' was tied to this development of the examination and a certain disciplinary method, and to that crucial inversion of the political axis of individuation which is integral to surveillance:

> For a long time ordinary individuality – the everyday individuality of everybody – remained below the threshold of description. To

be looked at, observed, described in detail, followed from day to day by an uninterrupted writing was a privilege. The chronicle of a man, the account of his life, his historiography, written as he lived out his life formed part of the rituals of his power. The disciplinary methods reversed this relation, lowered the threshold of describable individuality and made of this description a means of control and a method of domination. It is no longer a monument for future memory, but a document for possible use.

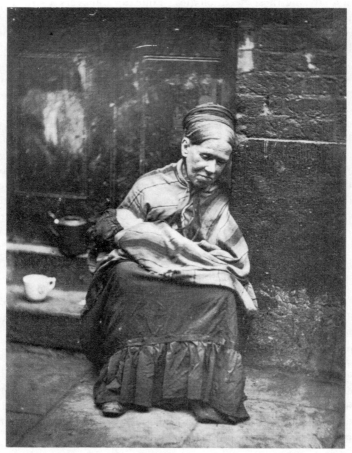

Plate 21. John Thomson, *The Crawlers* from *Street Life in London*, Woodburytype, 1877–1878. (The Mansell Collection)

And this new describability is all the more marked in that the disciplinary framework is a strict one: the child, the patient, the madman, the prisoner, were to become, with increasing ease from the eighteenth century and according to a curve which is that of the mechanisms of discipline, the object of individual descriptions and biographical accounts. This turning of real lives into writing is no longer a procedure of heroisation; it functions as a procedure of objectification and subjection ... The

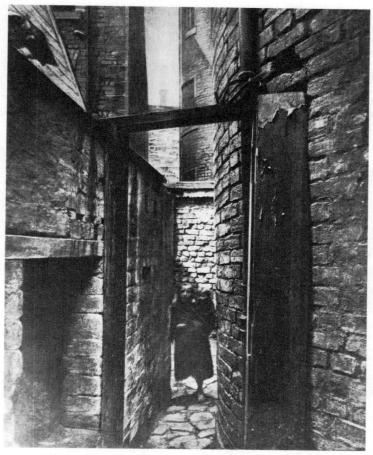

Plate 22. Thomas Annan, *Close No 11 Bridgegate* **from** *Photographs of Old Closes, Streets, Etc.,* **albumen print, 1867. (The Mansell Collection)**

examination as the fixing, at once ritual and 'scientific', of individual differences, as the pinning down of each individual in his own particularity . . . clearly indicates the appearance of a new modality of power in which each individual receives as his status his own individuality, and in which he is linked by his status to the features, the measurements, the gaps, the 'marks' that characterise him and make him a 'case'.[30]

It is not only the 'turning of real lives into writing' which is implicated in this process, but also the insatiable appropriations of the camera. Whether it is John Thomson in the streets of London or Thomas Annan in the slums of Glasgow; whether it is Dr Diamond among the female inmates of his asylum in Surrey or Arthur Munby among the trousered pit-girls of Wigan; whether it is Jacob Riis among the 'poor', the 'idle' and the 'vicious' of Mulberry Bend or Captain Hooper among the victims of the Madras famine of 1876: what we see is the extension of a 'procedure of objectification and subjection', the transmission of power in the synaptic space of the camera's examination.[31]

Whatever the claims of the traditional evaluations of such photographic 'records', whatever the pretentions of the 'humane' and documentary tradition, we must see them now in relation to the 'small' historical problems with which Foucault concerns himself: problems of the entry of the individual into the field of knowledge, of the entry of the individual description, of the cross-examination and the file. It is in what he calls these 'ignoble' archives that Foucault sees the emergence of that modern play over bodies, gestures and behaviour which is the emergence of the so-called 'science of man' and the constitution of the modern state.[32]

VI

I may have created the depressing impression of an inescapable network of immanent relations of power. Yet once we have grasped that power is not to be identified with its terminal forms – once we have seen that 'Power is not an institution, a structure, or a certain force with which certain people are endowed: it is the name given to a complex strategic situation in a given society'[33] – then we can also grasp the possibilities of resistance. It is because power is

relational that there is no power without resistance. As soon as there is a power relation, that relation can be modified or deflected within certain determinate conditions and according to a definite strategy. Power gives rise to a countervailing force: a resistance which, like the power it contests, is the product of a system of pervasive relations in stress and which exists in dispersed, local, multiplex forms – continuous perhaps, but reproducing no general law.

The form or forms of this resistance, which are so important to social advance yet have been so very little analysed, are bound up, at the level with which we are concerned, with the changed role of intellectuals in the modern technology of power. Analysis of this will show that we are no longer concerned with the intellectual who deals in generalities, prophecies and legislative edicts – that is, with the 'traditional intellectual' practising writing and claiming a universal consciousness – but with a whole new configuration of 'specific' intellectuals, strategically situated at precise points in specific sectors by their professional conditions of work and their conditions of life. The extreme development of the socio-technical division of labour has produced a multiform ensemble of experts and technicians – including all kinds of photographers – who have direct and localised relations with particular domains of knowledge and particular institutions, who have an intimate familiarity with the specific constraints which hold there, and who are therefore capable of locating and marking the weak points, the openings, the lines of force.

If we could escape our nostalgia for the great universal intellectuals with their visions of the world, we might see our way towards exploiting new strategic possibilities, towards a new kind of political effect based on the specialised knowledge of specific intellectuals and not on a universalising discourse. In the domain of photography, what this implies is not an attempt to devise a single stylistic strategy which will meet all contingencies, but a determination to begin the work of mapping out certain positions within an indeterminate field.[34] We must pinpoint those strategic kinds of intervention which can both open up different social arenas of action and stretch the institutional order of the practice by deploying or developing new modes of production, distribution and circulation; by exploiting different formats; by evolving different formal solutions; by cutting different trajectories across the ruling

codes of pictorial meaning; and by establishing different relationships both with those who are pictured and those who view the pictures. There is no centre to such a strategy, only a multiplicity of local incursions in a constantly shifting ground of tactical actions – specific contests which link up with others in all sorts of ways, which may hold significance for a chain of related struggles, and which are the precondition for any more concerted confrontation.

There is a danger that the particular struggles of photographers and other functional intellectuals may become too dispersed and fragmentary. What give such sectional actions a wider significance are their precise positions in that network of constraints which produces truth and which, in turn, induces the regular effects of power. That is to say, what is crucial is their special position in the 'political economy' of truth in our society, to which Foucault has given the name of 'a régime of truth'.[35]

A régime of truth is that circular relation which truth has to the systems of power that produce and sustain it, and to the effects of power which it induces and which redirect it. Such a régime has been not only an effect, but a condition of the formation and development of capitalist societies; to contest it, however, it is not enough to gesture at some 'truth' somehow emancipated from every system of power. Truth itself is already power, bound to the political, economic and institutional régime which produces it. We must forget the claims of a discredited documentary tradition to fight 'for' 'truth' or 'in favour' of 'truth' and see that the battle is one that should be directed at the rules, operative in our society, according to which 'true' and 'false' representations are separated. It is a battle waged against those institutions privileged and empowered in our society to produce and transmit 'true' discourse. It is a battle – going beyond the sectoral and professional interests of photography – around the specific effects of power of this truth and the economic and political role it plays.

The questions which are raised by such a conception of the 'régime of truth' revolve around the conditions of possibility of *struggle* in the particular domain of photography. How is photographic discourse related to those privileged discourses harboured in our society and caused to function as true, and to the institutions which produce them? What are the mechanisms or rules operative in our social formation by which truth and falsehood are to be distinguished and how do they bear on photography?

What are the techniques and procedures sanctioned as those which may be used to obtain truth and what particular forms do these take in the techniques and procedures of photography? How is this truth circulated and consumed? Through what channels and institutions does it run? Under the control of what specific powerful apparatuses does it begin to flow? How can it constitute an arena of social confrontation whose object is not the recovery of a pristine 'truth' but the effective displacement of the status of truth and the economic and political role it plays? What would it mean in photography to struggle not for 'correct consciousness' but to change the political, economic and institutional régime of the production of truth, to detach its power from the specific forms of hegemony in which it now operates, and to project the possibility of constructing a new politics of truth?

The territory of the dispute must be clear. You will see that we are thrown back again on that knot of assumptions about the nature of photography which was left to be unravelled in my discussion of police photography. It is the use of the photograph in police work – primarily for its 'value as evidence' – and the insertion of the photograph in legal structures that offer a privileged view of the organisation of the régime of photographic truth in our society, and it is to this that I want to turn.

VII

In a manual of police photography written by a former Detective Chief Inspector of Birmingham City Police, we find the following advice. First, on the level of production:

> A good record should of course be properly exposed, processed and printed. It must be correctly focused and sharp throughout, and all vertical lines of the picture must be upright and should not converge in the print.
>
> A photograph should include everything appertaining to its subject, and relevant to its purpose. If this cannot be done with one picture, then others must be taken in order that the whole subject is covered. Photographs of scenes of crime and other aids to evidence are usually examined in conjunction with a detailed plan to scale, showing the scene and enabling a true picture to be obtained.

Photographs made for the purpose of crime detection or for production in any court proceedings should not be retouched, treated or marked in any way. Exaggerated lighting effects must not be used, and deep shadows or burnt-out highlights could reduce the value, as evidence, of an otherwise good record picture.

Photographs should, where possible, be taken from eye level and this applies to traffic-accident photographs where the views of the drivers concerned may be an important factor.

Prints are usually preferred on the 'soft' side, because detail is more important than print brightness.

The police photographer who has in mind these basic requisites of a good record photograph will standardise his procedure and technique in order than the right type of photograph is produced automatically.[36]

Secondly, on the mode of presentation of the images:

In producing photographs to court, the police photographer must state on oath the time, day and date he took the photographs, and the fact that he processed the negatives himself. He then produces the negatives to show that they have not been retouched or interfered with in any way, and finally produces prints (usually enlarged from the negatives) which are entered as exhibits with the negatives.[37]

If this cannot be done, an affidavit sworn by the technician who processed the film or even the technician in person will have to be produced to prove the chain of possession. Finally, on the status of the photographer as witness to the 'truth':

A qualified police photographer with the necessary experience may be regarded as an expert witness and competent within his own field to express an opinion if asked by the court to do so.[38]

In these and other instances where an opinion is called for, the court places a great deal of reliance on the qualifications and experience of the witness. It follows that every police photographer should take every opportunity to obtain all necessary qualifications by examination and should also gain every possible experience in the specialised fields of photography appertaining to his work. If this is done, his evidence will stand up against any given by some other expert who may be called to rebut his testimony.[39]

Confirmation of these basic conditions and procedures comes from the standard British and American work of reference on photographic evidence by S. G. Ehrlich, a specialist in the preparation of court exhibits, Fellow of the Royal Microscopical Society and member of The American Society of Photographic Scientists and Engineers. Ehrlich is at pains to define the exact requirements of photography as an aid to counsel in civil cases so as to distinguish it from amateur, freelance or photojournalistic practice. But behind his detailed technical discussion lies the notion that:

> In addition to understanding the scientific principles of physics, optics and chemistry on which photography depends, the good photographer must have the imagination and creative ability to reproduce scenes on films so that they will convey to the viewer the same information and impressions he would have received had he directly observed the scene.[40]

Later Ehrlich summarises the nature of legal photography thus:

> Legal photographs are made for the purpose of ultimate use in a courtroom, or at least to be exhibited to people who are to be informed or persuaded by them. In making photographs for use in litigation, lawyers and photographers should strive for 'legal quality', a term used here to describe photographs having certain characteristics of objectivity and accuracy.
>
> So far as is possible, photographs should show the matter depicted in a neutral, straightforward way. The photographer should be cautioned against producing dramatic effects; any drama in the picture should emanate from the subject matter alone, and not from affected photographic techniques, such as unusual camera angles, printing variations, cropping and the like. Any such attempt to dramatise photographs may result in their exclusion and a consequent suspicion on the part of the jurors that the party offering such photographs cannot be trusted. Therefore, commercial photographers who are not experienced in legal work should be impressed with the importance of a neutral approach when making photographs for courtroom use.
>
> This is not to say that photographers making photographs should dispense with the elements of imagination and artistry, but only that the should strive for accuracy rather than effect.

Indeed, advanced techniques, and the use of very specialised and delicate equipment, are often necessary in order to produce photographs that are fair and accurate representations of the matters they depict.

There are courtroom advantages to be gained from using photographs that appear to have been professionally made. Compared with amateur snapshots or home movies, professional photographs have an aura of objectivity and purposefulness, and it is less likely that there will be anything in their appearance to divert the attention of viewers from the matters they depict.

On the other hand, there are instances in which counsel must use photographs of amateurish appearance simply because they are the best, or the only, pictures available. Furthermore, counsel should avoid obtaining photographs that appear too slickly made or too expensive, lest the jurors come to believe that the presentation is being overdone. Legal photographs should be rich in information but not expensive in appearance.[41]

These are disarmingly frank texts, with their recurrent themes of sharpness and frontality, exhaustive description and true representation, the outlawing of exaggerated effects and any overt kind of manipulation, standardised processing and careful presentation, and the expertise and professional status of the photographer. They set these forward, unabashed, as criteria which establish the credentials of the print as a 'good record picture' of 'legal quality' and therefore guarantee its objectivity and accuracy, or even that it presents a scene as it would have been viewed if one had been there. They are unshaken in their belief in the photograph as a direct transcription of the real. The falsifications that can occur – cropping, retouching, interference with the negative – are only perversions of this purity of nature. Behind every distorted or inadequate photograph is a truth which might have been revealed – that 'brute photograph (frontal and clear)' of which Roland Barthes once dreamed.

How are we to explain this configuration of demands and expectations levelled at the photograph? What are we to make of this assertion and qualification of its 'truth'? And how may we bring our explanation closer to our analysis of the field of power relations which constitutes the régime of truth? Recent advances in semiology and the theory of the subject have shown that every

text – including the photographic text – is an activity of production of meaning which is carried on within a certain *régime of sense*. It is this régime which gives the productivity of the discourse a certain fixity, dependent on the limits the society in question sets itself, in which the text is produced as natural.

The dominant form of signification in bourgeois society is the *realist* mode, which is fixed and curtailed, which is complicit with the dominant sociolects and repeated across the dominant ideological forms. Realism offers a fixity in which the signifier is treated as if it were identical with a pre-existent signified and in which the reader's role is purely that of consumer. It is this realist mode with which we are confronted when we look at the photograph as evidence. In realism, the process of production of a signified through the action of a signifying chain is not seen. It is the product that is stressed, and production that is repressed. The complex codes or use of language by which realism is constituted appear of no account. All that matters is the illusion; just as in the capitalist market economy, all that matters is the value of the commodity measured against the general medium of exhange – money. Production is entirely elided.[42]

Realist texts are based on a certain, limited plurality of language which is, however, subject to a definite closure: the text is nothing but what it can denote or describe, together with the rhetorical grace with which it does so. It rotates between these two terms in a pre-ordained oscillation: from description to rhetoric; from observation to expression. In this limited movement, it is the business of the language-medium only to 'express' or 'communicate' a pre-established concept. Such is the constriction that signifier and signified appear not only to unite, but the signifier seems to become transparent so that the concept appears to present itself, and the arbitrary sign is naturalised by a spurious identity between reference and referents, between the text and the world.

Realism is a social practice of representation, an overall form of discursive production, a normality which allows a strictly delimited range of variations. It works by the controlled and limited recall of a reservoir of similar 'texts', by a constant repetition, a constant cross-echoing. By such 'silent quotation', a relation is established between the realist 'text' and other 'texts' from which it differs and to which it defers. It is this mutuality which summons up the power of the real: a reality of the intertext beyond which there is

no-sense. What lies 'behind' the paper or 'behind' the image is not reality – the referent – but reference: a subtle web of discourse through which realism is enmeshed in a complex fabric of notions, representations, images, attitudes, gestures and modes of action which function as everyday know-how, 'practical ideology', norms within and through which people live their relation to the world. It is by the routes it opens to this complex sphere that the realist text trades with that generally received picture of what may be regarded as 'real' or 'realistic' – a picture which is not recognised as such but rather presents itself as, precisely, the Reality. It is a traffic which brings into circulation not a personal and arbitrary 'association of ideas' but a whole hidden corpus of knowledge, a social knowledge, that is called upon through the mechanism of connotation and which gives the encounter with the régime of sense its solidity.

We are not dealing here with a process of signification which is immutable but one that was, in Nietzsche's term, historically 'incorporated'and which is historically changing.[43] Its origins take us back to that same period in which Foucault traced the emergence of a cluster of institutions: the 'disciplinary archipelago'. A crucial part of the attempt of the emergent bourgeoisie to establish its hegemony in the eighteenth and nineteenth centuries was the creation of several institutions of language: in England, for example, the Royal Society with its 'scientific' philosophy of language, as well as the institutions of journalism and literature.[44] It was across such institutions that the realist convention was installed and ceased to be visible as convention, becoming natural – identical with reality. A general evaluation of discourse was established whose absolute value was that of reality itself. The dominant discourse attained this through the creation of an identity between signifier and signified. All other discourses were to be gauged against this measure, according to the varying degress of 'truth' they contained, so that a strict positionality was established whose reference point was the dominant discourse which appeared to have its point of origin in the Real.

At the same time, this whole process could only operate by placing the consumers – the readers – of the texts in an imaginary position of transcendence in relation to the system, in order that the texts should be intelligible. Just as Marx has shown that recognised, socially fixed positions are necessary for the exchange

of commodities which functions through a system of equivalences, so realism fixes the positions of its readers in order that the transaction between signifier and signified may take place. Realism sets its subjects in place at the point of intelligibility of its activity, in a position of observation and synthesis which cannot be questioned by the flux of the text and which cannot be thrown into process by the sliding of signifiers that disestablishes social positionality.

Thus the mechanism of realism has been effected over a multitude of 'texts' – in our case, of photographs and their supporting and surrounding discourses – which appear diverse and changing but are fixed and dependent on practices of production and reading which seem spontaneous but are determined by forms of behaviour fundamental to capitalist societies: a pattern of instrumentality and consumption which – as in sexuality and economics, the other major forms of exchange by which society reproduces itself – cannot function without a fixed positionality. To intervene in this institution of language is, therefore, to create a disturbance whose effects must necessarily be felt in the other modes of reproduction. What are put at issue are those chains of social meaning which were forged with the irruption of the financial bourgeoisie, whose wealth lay not in the forms of land, title and heredity traditional to feudal and early bourgeois society, but in exchange, the possession of money and the skill in its use. What is at stake in struggle is not only this political economy but what invests it: a universalised mode of representation in which things are individuated, separated and assigned places in an order of equivalence, an 'economy of signs', a régime of sense.

There is, however, a problem. Rejection of the idea that the Real is 'below', 'before' or 'behind' the process of pictorial production, and acceptance of the idea that photographic reality is a complex system of discourses and significations consistent with the text or picture, need not commit the photographer to the idea of a closed world of codes and codes of codes. What such a view ignores is the crucial relation of meaning to questions of practice and power. The Real is a complex of dominant and dominated discourses which given texts exclude, separate or do not signify. If the text or picture is going to represent a reality which is different from, and perhaps determinant of, the picture itself, then this representation will only be possible through an act of negation, through a demonstration of

the incoherence of the system of dominant images. Historically, there are two models for this.

In the work of the painter Courbet, as Timothy Clark has argued, the negation or critique of signifying conventions was bound up with a search for other signifying conventions, other orders of meaning, already existent in the culture, produced by a conflict of classes, ideologies and forms of control, but present in a dominated form, deprived of the semiotic space in which to live and resonate.[45] In the work of Manet and later 'Modernist' artists, however, this search for alternative meanings and forms as they exist dispersed and repressed, within class societies, disappears. Henceforth, the negation or critique is on the level of the sign alone: a purely 'formal' refutation. The works of such a negation may refuse to obey the dominant code of the imaginary, they may refuse the historical consumer any means of entry into or appropriation of the image, but they do so at the price of a failure to signify. Unlike the works of negation in Courbet's project, they do not establish other meanings, another realm of phantasy, another production of the subject, a place in another classed code, in short a reconstitution of the Imaginary – not in any mysterious sense, but using what is already present in the dominated forms of life of the dominated classes.

If the field of interventions is as I have described it, then these are its limits and these are the risks: the risk of ending up with no meaning at all. But within such parameters, one may speak of a practice which seeks out its manifold points of insertion into the economic, political and institutional régime of truth and the practices of signification which have solidified within it; which releases dissident codes and speaks in 'forbidden metaphors and extravagant combinations of concepts' in order to mock the old conceptual boundaries; which dismantles them, as Nietzsche foresaw, breaking up their order and reconstituting them ironically, bringing together things farthest apart and separating those closest together.[46] The documentary mode held in such esteem by certain sections of the left – call it 'real reportage' or what you will – cannot achieve this because it is already implicated in the historically developed techniques of observation-domination and because it remains imprisoned within an historical form of the régime of truth and sense. Both these bind it fundamentally to the very order which it seeks to subvert.

Chapter 4

A Legal Reality: The Photograph as Property in Law

In Chapter 3, on the development of photography as a means of surveillance and record, I argued that, in the process of a profound economic and social transformation in the course of the late eighteenth and early nineteenth centuries, the exercise of power in the emergent capitalist societies of Western Europe was radically restructured. The explicit and dramatic total power of the absolute monarch was displaced by a diffuse and pervasive 'microphysics' of power, operating unremarked in the smallest duties and gestures of everyday life. The seat of this capillary power was a new 'technology': a constellation of institutions – including the hospital, the school, the prison, the police force – whose disciplinary methods and techniques of regulated examination produced, trained and positioned a hierarchy of docile social subjects in the form required by the capitalist division of labour for the orderly conduct of social and economic life. At the same time, the power transmitted in the unremitting surveillance of these new, disciplining institutions generated a new kind of knowledge of the very subjects they produced; a knowledge which, in turn, engendered new effects of power and which was preserved in a proliferating system of documentation, of which photographic records were only a part.

To understand the role of photography in the documentary practices of these institutions, it was necessary to return to a whole set of assertions about the nature and status of the photograph and of signification generally, and to a range of techniques and procedures for extracting and evaluating 'truth' in discourse. These

were themselves constituted and incorporated in the institutions of the emerging bourgeois societies which established a new 'régime of truth' and a new 'régime of sense'. The privileged point of access for studying the insertion of photography into this 'régime of truth' was the law court, in which photography came to function as a source of evidence – a function premised on the dominance of the 'realist mode' in the discursive formations of capitalist societies.

But in this same site and in the same period, photography was involved in another, apparently unrelated, set of transactions by which a complex ideological contradiction was negotiated. Appearing as the *target* rather than the *instrument* of law, photography was, from the mid-nineteenth century on, the object of a series of legal suits and judgements in which the possibility of a photographic art was determined and the limits of 'creativity' in photographic practice were established. The legal disputes had their counterparts in the columns of professional and amateur photographic journals, in literature and in studio talk, in the fulminations of critics and commentators, in official reports and parliamentary exchanges. But it was in the court of law that the issues were most acutely posed and a solution most urgently sought. It was the court of law, with its power not only to order the debate but also to enforce its judgement, that was to effect the difficult ideological work of separating the instrumental use of photography from its function as art which was bound up with its value as a commodity. Such a separation was imperative if contradicting photographic practices were to coexist without conflicting, and if the double threat to legal and aesthetic categories which the invention of photography posed was to be contained.

As guardian of morality, the law had interested itself at an early date in the traffic in photographic images. The invention of the *carte-de-visite* photograph was particularly suited not only to the relatively quick and cheap production of standardised-format portraits but also to the circulation of pornographic pictures by which certain photographers in short time amassed considerable fortunes. As Baudelaire commented in 1859:

> The love of pornography, which is no less deep-rooted in the natural heart of man than the love of himself, was not to let slip so fine an opportunity of self-satisfaction.[1]

So outraged were the public representatives of the class that consumed these images so avidly in private that, by 1850, a law had been passed in France prosecuting the sale of obscene photographs in public places and making the possession of negatives punishable by a long prison sentence.

The function of the law as censor was not, however, the central arena of the engagement of photography and juridical practice. This engagement was not just repressive but, above all, productive – productive both of a *truth* in photography as evidence, and of the potential status of photography as the *property of a creative subject*. Throughout the nineteenth century, the question of whether photography fell in the domain of art or in the domain of science could not be separated from the regulation and control of a burgeoning photographic industry. Where questions of reproduction rights arose, the law was forced to intercede between a defence which argued that the photograph was not a work of art and therefore could not be the object of restricted ownership, and a prosecution which argued the contrary. Already, at a time before the era of the illustrated press and pictorial journals, when the sale of reproductions of *carte-de-visite* photographs of famous persons was a main source of the studio photographer's income, the dispute about the artistic status of photography was to be settled not in aesthetic debate but in the courts.

The law occupies a peculiar position within the capitalist social formation. It has, for bourgeois societies, a double existence. On the one side, it operates as a means of coercion through its decrees, prohibitions and penalties, but, on the other side, it exists as ideology – as a framework of values which are lived; as a set of inalienable rights which the law asserts and which we accept as natural, self-evident and just; and as the constitution of a field of legal subjects who are called forth and set in place, individuated and subjected to the absolute authority of law. The law presents, therefore, the double necessary function of, on the one hand, rendering effective the relations of production and, on the other hand, concretely representing and sanctioning the ideas social beings form about their social relations. In the words of Bernard Edelman:

The law occupies, the unique place from where it can sanction its own ideology by force, that is, in an equally direct way it can

render effective the relations of production. The fact that these relations of production are rendered juridically effective by the primary category of the subject in law clearly reveals the imaginary relation of individuals to the relations of production; and juridical practice refers back to ideology its own practice – the practice of the Civil Code, the practice of the Penal Code, and the practice of the courts.[2]

For Edelman, the founding moment of bourgeois law is the postulate that persons are naturally subjects in law, that is, potential owners, since it is of their essence to appropriate nature. In the juridical language of the classic treatises of French civil law:

> beings capable of having rights and obligations are deemed 'persons'. More briefly, the person is said to be identical with the subject in law. The idea of personality, necessary for giving support to the rights and obligations . . . is indispensable in the traditional conception of law.[3]

The doctrine of property in the French civil code thus derives from the properties of the subject as possessor of itself, its labour and its products, and it is in the form of a subject that the advance of capitalist productive forces is realised: 'All production is the production of a subject, meaning by subject the category in which labour designates all man's production as production of private property.'[4] Like the camera itself, the law depends, therefore, on reference to the subject for the constitution of its categories and to the attributes of this subject for its grounding of the rights of property. Yet this very subject to whose existence it refers is, itself, constituted in law and set in place with certain definite attributes by legal practice. This legal practice is, in turn, inseparable from the definite social conditions within which bourgeois law has its function, for the category of the universal, self-possessive subject is not given but is produced by and is necessary to generalised commodity exchange and production based on wage labour.

It is this founding of the law on the fundamental category of the subject, however, which is to be the source of a crucial contradiction:

> if, on the one hand, all juridical production is the production of a subject whose essence is property and whose activity can only be that of a private owner, then, on the other hand, the specific activity of the film-maker or photographer is exercised on a real

already invested with property, that is, already constituted as private common property, in the public domain. The law must therefore accomplish the '*tour de force*' of creating a category which permits the appropriation of what has already been appropriated.[5]

That is, the law must permit what Edelman calls the 'overappropriation' of the real,[6] and the problem which the search for property rights over photographs poses for the law will be whether the concept of 'overappropriation' can apply to what seemed at the time of its invention a mere mechanical reproduction of reality. It is the ideological construction of this possibility of overappropriation in photography that Edelman studies in the material existence of juridical practice and its texts, in the 'laboratory of practice', in the hidden elaboration of everyday jurisprudence through which legal categories come to life and the 'subject in law' begins its evolution.

Edelman's purpose is to produce a general theory of the nature of legal categories and their social function; to theorise law as a specific discourse and a specific practice whose form is not simply reducible to pre-existent class interests or the exertions of class forces. The law relating to photography is chosen for analysis because it is central to the theory in that it concerns the law of property and the definition of the status and rights of 'labour'. It is this law which is 'caught out' by the technical innovation of photography which contradicts the existing formulations of property right in representations of things. Edelman uses this 'surprise' as a device to reveal the categories constitutive of property law and the pressure exerted on legal practice by the development of industry and big business. But the historical process he uncovers also exhibits the complex negotiations this development compelled within the 'régime of truth' of French society and the articulation of the nineteenth-century theory of photography within this more general system. The juridical problems thrown up by the technical and economic irruption of photography revealed, in this apparently specialised and insignificant area, 'the entirety of the law in condensed form'; at the same time, revealing and forming the aesthetic, philosophical and economic questions in juridical concepts. The discourse of law was surprised or, in the original title of Edelman's work, 'seized' by photography, and, in this critical

moment, in the process of absorption of this new mode of apprehension of the real, the functioning of the law was revealed. At the point of confrontation of photography and the law, at this historical frontier of legal practice, we see how property is created, how the creator is designated as subject in law, and how the domain of exchanges between owner subjects is designated as 'civil society'.

If, given the fundamental structure of bourgeois legal categories, the 'reality' whose image is constructed in the negative always belongs to someone, then one must ask: what are the juridical conditions which permit a discourse about ownership of a real which is 'always already' invested with property? How can the photographer's reproduction of what belongs to everyone – the public domain of streets, rivers, and territorial waters – re-appropriate public property as the property of the photographer? How can the photographer be able to be the owner of the reproduction of the real, that is, the photograph? These are the questions that engaged the urgent attention of judges and counsels in nineteenth-century France as they wrestled with established legal categories and juridical conceptions of the subject, reality and the photographic image.

A judgment of 1905 declared that it followed from the right to view which every individual has over everything there is in the street, that there is the right to make a photographic negative of everything the individual sees for reproduction on picture postcards or on cinematograph reels. Since 1861, the streets of town and country, including picturesque places, had been regarded as a public right as far as their reproduction by the photographic industry was concerned. And in 1865, the Code Internationale de Propriété Industrielle, Artistique et Littéraire ruled that the personal appropriation of this public domain which harms no one was permissable, but only on condition that the reproduction of the public domain was a *creation* and not a mere reproduction: 'for a natural product which is not stylised (meaning by that that it has not been invested with a personality) belongs to the public domain'.[7] The crucial question was whether photography might lay claim to be such a 'creation'. Whatever photographers and theoreticians might have replied, the 'history' of its judicial solution fell into two stages. In the first of these, the irruption of new mechanical techniques for the reproduction of the real surprised the law in its

established categories which recognised only 'manual' and 'intellectual' art. The question that had to be asked was: is the reproduction of the real which takes place in photography equivalent to the acceptable overappropriation of the real? The first answer was that it was not, because photography was *soulless labour*. In the period of craft production and eccentric experiments, before the radical reversal produced by industry's taking account of photographic techniques ensured its juridical emergence, photography was not to be granted access to that privileged site of the bourgeois soul which is called 'creation'. The camera operator, it was argued, merely deployed an apparatus and therefore could not be a 'creator'. The photographers or 'camera operatives' of 1860 were the 'proletariat of creation' and, like the proletariat, squandered their freedom through the use of their labour power in the service of a machine.[8]

Writing in 1848, Lamartine, then Minister of Foreign Affairs and virtual head of the Provisional Government, declared:

> It is because of the servility of photography that I am fundamentally contemptuous of this chance invention which will never be an art but which plagiarises nature by means of optics. Is the reflection of a glass on paper an art? No, it is a sunbeam caught in the instant by a manoeuvre. But where is the conception of man? Where is the choice? In the crystal, perhaps. But, one thing for sure, it is not in Man.[9]

> The photographer will never replace the painter; one is a Man, the other a machine. Let us compare them no longer.[10]

A decade later, Baudelaire still railed against the soulless machine which had so captured the eyes of a novelty-seeking public:

> I am convinced that the ill-applied developments of photography, like all other purely material developments of progress, have contributed much to the impoverishment of the French artistic genius, which is already so scarce.[11]

> If photography is allowed to supplement art in some of its functions, it will soon have supplanted or corrupted it altogether, thanks to the stupidity of the multitude which is its natural ally. It is time, then, for it to return to its true duty, which is to be the servant of the sciences and arts – but the very humble servant

. . . let it be the secretary and clerk of whoever needs an absolute factual exactitude in his profession – up to that point nothing could be better. . . . But if it be allowed to encroach upon the domain of the impalpable and the imaginary, upon anything whose value depends solely upon the addition of something of a man's soul, then it will be so much the worse for us![12]

But were such sentiments rigorous enough for the bourgeois jurist? How was 'soulless labour' to be proved juridically? The answer lay in the product. Under the law, the photographic negative was soulless because only the machine had worked. The photographer, according to a Tribunal of Commerce of 1861,

has merely learned to get it working properly . . . and to set up chemical operations for reproduction . . . His art reduces to a purely mechanical process in which he can show more or less skill, without his being capable of assimilation to those who profess the fine arts, in which spirit and imagination operate, and sometimes genius formed by the precepts of art.[13]

In fact, as a further Tribunal in the same year declared:

the art of the photographer does not consist in the creation of subjects as its own creation, but in the getting of negatives and subsequently in the making of prints which reproduce the image of objects by mechanical means and in a servile way.[14]

What matters for juridical analysis is that the spirit, imagination and personality of the subject must always be present in the creation. Once they disappear, their absence designates a 'mechanical' product. As the Imperial Advocate argued in 1855:

All the intellectual and artistic labour of the photographer is anterior to the material execution . . . When the idea is about to be translated into a product, all assimilation (into art) becomes impossible . . . The light has made its work, a splendid agent but one independent of achievement . . . the personality will have been lost to the product at the precise moment when that personality could have given its protection.[15]

The judgements of the Tribunals of 1861 follow from this view: 'mechanical labour cannot therefore give birth to products which can justly be ranked with the production of the human spirit'.[16]

Photography is no more than its means and is compromised by its mechanical nature. It cannot therefore be assimilated to the personal and interpretive art of the painter and, in consequence, cannot constitute a *property* in the photographer's name. It is 'only an industrial instrument' which has no privilege: 'the industry cannot be assimilated to the art of the painter or the sketcher who creates compositions and subjects with the sole resources of the imagination, or again, the artist who, following his personal feeling, interprets the view-points which nature offers him and which constitute a property in his name'.[17]

The historical voices of bourgeois legality dare to speak what we might have only suspected: that individuality, creativity and property are inseparably bound together. And yet, while for a definite period photography was excluded from this charmed circle, the force that expelled it and which made of the photographer a machine stripped of rights as subject in law, was not economically neutral. This first photograph of the law was therefore transformed as the force was displaced. Under the economic pressure of a photographic industry which had become a significant sector of capitalist production, the soulless machine was translated into a means for the creative expression of the subject; this latter could receive legal protection because it bore the intellectual mark of its creator which was 'the imprint necessary to the work's having the characteristics of individuality necessary to its being a creation'.[18] The shifts of an economic process – a paradigm of capitalist industrialisation – were reproduced within the law and made effective by it. As industry took account of photography, the most unexpected juridical effects were engendered: the servile photographer was set up as an artist and creator, since the relations of production demanded it.

From its very beginning, the history of photography had been the history of an industry. The impetus for its development came from a vast expansion of the market for reproductions – especially portraits – which both necessitated and depended on a mechanisation of production which could guarantee the cheapness and availability of the images but also, so it seemed, their 'authenticness'. Its subsequent growth was that of an arena of enterprise ripe for entrepreneurial exploitation, driven by needs alternatively manufactured and supplied by an unlimited flow of commodities. It was, in short, a model of capitalist expansion. Already in the

1850s, for example, Louis Blanquart Evrard, the inventor of albumen paper, ran a huge printing establishment resembling a factory, employing thirty to forty assistants (mostly women) who were instructed according to a most elaborate division of labour. In the same decade, especially in America, daguerreotype galleries, such as those owned by Matthew Brady in New York and Washington, mechanised the processes of daguerreotype production such as buffing and coating in order to produce plates as cheaply as possible at the rate of a thousand a day. Even this rate of production was increased eightfold by the introduction of Disdéri's method of mass production of *carte-de-visite* photographs through which Disdéri's studio in Paris achieved a turnover of four thousand francs a day.

In the 1880s, however, photography underwent a second technical revolution. It involved the development of faster dry plates and flexible film which layed the basis for a photo-finishing industry; the opening of new markets for mass-produced photographic equipment; and the invention of the half-tone plate which enabled the reproduction of photographs on an ordinary letter-set press, thereby making possible that economic and limitless production of photo-mechanical images which transformed the status and economy of photography and traditional image-making methods as dramatically as had the invention of the paper negative by Fox Talbot in 1835. Between 1880 and the early 1900s, millions of professional photographers, manufacturers and workers came to depend on photography for their livelihood and would have been damaged if the law had not protected them against unscrupulous competition. In 1891, in France alone, more than a thousand studios existed, employing more than half a million people, and the total value of annual production had risen to around thirty million gold francs. In other European countries, and especially in America, this expansion was even more marked. Photography had also given rise to a welter of chemical, mechanical and industrial processes and applications which fed a flourishing industry. Legal commentators began to call for the protection of those with 'artistic feeling'. It had become a necessity of industry that photography be recognised as property and, therefore, that the photographer be seen as a creator. Pseudo-aesthetic considerations were mixed up with, and in effect subordinated to, openly commercial considerations in the demand for the recognition and limitation of copyright. The

'veering of jurisprudential opinion' which was to be evident in the legal conception of photography was, in the last instance, a response to the capital investment in an industry which had to secure its conditions of production.[19]

The change in the juridical representation of the relation between photography and the real was through the agency of the concept of 'imprint of personality'. This lifted certain kinds of photography from the level of the machine and brought them into the domain of the activity of the subject. The point of entry of this subject was through *technique*, which, as only a means to the creation itself, subjectivised the machine and transformed its labour into the labour of the subject. On this condition alone, certain photographic products became creations worthy of protection. The machine became pure mediation, submitting to the domination of the actuating subject and leaving this subject to invest the real. Hence Edelman concludes that:

> The advance of capitalist productive forces is concretely realised in the site of the subject in law. And that realisation takes the very form of a subject. All production is the production of a subject, meaning by subject the category in which labour designates all man's production as production of private property.
>
> The will of man is the soul of external nature, and this soul is private property, for it is the intended purpose of man, *qua* subject in law 'to take possession of this nature and make it his private property'.[20]

The law speaks the needs of the productive forces. The terms of the original judgements are permutated, though the structure remains the same. Photography appears a second time. The 'soulless machine' becomes the vehicle of the 'soul of Man' whose essence is private property.

A yet more remarkable juridical effect was in train, however. Though photographic 'creation' was here presented in law as the product of the labour of an isolated subject, what in fact was involved – even before the invention of the cinema – was the industrialisation of artistic production: that is, a production in which the socialisation of production, exchange and consumption are realised at the same time. The essence of industrialised labour is that it is collective, yet, in the categories of French bourgeois law, the collective product – the photograph – was conceived as author's

property founded on the idea of the creative individual subject. This travesty was effected in the interests of the economic realities of capitalism and the capitalist production of images. The effective 'subject' of industrialised photographic and cinematic production was designated as the entrepreneur or producer who, as 'creative subject', secured the property right for disposition and commercial exploitation. But the producer was, in turn, no more than the one who undertook entire financial responsibility for the product, the agent of the placement of capital. Moving to fill the fixed space of the legal subject, the process of capital became the very process of intellectual creation, and the commodity form became the form of the creative product.

We have seen how the production of still photographs was already by the 1880s subject to an elaborate division of labour controlled by entrepreneurs like Nadar who, on returning to photographic portraiture in the changed economic conditions of the last quarter of the century, took control of an extensive photographic business even though he did little more than receive sitters into the studio and direct the setting of poses. It was above all in the cinema that the socialisation of the industry produced the socialisation of the subject-creator and led to the emergence of the collective subject. And yet, through the purchase of literary source material, news product and so on, and through the judicious use of that privileged instrument of capitalism, the contract, both the 'intellectual primary material' and the 'intellectual labour power' of the cinema were monopolised under the control of the producer. From the start, the courts recognised the producer as author and, therefore, owner of the 'creation' produced. The actual makers of the film sacrificed their legal claim to 'creative activity' by being under hire or contract. What legally constituted the essence of film was capital itself, whose representative – the producer – was sole author; author *par excellence* of the film as commodity. Financial direction became creative direction. The determinant influence of capital became, for the law, the creative influence.

The development of the productive forces had created a contradiction between an artistic ideology of the creative subject and a mode of production which was threatened by this ideology. The legal 'resolution' of this contradiction was clearly in the interests of production and the right of the actual 'creators' disappeared. It was a resolution which bespoke the ideological

inconsistency of the relations of production. In the combination of the 'sphere of creation' and the realm of industrial production, legal representation designated the true 'creative subject' as *capital itself.*

The introduction of modern techniques for the reproduction of the real allows Edelman to mark out the functioning of the law on virgin ground. In order to produce a law of photography, he argues, the law puts to work the categories of (literary) property and the essential characteristics of the personality. In the last analysis, these categories refer to the category of the subject in law revealing that, for the law, every process is fundamentally the process of a subject. In bourgeois society, in which ideology has the ultimate function of idealising the determinations of property – 'freedom' and 'equality' – that is, the objective determinations of exchange value, the process of the subject becomes the process of exchange value:

> In other words, in the sphere of circulation everything takes place (and does not take place) between subjects, who are also the subjects of capital, the great subject. And, furthermore, as circulation conjures away production (while revealing it), it can be said that all production is manifested as the production of a subject.[21]

Edelman concludes:

> If it is true that all bourgeois ideology interpellates individuals as subjects, the concrete/ideological content of the bourgeois interpellation is that the individual is interpellated as the embodiment of the determinations of exchange value . . . the subject in law constitutes the privileged form of this interpellation to the exact extent that the law assures and assumes the effectivity of circulation.[22]

By this means, the law assumes and fixes the sphere of circulation as a neutral given, thereby making production possible, while in the same movement exchange value and its most developed form in capital are posed as the absolute subject.

It must be added, in conclusion, that Edelman's case would not work so easily in relation to English law. In France, there was an explicit legal conception of a class of property and the reference of rights in that class to the principle of creativity. In England, what

applied was not author's right but copyright. English copyright began as part of an attempt in the early eighteenth century to protect the book trade, particularly against Dutch pirating, and not to secure author's right as such. Copyright was specified as certain definite capacities of legal subjects who met certain conditions, and the basis of this right was not morality but statute. The 'author' of a photograph was the owner of the material on which the photograph was made at the time when it was taken. If this 'author' was a 'qualified person' – that is, a British subject or a body incorporated under United Kingdom law – then he, she or it, not the 'creator', held the copyright. No attempt was made to define a coherent right arising from creativity and no creative subject was implied. Copyright resided in the 'person' by whom the arrangements necessary for making the work were undertaken and might apply as well, for example to a particular type-setting as to a particular literary work. A creative subject was not presupposed and photography presented no special problems, being brought under copyright law in 1862. As Paul Hirst has shown, English law therefore 'fails to depend on the (supposed) attributes of individual subjects for the foundation of its provisions and persists in treating of legal subjects with indifference to any formal doctrine of the subject'.[23]

In this sense, there are definite limits to the applicability of certain stages of Edelman's argument. The point of entry which the law of photography offers into the generalised structure and functioning of bourgeois ideology is historically specific and particular to France. Even so, the convergence and conflict of legal categories, aesthetic ideologies and the needs of industrialised production which we see in the engagement of photography and French law disclose in legal representation processes of negotiation which are crucial to an understanding of Realism in the nineteenth century. Any discussion of Realism in art must be referred to these same processes and to their workings in the privileged site of the law where the problem of the real in artistic representation is articulated into the wider question of the production and regulation of truth and sense in the society as a whole. Whatever the status of Edelman's general theory of ideology, it is clear that, from an art historical point of view, the dispute between the photograph, the real and the work of art can no longer be settled out of court.

Chapter 5

God's Sanitary Law: Slum Clearance and Photography in Late Nineteenth-Century Leeds

I

The history of photography is a relatively recent invention – one of those 'diversifications' to which art history has recently been prone. A certain anxiety about its academic standing has therefore been evident in attempts to integrate it into what are regarded as mainstream art historical theories. Dominant among these has been the assimilation of the history of photography to a particular view of modernism, most powerfully disseminated since 1962 in textbooks, catalogues and exhibitions from the Photography Department of the Museum of Modern Art, New York. In the crudest forms of this modernist history, photography evolves by a process of internal self-criticism towards the ever sharper definition of what the medium uniquely is. The violence that this representation does to the history of a practice Greenberg himself overlooked is transparent enough and would merit little attention if it had not become so deep-seated in institutions of photographic education. But it has also, by reaction, spawned another narrative which is its mirror image and for which subject matter or authorship is all.

Calling themselves 'social' or even 'socialist', histories of this type have seized on every picture of a factory or worker, every picture of or by a member of the working class, and have imagined them to constitute evidence of a 'hidden' history. (I needn't point

out the 'feminist' variant which corresponds to this; Griselda Pollock has dealt elsewhere and clearly enough with the consequences of that.)[1] What such accounts entirely erase is the multiplicity of social sites and social practices in which the representations they appropriate were produced and seen as meaningful. Yet, in photography above all, even a casual assessment could hardly avoid taking this in. Photography spans such diverse domains: the amateur and the professional, the commercial and the 'creative', the instrumental and the aesthetic, the public and the private, and so on. Such differences may be hard enough to ignore, but even this recognition may not go far enough.

Exhibitions such as *Three Perspectives on Photography* and publications such as *Photography/Politics* have given this diversity full weight.[2] But still the desire returns to reinstate a unity. Common ambitions, purposes, usages and conditions of existence cannot be shown, so what both modernist and labourist interpretations have to cling on to is the trivial fact that all the practices they subsume deploy one 'medium' – as if photography was a neutral technology or means of representation to which any general and unconditional definition could be given. But the so-called medium has no existence outside its historical specifications. What alone unites the diversity of sites in which photography operates is the social formation itself: the specific historical spaces for representation and practice which it constitutes. Photography as such has no identity. Its status as a technology varies with the power relations which invest it. Its nature as a practice depends on the institutions and agents which define it and set it to work. Its function as a mode of cultural production is tied to definite conditions of existence and its products are legible and meaningful only within the particular currencies they have. Its history has no unity. It is a flickering across a field of institutional spaces. It is this field we must study, not photography as such. To ask for a history of photography makes as much and as little sense as to ask for a history of writing and, if Foucault has ironically seemed to call for such a history, it has been precisely to challenge the notion that writing is one thing rather than a proliferation of small techniques which historians have till now ignored. His purpose was to displace the history of Literature in a way comparable to that in which the development of photographic technologies could have displaced the history of Art, instead of being assimilated to it.

Photographies (the word does not sit happily in the plural) are discursive practices and, as Foucault has stressed:

> Discursive practices are not purely and simply ways of producing discourse. They are embodied in technical processes, in institutions, in patterns for general behaviour, in forms for transmission and diffusion, and in pedagogical forms which, at once, impose and maintain them.[3]

For this reason, one cannot 'use' photography as an unproblematic 'source'. Photography does not transmit a pre-existent reality which is already meaningful in itself. As with any other discursive system, the question we must ask is not, 'What does this discourse reveal of something else?',but, 'what does it do; what are its conditions of existence; how does it inflect its context rather than reflect it; how does it animate meaning rather than discover it; where must we be positioned to accept it as real or true; and what are the consequences of doing so?

Why were photographs of working-class subjects, working-class trades, working-class housing, and working-class recreations made in the nineteenth century? By whom? Under what conditions? For what purposes? Who pictures? Who is pictured? And how were the pictures used? What did they do? To whom were they meaningful? And what were the consequences of accepting them as meaningful, truthful or real? These are not questions about the 'externals' of photography, as 'modernists' would have us believe, but questions about the very conditions which furnish the materials, codes and strategies of photographic images, the terms of their legibility, and the range and limits of their effectivities. Such determinations are scored across the images, in what they do and do not do, in what they encompass and exclude, in the ways they open on to or resist a repertoire of uses in which they can be meaningful and productive.

Such questions, then, do not deal with the photograph as 'evidence' of history, but as historical. From this point of view, exhibitions such as *The British Worker* must appear not only incoherent but entirely misleading in their purpose, eliding as they do complex differences between the images they assemble, between their contrasting purposes and uses, between the diverse institutions within which they were made and put to work, and between their different currencies which must be plotted and mapped.[4] The notion of evidence on which *The British Worker* rests can never be

taken as given. It has itself a history. And the way in which photography has been historically implicated in the technology of power/knowledge of which the procedures of evidence are part, is something that will have to be investigated.

It is the outer edges of this investigation that have led me to my subject: the involvement of photography in the politics of slum clearance and working-class housing in Leeds at the turn of the century. I begin with an object: a folio, a composite text – photographs and writing. It would be easy to take the photographs and put them alongside others – Le Nègre's or Marville's photographs of Paris, Annan's of Glasgow, Riis's of New York, or Cleet's of South Shields – and think that we had done enough to constitute a history, a transparent document of working-class

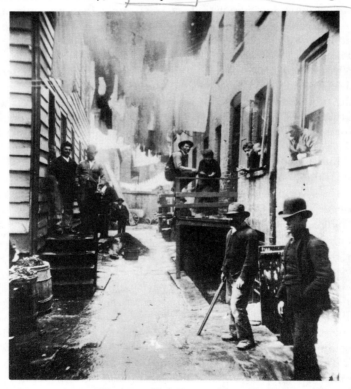

Plate 23. Jacob A. Riis, *Bandits' Roost, New York*, bromide print, 1888. (Museum of the City of New York)

housing conditions, or an unambiguous tradition of documentary
photography. But – aside from the difficulty that the constitutive
category 'documentary' did not exist until the late 1920s – such
fabricated histories would only lead us away from what ought to be
our concern: the historical significance of the textual object; its
meaning as the historical.

The folios of photographs which are now in the Brotherton
Library of Leeds University belonged to a complex of discourses
whose origins and limits we must discover. They were part of a
system of truth which exercised a particular historical power and
which depended on the convergence of a number of historical
conditions. The place where that discourse spoke and that power
was evoked was Parliament. But what the photographs had to do
was make present another space, a space whose meaning would be
already clear: the space of Quarry Hill.

II

The Quarry Hill area of Leeds was the heart of the town's first
East End, bounded on the south by the marshland bordering the
noxious River Aire, and on the west by the mills along Sheepscar
Beck, whose smoke was swept by the prevailing wind over the
sprawl of workers' cottages but well away from the homes of the
gentry in the west and north. Building in Quarry Hill began in the
1780s, but the decade of its greatest growth came between 1821
and 1831, at the height of a wave of immigration which more than
doubled the population of the borough. At the end of this period,
half the population of Leeds township was crowded into the area
east of Vicar Lane and the Leylands, and north of the Bank. It was
a population which continued to grow for the next fifty years, as
the York Road offered the only area remaining for development
within the township. This development was typically sporadic and
piecemeal, and the buildings which sprang up filled in every plot
and corner without plan. Small-scale speculative builders, working
without co-ordination or the constraint of building bye-laws, left a
legacy characteristic of Leeds: high-density housing, often without
sanitary facilities of any kind, built, as the *Leeds Mercury* put it in
1862, 'without the slightest regard to the health and comfort of the
inhabitants', in a jumble of closed courts, yards, cul-de-sacs, and

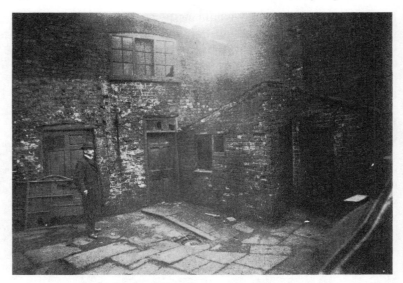

Plate 24. Unknown photographer, *Yard off St Peter's Square, No 79 on Plan* from *City of Leeds, Insanitary Areas*, 1896. (University of Leeds, Brotherton Library)

narrow streets, usually unpaved and undrained.[5] As for the houses, they were overwhelmingly the one-up, two-down, single-entry back-to-backs which maximised profits for the landlords and which the Council persisted in favouring, against the opposition of the Local Government Board and its own Medical Officer of Health, long after they had been prohibited in every other town.[6] The earliest appeared in the 1780s. The last was built as late as 1937. Between 1886 and 1914, nearly two-thirds of the houses completed in Leeds were back-to-backs, in defiance of the spirit of the 1909 Housing and Town Planning Act, which sought to ban their further building.

The consequences of unplanned development to which the council remained aloof were registered in the deplorable reputation in sanitary matters Leeds could boast for much of the nineteenth century. Indicted by Robert Baker in 1842 as 'certainly one of the most unhealthy towns in England', Leeds was the object of numerous private and governmental enquiries.[7] On four occasions between 1858 and 1874, it was subjected to special visitations by the Medical Department of the Privy Council which was concerned

over the town's static or worsening death-rate. The Department's officers berated the municipal authority for its lack of activity and reported that the provision for public health 'in proportion to the importance of the town may perhaps be deemed the worst that has ever come to the knowledge of this department'.[8] Outbreaks of cholera in 1832 and 1848 had appalling effects and focused public concern. Yet they were less important statistically than the continuing presence of tuberculosis and other infectious diseases like typhus, typhoid and dysentery which spread easily among the inadequately fed working class crowded into insanitary areas which the Council persistently failed to cleanse or abolish.

Occasional dramatic epidemics might arouse a public outcry, but it would evaporate as soon as the immediate crisis was past. That public opinion which mattered in Leeds was little moved by the endemic diseases of the industrial ghettos. Lung disease resulting from smoke, industrial hazards, and general working and living conditions, accounted for 25 per cent of mortality between 1851 and 1911. And with the continued existence of the notorious middensteads and ashpits in the closed streets, courts and yards of the slum areas, diarrhoea remained the greatest killer even beyond the turn of the century.[9] The death-rate changed little in Leeds from the 1840s to the 1870s, and the mortality rate for children under one year old peaked in 1893 at 21 per cent. The culprit was not necessarily old and decayed housing but the unregulated pattern of separate yard development which, in the absence of any municipal intervention, weighed heavily against the common provision of even the most rudimentary sanitary services. 'Indeed as to arrangement', the *Leeds Mercury* confessed, 'the whole town might have had an earthquake for an architect'.[10]

Yet all but a handful of the streets which won notoriety at the time of the cholera outbreak in 1832 survived till 1914. The 1870 Improvement Act was used for slum clearance on only three isolated occasions, and it was not until the turn of the century that the Council did anything to employ the powers it had acquired under a further Improvement Act of 1877 to rehouse desperate and impoverished slum dwellers. Without sewers, drains, or any adequate system of public cleansing, the closed courts and rows of back-to-backs remained, their red brick turning black in a pall of smoke from domestic fires, dyehouses, tanneries, potteries, steam engines and gasworks which – according to measurements made in

1888 and 1889 – obliterated the sun in central Leeds for 84 per cent of daylight hours.

The Quarry Hill and York Street area epitomised such slums. It covered just under 67 acres, taking in 2,798 houses with 16 cellar dwellings, 40 registered common lodging houses, 287 shops with dwellings attached, a Board school, a Roman Catholic day school, two private Jewish schools, five chapels, five Sunday schools, four synagogues, a police station, 63 public houses, four institutes, and 487 other buildings, including warehouses, workshops, manufacturers' offices, ten bakeries, two bathhouses, two cowhouses, a pig slaughterhouse, a fowl slaughterhouse (underneath a synagogue), stables, a herring curer's, a sausage skin manufacturer's, a grease refinery, and a tripe-boiling works.[11] The Leeds gasworks on York Street added to the environmental pollution. The railway ran over the roofs of the houses on a twenty-foot-high viaduct. To the south, the River Aire was an open sewer for nearby factories, frequently flooding the neighbouring lands. Into this area were crowded an estimated 14,132 people, many of them Irish or of Irish origin, and many others – up to 85 per cent of the population in certain streets – Jewish refugees from the pogroms of Russia and Poland which began in the 1880s. Perhaps it was not civic rivalry which made the Medical Officer of Health for Sheffield describe it as 'about as insanitary an area as one can imagine'. 'There were spots there as black as they could possibly be', reported a Local Government Board inspector. 'I have never seen a more unhealthy area. It was with great difficulty in many parts of the area that you could walk without trampling upon excreta and other filth.'[12] It was as squalid as it was overcrowded, and the death-rate, even in the 1890s, was on average 90 per cent above that for the city as a whole.[13] Yet, however intolerable its conditions to those who lived there, it stood until nearly the end of the century without hurting civic pride; that is, until an outbreak of typhus fever in the township in the spring of 1890.

The final tally for the 1890 outbreak was twelve cases and three deaths – little enough by the standards of the preceding decade – but typhus fever was becoming rare enough by then in England to cause the Council unavoidable embarrassment. Improving sanitary conditions had almost banished it elsewhere, and it stood as an index of municipal concern for public health. More than this, the cases of infection, though fewer in number than feared, began in the

heart of the Quarry Hill area, at Allison's Buildings, and all occurred within the same ward. It was no longer possible to ignore the problems. The Sanitary Committee came to realise that the whole area would have to be acquired and cleared and, as it became aware towards the end of the year of the consolidated powers granted by the 1890 Housing of the Working Classes Act, it began to move cautiously towards an assessment of the political implications. A sequence of events was then set in train which was to lead to the adoption by the Council of its most ambitious scheme of slum clearance. Yet the Quarry Hill clearance campaign cannot be explained solely by the typhus epidemic it followed, or by the more severe outbreak in the same neighbourhood in 1896, while the first scheme was still being fought for in Parliament. It has to be seen as bound into a complex series of shifts and struggles in Leeds conducted on a number of different fronts and levels. It is also within this complex confluence of determinations that we must come again to see the photographs which were to play such a crucial part in those same struggles.

Undoubtedly, financial factors came into play. The functions of the Corporation had expanded enormously in the second half of the century. In forty years, the Council had added responsibility for the water supply, gas, tramways, electrical lighting and elementary education to its responsibilities for law and order and the environment, and it had also begun a major replanning of the city's commercial centre.[14] The scale of municipal expenditures by the 1890s and the growth of rateable values must have made the slum clearance programme seem less of an impossibly costly venture in the context of the total municipal budget. The Housing of the Working Classes Act had also given councils less costly and more effective powers of compulsory purchase by changing the basis of valuation and compensation where the property concerned was to be acquired for slum clearance. This removed the Council's objections to the national Slum Clearance Acts of 1868 and 1875. If purchases in Quarry Hill finally cost the Council nearly three-quarters of a million pounds, estimated at between ten and twenty per cent more than the properties' market value, then this was far less than it would previously have had to pay under the 1845 Lands Clauses Act.

Then, too, undisguised class interest focused the new concern for environmental hygiene. Weakening of the workforce and disruption

of the wholesale trade aroused commercial anxieties. But, on a more general plane, if the outbreak of typhus provided the stimulus and confirmed the need to retrieve Leeds' dismal reputation for public health, then it also revived recent memories of a typhoid epidemic in 1889. Not that typhoid wasn't a regular enough occurrence in the township. The difference here was that the outbreak occurred not in Quarry Hill or a similar slum district, but in Headingley, home of the Leeds elite. The fear of contagion was real. As the Mayor of Leeds let slip to the parliamentary enquiry of 1896:

> The people of Leeds take the view that they cannot have a centre of disease within the area of the city without its communicating that disease to the other parts of the city.[15]

Yet why should a century of inactivity and indifference have given way so rapidly to such a sweeping plan to eradicate even the prime suspect source of infection? The answer lies in an accumulation of factors at the political level, issuing in a renewed political struggle which began to unsettle the established pattern of municipal affairs in the 1890s and made slum clearance an issue in every election in that decade.

Since the 1830s, politics in Leeds had been dominated by the Liberal Party. But in sixty years that Liberal Party had changed. The mercantile and manufacturing elites who controlled the Party and the Corporation in the 1830s and 1840s had tended to withdraw from the municipal arena in later decades, leaving Liberal politics increasingly in the sway of non-conformist, small tradesmen who pursued their own narrow interests. By the 1860s, Leeds exemplified a 'shopocracy' under which the first and only considerations were self-help and economy, which meant keeping the rates low. In 1870, the Council's expenditure outside the field of law and order amounted to no more than £22,000.[16] Little wonder that the town was not at the forefront of housing reform in the nineteenth century and continued to sanction the unrestrained private construction of back-to-back houses long after other cities, such as Liverpool and Glasgow, had begun to implement slum clearance schemes. It was only in the context of a pronounced change in political climate and public life in the borough that the Council was pushed into a more active concern for civic affairs

and an attempt to repair the damaging neglect of more than half a century. To the centre of local debate moved health and housing.

The shift that occurred coincided with but cannot be entirely explained by renewed political rivalry following the revival of the Conservative Party which held power in the city, as at Westminster, from 1896 to 1904. One cannot talk simply of Conservative municifence superseding Liberal parsimony. Yet, on one level, the struggle to wrest local political power from Liberal domination had turned both Conservative and Liberal parties into parties of urban reform. When this stratagem began to pay off at the polls, the Leeds Liberal Party responded with its first written programme of reform for sixty years, offering slum clearance as one of its main planks. Three years after the typhus epidemic, the Liberals suddenly promised, as the first point in their plan, 'The immediate clearing of insanitary areas, with due regard to the provision of accommodation for persons displaced by demolition.'[17]

At the same time, the hegemony of both parties was threatened by the arrival of a more effective, organised labour movement which, through Leeds Trades Council, independent socialist groupings and various Social Reform Unions, lent its support to slum clearance. Locally and nationally, by 1892 the Liberal Party was well aware of the pressing need to establish a popular platform which would forestall the emergence of a Labour Party. But within the dominant parties, too, a struggle was occurring which would have consequences for the perception of the 'sanitary question' as an urgent political issue. The 1890s saw the interests of the small trading bourgeoisie come under pressure from a revival of active participation in local politics among the representatives of more substantial business interests and professional groups. Outside party organisations, too, pressure from the same elite strata was exerted on the Council and on public opinion by philanthropic bodies such as the Leeds Ladies' Sanitary Association (founded in 1865), the Sanitary Aid Society (founded in 1892), and the prestigious Leeds Literary and Philosophical Society, which also campaigned for slum clearance. In such a changed mood of political concern and with one eye on the municipal elections, even the influential *Leeds Mercury* – mouthpiece of traditional Liberalism and usually opposed to any extension of municipal powers – sent its 'Special Commissioner' to Quarry Hill and published a series of

ten articles on conditions to be found there and their implications for 'The Health of Leeds'.[18]

The revival of interest in municipal affairs and public health must be understood, therefore, as the result of an accumulation of critical factors. To those already outlined must be added two more: increasing financial and legislative interventions by central government in local affairs and, not unrelated to this, the emergence of a new professional and technicist bloc within the evolving institutions of a diversifying local state. One result of the Headingley typhoid epidemic of 1889 had been the dismissal of the Medical Officer of Health, Dr Goldie, and the appointment of a certain Dr James Spottiswoode Cameron, who was to play a crucial role both in the Quarry Hill clearance scheme as a whole and the production of the photographs in particular. Cameron was a consulting physician at Huddersfield Infirmary with twenty-two years' previous experience in medical practice and thirteen years' as Medical Officer of Health to large county boroughs.[19] His particular professional enthusiasm was for sanitary matters, but he also had an amateur interest in urban historical records and played a prominent part in a local antiquarian society. He was, in short, typical of a new kind of professional: a 'specific intellectual', as Foucault puts it – a trained expert occupying a particular institutional position whose fight for recognition of his expertise was bound up with his determination to exercise his authority in reshaping the social and urban environment according to his expert and technicist vision. Professionals like Cameron were part of a new elite in the making who identified with advanced techniques, sought out publicity in order to shape public opinion, and readily allied themselves with pressure groups and like-minded councillors, frequently drawn from the same educated, professional class. It was not that Cameron had special or original views on public health and urban development, though he was proud to be considered 'in the forefront of sanitary information' of the day.[20] What is important about him is that he was a representative of a particular and increasingly influential type of intervention in social reform.

Throughout the nineteenth century, medical practitioners like Dr W. H. Duncan, Liverpool's and Britain's first Medical Officer of Health, and reformers such as Edwin Chadwick had played a specially important role in presenting poverty, health and housing

as sanitary and welfare matters; as technical issues removed from the domain of politics. Towards the end of the century, however, the pace of this intervention was significantly changed with the mobilisation of new technologies of knowledge and representation. The methods of social census and statistical survey were refined and more commonly put to use, and *photography* was taken up by officials such as Cameron as a means both of record and publicity.

This new style of officialdom did not pass unremarked or unresisted. In the course of his advocacy of the Quarry Hill clearance scheme, Cameron was with reason to be accused by the opposition of a 'sanitary enthusiasm' and of being a 'purist' in sanitary affairs.[21] His official reports and writings dwelt incessantly on the lack of 'pure air' in slum areas, on the absence of 'ventilation' in the houses, and on the connection of both with disease.[22] In contrast, Cameron imagined a cleansed and open space which would also be an arena for his professional skills and in which 'God's sanitary law' would prevail. The increasing professional status he acquired put him in a powerful position to construct his ambitions as a social ideal. His presidential address to the Incorporated Society of Medical Officers of Health in 1902 was entitled *Sanitary Progress during the last Twenty-Five Years – And in the Next*, and described his hopes for a future in which electrification would remove industry to outlying districts and enable the construction of garden cities.[23] Like Sir Benjamin Richardson's vision of 'Hygeia', Cameron's dream was of a semi-rural arcadia which the wealthy already possessed. But, for the working class, it was to be regularised, cleansed and supervised.

What are never of concern in Cameron's writings are the actual interests, experiences and feelings of the people he intends to reform. His plans are as empty of people as his photographic evidence is of street life. In this he was quite unlike the advocates of public health of two generations earlier. Reformers such as Robert Baker, who mapped the effects of cholera in Leeds in 1842, were concerned with desperate conditions of life, with the immorality brought on by wretchedness, and with the details of specific case histories which they cited at length.[24] Cameron's was a depersonalised approach, a matter of technique practised by professional social technicians, articulated in new socio-political discourses, and set to work in new local governmental institutions to restructure and reorder urban life. It was a view in which

environmental change would solve social problems simply by
changing the behaviour of people who were expected to be silent
and entirely amenable to large-scale manipulation. The local labour
movement, led by missionary christians and minor professionals,
largely accepted the same assumptions. Leeds solicitor and former
Liberal Councillor Edmund Wilson, who later acted for petitioners
against the clearance scheme, was one of the few to take issue with
the way in which the housing issue had been professionalised,
taken out of the realm of politics, and made the target of a specific
medical expertise embodied in a department of the local state. As
he told the Society of Arts:

> It is believed that [the clearance scheme] was prepared by the
> Medical Officer of Health and the Borough Engineer. Perhaps it
> is unfair to blame the Corporation for the mistakes they have
> made, seeing that they have no expert guide in this matter, but
> there is a common error which must be pointed out. It seems to
> be assumed that the housing of the working classes is a question
> which should be dealt with by a medical man. No greater
> mistake can be made. If you must have a Medical Officer of
> Health limit his operations to subjects for which he is acquainted.
> To be skilled in the housing of the working class two qualifications
> are all – commonsense and a knowledge of the needs and habits
> of the people with whom you have to deal.[25]

It is to less common knowledges, however, that we must refer
Cameron's plans and the photographs he caused to be made. For it
is of these they speak – and not of the lives and experiences of
working-class slum dwellers. Yet the silence of the records on this
point cannot go unremarked. It is too paradoxical. However myopic
Cameron might have been in his professional concerns, the
Corporation and its officers knew more than enough about the
inhabitants of Quarry Hill. They might be unseen and remote, but
they also seemed threateningly near. They might be conveniently
held back from the record camera's field of view, but they threw a
long shadow across the bright picture of middle-class life.

Quarry Hill had been from the beginning a working-class and
racial ghetto. It developed rapidly because of the demand for cheap
workers' housing close to employment in the workshops, markets,
warehouses and wharves of the old town and the newer mills and
foundries along the Meanwood Beck. Yet it was not very distant

from the rich merchant houses, the parish church, or the commercial heart of the town. By the 1850s, however, Leeds was becoming much more rigidly segregated, as the middle classes escaped 'above the smoke' to the northern suburbs, leaving the workers behind in the industrial areas to which they were tied by casual employment, long hours of work, and the absence of cheap public transport.[26] The East End had always been viewed from the outside and understood through the representations of distanced reporting, but it now became something radically other.

For the middle classes, however, physical separation and private self-absorption could not bring continuous relief. What could not be known had to be imagined, and the imagination was inflamed by official inquiries, pamphlets, and sensational reports in the press. From the heights of Headingley, Quarry Hill seemed a nether world lost in satanic fumes, the breeding place of infernal beings. The obsession with light and air which was such a constant feature of the arguments for clearance was more than a reference to the 1890 Act or the index of an often eccentric medical knowledge. It was a metaphor whose Biblical resonances were well understood and which already had a history in the missionary literature of slum life.[27] Dwellers in the slums were to be pitied for living beyond the reach of the Light of Civilisation and Grace, but they were also feared to be revelling in the blackness of their unseen abyss which nurtured sin and disorder. Light was needed for health but also for sight. Rays from the Light of Truth would illuminate the souls of the poor but would also gather to the Eye of Power. 'So out of the way are these places', argued the christian social reformer D. B. Foster,

> that deeds of shame and blood can easily be perpetrated without detection by the authorities . . . so long as these secret places remain they must, by their very nature, tend to produce a lower moral tone, for the best of us are considerably stimulated to higher efforts by the consciousness that other eyes are upon us.[28]

Foster's solution, like Cameron's, was to take the camera into the slums, for the camera was the modern instrument which both measured light and offered the means of a detached but continuous surveillance. The camera operated across the gulf dividing here from there, the eye from the real, the seer from the seen. But it made these points seem irreversibly fixed, and rendered transparent

what held them together and apart: the shifting field of the sign which is both object and producer of relationships of power.

The gap which separated the middle classes from the slum was more than geographic, and the imagery they evolved to describe it was a condensation of all that filled the gulf between two nations; all that could be acknowledged and all that had to be repressed. The spectre of the death-rate was only one strand. Concern about public health among the propertied classes was always bound up with a complex of fears about this 'other place'. It manifested itself periodically in phases of anxiety about the behaviour and attitudes of the working classes, about disease, about immigration, about the deteriorating standards of work brought on by industrialisation and the growth of sweated trades, as well as about political instability at home and revolutions abroad. Across the country as a whole, the 1880s were just such a period, when middle-class concern over low profits and high unemployment was added to fears about the growth of socialism, European political upheavals, Jewish immigration, disease and overcrowding in the cities, police inefficiency, municipal corruption, and the effects of a succession of severe winters on the poor.[29]

If these fears had one focus in Leeds at this time, it was the East End of the city and the Quarry Hill area in particular. Whereas in 1885 the Medical Officer of Health, Dr Goldie, had complacently declaimed to a Royal Commission on the Housing of the Working Classes on 'the opulence of the working classes in Leeds', who were 'all well to do people, all people earning good wages',[30] the National Society, which set up two voluntary schools in east Leeds, reported the area the 'most dense and degraded in the town', whose population was 'almost entirely destitute'.[31] In particular, Irish immigrants 'from the wildest parts of Connaught' led lives there of 'indigence, squalor and hopelessness . . . in complete disregard . . . of schools for their children', and could not anyway pay school pence.[32] What characterised the East End to outside middle-class commentators was its utter otherness, its intransigence, and its unruliness on a whole range of levels from the moral to the political. It began with the nature of the population itself – a paradox indeed for the historian who seeks to know Quarry Hill 'through' the Corporation's photographs.

With its varied opportunities for employment and its position as a centre of communications and exchange, Leeds never had the

stable population of nearby wool towns like Bradford. As its populace swelled in the last quarter of the eighteenth century and the second and third decades of the nineteenth, immigration was always a major contributor to growth.[33] The bulk of its immigrants would have come from Yorkshire, travelling relatively small distances, but the telling exceptions were the Irish and the Jews.

Jewish immigration became a major factor only after 1881, when 6,000 refugees from Polish and Russian pogroms arrived in the town. By 1909, numbers had grown to around 20,000. Like the Irish before them, the bulk of these immigrants were congregated in the poorest areas around Quarry Hill, especially in the Leylands where many streets were 85 per cent Jewish. But unlike the Irish, the Jewish community was relatively quick to find a place in Leeds political life, even though it remained a target of prolonged racialist agitation which fed on fears about the undercutting of wages and prejudice about the condition of Jewish housing and workplaces, and which on several occasions broke out into gang fights and rioting.[34]

But if Jewish immigration into the East End aroused disquiet for the public disorder it threatened to attract, of much more direct concern were the first foreign immigrants, the Irish. In flight from famine at home, 10,000 had settled in Leeds in the decade of the 1840s and, at its peak in 1861, the Irish community amounted to 12·5 per cent of the population of the township. Eighty-five per cent of them were crowded into the slums of the East End where, despite the attentions of philanthropists, educators, churchmen and magistrates, they remained impervious to moral reform and slow to integrate. Largely confined to the lowest occupational levels in a town dominated by artisan pride, Liberalism, Methodism and Dissent, they were isolated racially, economically and religiously, and were feared and despised even by their English catholic counterparts. More fundamentally, their history had politicised them to a degree not matched by the poorest English working class and had placed them outside the imperialist assumptions which united virtually the entire spectrum of Leeds politics. Yet their very concentration gave them appreciable political weight, and the small majorities in parliamentary elections after the 1885 redistribution of seats compelled resentful Liberals and Conservatives to treat them circumspectly, especially in the newly created constituency of East Leeds where they held the balance. Of the three areas of heavy

working-class concentration, East Leeds was politically the least predictable precisely because of the ambivalence of the Irish vote which, from the mid-1880s, tended to be Liberal when Home Rule was at issue but Conservative when education came to the fore. In 1885, Irish opposition to Liberal policies secured the election of a Tory in what ought to have been a safe Liberal seat, but swung back the next year as Conservatives in the city played on the theme of working-class antagonism to Irish competition for employment during the recession.[35] As a result, Irish nationalists were driven much closer to the Liberals and even attacked the emerging Labour movement, itself strongly Irish, for threatening the common front. In 1900, however, the Irish vote again rejected the renegade nationalist candidate fielded by the Liberals against local opposition, and the problem of the politically unpredictable constituency was only solved by the trading of the seat to Labour under the 1906 Gladstone–Macdonald pact, though Labour too took care to stand a declared nationalist, James O'Grady.

If Irish nationalism was a significant disruptive element in Leeds politics in the last quarter of the nineteenth century and an irritant to the major parties, then the Irish also made their political presence felt on another front. From the early 1880s they provided both activists and a base for an emerging radical socialist movement which threatened traditional loyalties in the borough and challenged the delegation of political responsibility to middle-class representatives.[36] The Social Democratic Federation, the Socialist League, and the Independent Labour Party were active successively in the Quarry Hill area, largely under the leadership of Irish descendants like Tom Maguire, who was raised in the Roman Catholic community of East Leeds. From their nationalist perspective, such socialist groupings began to argue a close connection between the question of empire and labour troubles in England and, if a divided working class did not take up their cause in great numbers, they did succeed in radically changing the tenor of debate in clubs and trade unions and laid the basis for a new understanding of working-class life. The period in which their influence grew was one of great difficulty for Leeds' industries, which now faced German and American competition and no longer enjoyed the position of being sole producers on the world market. Throughout the 'exceptional depression' of the early 1890s, socialists attacked the complacent acceptance of rising unemployment as

normal, and the years in which the clearance of York Street and Quarry Hill was planned saw an upsurge of strikes, often, as in the 1890 gas strike, emanating from the area itself.[37]

The residents of Quarry Hill were clearly something of a problem for the governing classes in a number of ways, whether owned or not. It was not that they formed a unified body, for differences of work and skill, the great variety of trades, and divisions of sex, race and religion produced a much more fragmented social structure than the rigorous class stratification which Leeds' residential zoning would suggest. But neither can we imagine a coherent set of interests behind the municipal clearance scheme itself. The point is that two confronting classes were defined in a simplifying opposition by a physical and cultural separation which set them so remote one from another as to be almost unknown but not unimaginable to each other. The slum dwellers registered their difference in ways only too clear to those who deliberated their fate, and these latter in turn fashioned their own phantastic or scientific images of those who lived beyond the pale. It is a remarkable picture, therefore, which is offered as evidence but conjures the inhabitants of the gangland and insanitary area away. It is a remarkable, if successful, strategy which says nothing of political reversals or the intractability of the slum population to 'regular industry', schooling, or moral reform, but speaks only of space, light, and air, resting its case for clearance on the technical claims of a pseudo-medical discourse itself underpinned by the technicism of photography.

It should be said at this point that at no time in the campaign for Quarry Hill's clearance was any attempt made to consult the residents of the condemned area. Cameron contented himself with the assertion that the petitioners were few and that the press and public opinion were on his side.[38] Nor are there records of protest meetings called by the slum dwellers either against their living conditions or against the clearance proposals. Since few of them could write or were interested in recording their opinions, their attitudes are simply not present in representation and it is important to remember this when looking at the photographs. At most, it might be surmised that they would have opposed the scheme since their access to work, amusement and credit depended on the position and close-knit structure of their neighbourhood communities. More obviously, the corollary of Quarry Hill slumdom was cheap rents. At 5s 6d per week or more, the rents of the bye-

law blocks being erected in the new working-class suburbs were more than twice as much as the displaced tenants were paying from wages which averaged 19 shillings to £1 10s. a week at most, when they were in work.[39] There were no proposals to break the pattern of earlier philanthropic model housing schemes which had foundered between the economics of high building costs and the low wages of those they sought to house. The tenant population of Quarry Hill must have been well aware that there were no concrete plans for rehousing. Like rent subsidies, municipal housing schemes were generally regarded among the governing classes of Leeds as an unwarranted interference with the rights of private landlords and a misuse of public funds likely only to destroy the moral energies of the deserving poor. The Trades Council's request that Part III of the 1890 Act be used to build working-class lodging houses, and Nationalist protests in Parliament, went unheeded, and it was 1919 before the Corporation had any truck with the 'socialistic idea' of municipal housing.[40] What the clearance of one slum meant, therefore, was that surrounding areas would become even more densely populated. As Engels warned in 1872:

> The breeding places of disease, the infamous holes and cellars in which the capitalist mode of production confines our workers night after night, are not abolished; they are merely shifted elsewhere.[41]

It was for this reason that radicals in Parliament, including Kier Hardy, deplored the fact that the clearance proposals included no provision for compulsory rehousing. Edmund Wilson raised the same question from a less progressive perspective in the paper on 'the housing of the working classes' he gave to the Society of Arts. Speaking specifically about Quarry Hill, he argued:

> If the area be completely cleared, any dwellings that may be erected in it must comply with the modern regulations and command high rents. A monstrous injustice will have been done to poor people. Two or more families will have to live in one house and as they carry their habits with them, the last state of that area will be worse than the first. Wholesale and sudden changes are not practicable. It is only on the pantomime stage that the waving of a wand can turn a pumpkin into a gilded coach.[42]

In the event, Wilson and the others were right. Election promises were forgotten and, by 1900, while the extension of the clearance scheme was being negotiated, only 198 of the 4,000 inhabitants of the first phase of clearance around York Street had been provided with alternative accommodation.[43]

III

The actual procedure for clearing the Quarry Hill area under the 1890 Housing of the Working Classes Act involved the cycle of approval by the Local Government Board, the issuing of provisional orders, and final confirmation by Parliamentary Bill. Though councillors were aware by September 1890 of their powers under the new Act, and though clear promises were made to the electorate in 1893, the Council was not finally presented with a clearance scheme for its approval until October 1895. The proposal came in the first instance from Cameron, the Medical Officer of Health, supported by the Borough Engineer. Between 1890 and 1894, they surveyed the area, assembled their evidence, and made repeated representations to the Council and its Sanitary Committee. In April 1894, the Committee inspected the area and accepted the need to call on the powers of the 1890 Act in a large-scale clearance rather than the limited programmes of 'ventilation' and road widening it had ventured so far. In February of the following year, Cameron presented his final report, which was debated at a special meeting of the Council in April. Even so, it was not until October that the final resolution was passed by 50 votes to 5 and the matter referred to the newly constituted Unhealthy Areas Sub-Committee, under the chairmanship of Frances Lupton, a supporter of improvement rather than wholesale clearance schemes and an outright opponent of municipal housing, especially the building of tenement flats which he likened, perhaps quite appropriately, to 'barracks'.

The first phase of the plan involved clearing a sixteen-and-a-quarter acre site around York Street in the south-west corner of Quarry Hill, an area with a population around 4,000, occupying 634 dwellings. The Provisional Orders were granted by a Local Government Board inquiry in March 1896 and confirmed by Act of Parliament in August, following the recommendations of Select

Committees of both Houses. The necessary compulsory purchases were not successfully negotiated, however, until 1899, at which point Cameron began to press his plans for proceeding with the remaining fifty acres. The timetable for this second phase was substantially the same as that for the first, and again it was opposed at every stage. The Council gave its approval in September 1900 and, in March of the following year, the proposals came before the Local Government Board which held its inquiry in Leeds. Following its approval, Provisional Orders were presented to Parliament in May. The second reading of the confirming Bill was heard on 14 June 1901 and was accepted, not without opposition, by 307 votes to 52. The Orders then passed, at the beginning of July, to a House of Commons Select Committee which met over five days, and finally to a Select Committee of the House of Lords which returned its favourable verdict on 26 July. As was the case in 1896, so in 1901: it was to the Select Committees, meeting in London, that folios of photographs were presented.[44]

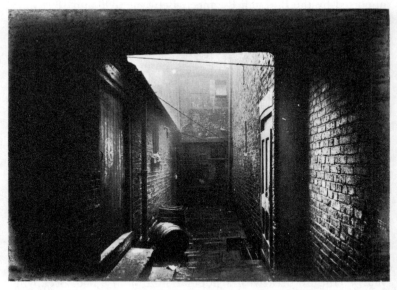

Plate 25. Unknown photographer, *Yard, East of Bridge Street* from *Photographs of Properties of Petitioners in the Quarry Hill Unhealthy Area*, 1901. (University of Leeds, Brotherton Library)

The photographs were prepared, therefore, between February 1896 and the beginning of 1901, and this is confirmed by internal evidence of dates on fly posters. However, the major albums, in the form in which they have survived, seem, with one exception, to belong to the end of the period when large commemorative volumes were also being bound for presentation to the Leeds Public Free Library and the Thoresby Society in 1902.[45] It is difficult to establish exactly who might have made the plates rather than have caused them to be made. A comparable record of housing about to be demolished under the 1890 Act in Kingston-upon-Hull was set in motion in April 1899 by Hull's Senior Sanitary Inspector, who was authorised by the Unhealthy Dwellings Sub-Committee to commission a commercial photographer named Watson to do the work.[46] Similarly, Thomas Annan was commissioned in 1866 by the Glasgow Town Council City Improvement Trust to photograph old closes and streets scheduled for demolition under their clearance scheme (and it may be worth noting that Annan's photogravures were included in a Leeds Photographic Society exhibition in September 1895).[47] Between 1900 and 1914, the Planning and Sanitary Committees of Glasgow Corporation also employed local photographers in connection with a campaign against overcrowding in 'ticketed' lodging houses, a survey of improvements areas, and a petition for a Smoke Abatement Act.[48] Nearer to Leeds and as early as 1852, the professional photographer William Pumphrey had been engaged to record the architecture of York, including the back streets then facing demolition. In Manchester, too, the Amateur Photographic Society had since 1888 been compiling an archive of 'photographic memorials' of buildings in the city and was in touch with similar projects in Birmingham, Sheffield, Liverpool, and York.[49] None of the photographers involved in these projects was an actual official of a local government department. They were commercial traders and enthusiasts, as independent as the amateurs, like John Galt or Willie Swift, who took up photography in the 1890s in furtherance of their mission to aid the slum-dwelling poor.

What happened in Leeds cannot yet be established. Though quite small items of outside expenditure are recorded in the Sanitary Committee minutes, there is no reference to fees paid to a photographer and only one entry, in the *Report of the Unhealthy Areas Sub-Committee* for 1902–3, for £35 5s. 1d spent on 'photographs,

plans, tracings, etc.' in connection with the York Street area.[50]
Photographic records of rebuilding go back, however, to the
widening of Boar Lane in 1866, and it had become the practice of
the Borough Engineer's Department from the mid-1890s to take
photographs of areas in which they were working. (Indeed, one of
the Brotherton albums bears the stamp of the City Engineer's
Department.) But, as with the drawing of plans, work done by the
Engineer's Department was often at the instigation of the Medical
Officer of Health. In 1880, for example, the Medical Officer of
Health, George Goldie, was requested by Dr Edward Ballard
representing the Local Government Board to obtain photographs of
seven slaughteryards in the township whose overcrowded conditions
and insanitary arrangements were under investigation. Thirteen
numbered photographs were subsequently published as evidence
and illustration in a collection of reports to the Local Government
Board, the Markets Committee, and Leeds City Council.[51] The
views they showed were said to speak for themselves.[52] The

Plate 26. Unknown photographer, *View No 13: Interior of Higgins'
Yard. The View Speaks For Itself* **from** *Report of Dr Ballard to the Local
Government Board, etc. . . . upon the Slaughter-Houses and Slaughter-
Yards in the Borough, and as to the Establishment of a Public Abattoir,*
28 June 1880. (Leeds City Libraries, Local History Department)

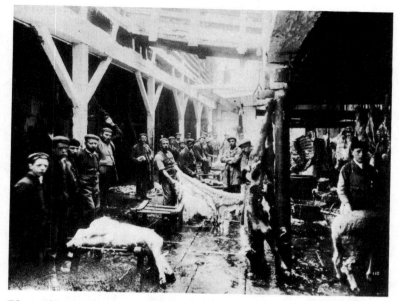

Plate 27. Edmund & Joseph Wormald, *Slaughter-House Looking Towards Entrance, Vicar Lane*, c.1893. (Leeds City Libraries, Local History Department)

narrowness and airlessness of the yards, their defective paving and walls, their lack of cleanliness and unhygienic arrangements described at length in the written reports were taken to be simply self-evident in the images. Yet the rhetoric of these early official photographs is entirely unemotive compared to the language of the reports. Their sepia tones describe bare, uninhabited spaces, empty of butchers and cattle, and only identified by the occasional hanging carcass. They are quite unlike the same yards a decade later, which teem with picturesque insanitary life in the commercial views sold by the Leeds firm of Wormald as part of their series on 'old Leeds'.[53]

The precedent is important and the contrast instructive. The slaughteryard photographs, like those of the Quarry Hill albums, are the beginning of a systematic official photographic discourse which shuns picturesqueness and emotion and yet claims an irrefutable immediacy of expression. Certainly, the line is not yet clearly drawn. The Quarry Hill photographs still resemble the

views of 'old Leeds' sold by Edmund and Joseph Wormald from
the 1860s on. The pictorial rhetoric in both is rudimentary enough.
But they are equally close to the later officially commissioned work
of Charles Pickard and to the amateur photography of socialist and
local historian Alf Mattison, or Willie Swift, who photographed
'the fearful conditions of slumlife' for the Holbeck Social Reform
Union and illustrated his friend D. B. Foster's indictment of *Leeds
Slumdom* in 1897.[54] The search for a photographer's name has its
own fascinations. Some of the photographs, for example, have been
attributed to Alfred Ernest Matthewman, a solicitor who worked in
the town hall in the late 1890s, but nothing is known about his
photographic activities.[55] Yet the search is deceptive. Enthusiastic
amateur, commercial photographer, or employee of the Engineer's
Department, there is no reason to assume that the corpus of images
made over five years is the work of one hand. More fundamentally,
the question of authorship cannot be closed by establishing who
released the camera shutter. All the plates were exposed, mapped
and recorded under the close supervision of the Sanitary
Department, and even of the Medical Officer of Health in person.
A number of sanitary officials, perhaps including Cameron himself,
appear in the photographs, controlling onlookers, setting the scale,
directing the viewer's gaze. More to the point, the record of the
Select Committee minutes shows that Cameron was able to locate
and date particular photographs and speak confidently about the
weather conditions prevailing when they were made. He was also
clearly aware of at least some of the technical problems involved.
He knew about exposure times and understood the effects of
different lenses. In an important sense, Cameron and his trained
team must be seen as instrumental in constructing the images; the
images belonged to Cameron's strategy of social engineering and
became meaningful precisely when inserted into his professional
discourse on health and housing. This is not to say that Cameron
could control their meaning, for this, as we shall see, was to be the
site of a political struggle. To grasp this, we must look at the
currency of the photographs.

In both 1896 and 1901, carefully ordered selections of prints
were bound together for presentation to Parliament, together with
the 'maps, particulars, and estimates' which the 1890 Act required.
The choice and arrangement seem to have been designed with a
particular eye to rebutting the case of petitioners against the

scheme, among whom estate agents and the owners of public houses figured prominently. At the Local Government Board inquiries in Leeds, the books of photographs do not seem to have been submitted, perhaps because the Board inspectors made extensive visits to the insanitary areas themselves.[56] Before the Parliamentary Select Committees, however, the folios came to play a crucial part. What the minutes show is that the photographs were produced in committee with deceptive straightforwardness as evidence, as 'a true representation', proof that the areas they depicted were insanitary. But what needs to be grasped is that in this context and in this usage, photographs constituted a relatively new kind of material whose use and acceptance had to be negotiated, learnt and officially established. Cameron had clearly developed the requisite skills, even by 1896, and adroitly deployed the photographic images to augment the established authority of his testimony which rested on the prestige of his office and on his professional medical expertise. Other witnesses lacked such competence and had to rely on other forms of evidence or deny the photographs' legitimacy. Early in the proceedings of the first Commons Select Committee, Cameron was challenged 'That you do no more than rout people up with postcards?'[57] Not only did Cameron deny this slight, as might have been expected, but he immediately turned the situation – a dispute about the condition of a public house – to his advantage in establishing the systematic nature of his visual evidence: 'E is the front of it', he explained, 'G is a photograph taken from the back of it; E, F, G and H all show it.'[58] When questioned, he did not relent:

> E is the front of it; F is the yard behind it; G is the back of the house taken from that same yard; H is the north end of Riley's Court adjacent to it; I is another view of the same court.[59]

Cameron had prepared his case minutely and followed a detailed written proof in giving his evidence. The opposition had clearly underestimated his strategy. Yet, for it to be successful, the Select Committees had themselves to be convinced of the legitimacy and schooled in the reading of photographic evidence, for these were possibly the first and certainly among the earliest occasions on which photographs were presented to a Parliamentary committee as evidence. But the Committees did not just need to be persuaded to accept them; obviously, they also needed to be persuaded to

accept that reading which supported the slum clearance proposals. There was never any question of the photographs speaking for themselves. Cameron intervened continually to explain the pictures in the smallest detail, though by contrast maps and plans were regularly used and called for no such expert guidance. What Cameron was trying to do was to establish technical rules about the meaning of images which would also connect them to other kinds of evidence – to records of people and places – and evoke absent spaces – spaces which, in turn, he sought to connect with disease. Questioned in 1896 about a photograph of a yard off Harrison's Buildings, he responded with an exhaustive explanation which might seem redundant but which unobtrusively tied the Committee to the realism and evidential value he was seeking to establish for his folios of images:

> on the right hand side, that is the back door of the common lodging house – this yard is 25 square yards in area – the photograph is taken from a narrow entry, and the only way into that yard from the other side in that yard is on the right hand side, the window and back door of the common lodging house, and on the left hand side two small two-storied buildings let off in furnished apartments, and then in front that wall with the line of light shown upon it is the wall of the 'Yorkshire Hussar', and the 'Yorkshire Hussar' prevents the only day light that might possibly get into these buildings on the left hand side from getting into them.[60]

In the same movement, what the photographs did not show was made to signify. Cameron was at pains at the second Parliamentary inquiry to point out the technical difficulties of making exposures in the dark and confined spaces of Quarry Hill. Of one small yard, he claimed: 'I should like to have shewn you a Photograph of some of these places but the difficulty is that the yards not big enough to allow the camera free scope.'[61] Of a larger yard, he insisted it had only been recorded because 'The photograph was taken when the sun was shining about mid-day on January 22nd and the exposure given was one hour.'[62] By these means, a contentious legal realism was evoked for the photographs and tightly controlled. Through this, another space was conjured up, beyond photography, blacker than the dark images and more confined. What was signified was quite deliberately 'the narrowness, closeness, and bad

Plate 28. Unknown photographer, *Yard off Harrison's Buildings* from *City of Leeds, Insanitary Areas*, 1896. (University of Leeds, Brotherton Library)

arrangement . . . the bad condition of the streets and houses . . . the want of light, air ventilation, or proper conveniences' which defined an unhealthy area under the 1890 Act.[63] Moreover, all the while, Cameron was establishing practical procedures and protocols for handling visual evidence. The albums were in the room. They passed from hand to hand. Particular photographs became objects of debate. Something was being negotiated which the minutes could hardly trace.

Even so, for all his skill, Cameron could not police the meanings of the photographs in the way he wished. He may have employed a modern technology in a way that was advanced for the time, but he could not uncontroversially fix its representations solely within his technicist conception of social problems. His legal opponents took up the debate about the images in an attempt to prove the soundness of the properties they were defending. One witness in 1901 welcomed a photograph of his premises as 'a very good photograph' showing a substantial building.[64] But Cameron took up such challenges, and the Committee minutes dramatise what

might otherwise be lost: the constant negotiation of the conditions of meaning. Cross-examining for the petitioners, Forbes Lankaster asked: 'Is that photograph a fair representation of the three cottages in Hope Street?' Cameron answered 'Yes', and Lankaster instructed him: 'Show it to the Chairman', at the same time handing in a small hand-plan which he hoped would support his description of the properties. But Cameron would not let it rest there:

> I should like to identify the complaints I made in my evidence in chief. *These* are cottages below the level of the ground. I do not agree that this entry is over the top; *that* is a staircase which goes down to the ground floor. *This* is a bedroom, and *this* is also a bedroom; *this* is a yard, and *these* three houses of which you have a photograph are what I call back-to-back houses facing north; *this* is a back-to-back house with a stable behind it. *This* house goes through and has the door made up; then there are places shown on the map which are not shown here. *This* which is shown as an open space is covered in as far as *there* (pointing to the plan).

At this point the Chairman intervened to confirm what Cameron had said. Then Forbes Lankaster came back:

> Look at this photograph. Do you repeat your evidence that it is covered in – that is a photograph of the yard as it is now?

Cameron did not hesitate but changed his tactic, from realism to construction:

> Yes, it is taken at a very wide angle of lens, and makes this part broad; the impression is that you are coming into a shut-in place.

The registering of the technical level of the image entirely threw the cross-examining counsel and, as Cameron continued to explain the photograph to the chairman, Forbes Lankaster could only bluster:

> I will not discuss with you whether it is covered in or not.

But Cameron was determined to underline his knowledge and have the last word:

> It is covered in where you see on the photograph. If you take the picture with a wide angle lens you magnify the foreground at the expense of the background; the background is covered in.[65]

Plate 29. Unknown photographer, *Yard in Paper Mill, Looking East* from *Photographs of Properties of Petitioners in the Quarry Hill Unhealthy Area*, 1901. (University of Leeds, Brotherton Library)

When it suited him Cameron would therefore point to the technical construction of the image, but he was still arguing the need to see through the photograph to the reality disclosed – a reality naturally imbued with the meanings it had for him. What he was defending was the meaning and realism he wished to establish for the images. Yet no one ever accused him of deliberately tampering with the photographs, by retouching or cropping, for example, or by underexposing the glass plates in the camera to increase the gloominess of the image. The opposition was stuck on the photographs' realism but failed to establish other positions from which the images might have become legible in alternative ways. They did not have Cameron's skill. They were caught in his meanings and lost their suit, even though by 1901 certain petitioners had learnt enough to table their own photographs of their properties.[66] They could not match the systematic organisation of Cameron's documentation which had no need of the legalistic rhetoric and bad faith of the Town Council's attorney Lord Robert

Cecil. At the very last hurdle, faced with a petitioner's photographs before the Select Committee of the House of Lords, Lord Robert sounds an ironic epitaph to the whole proceedings:

> I do not want to ask you about the photographs, because we know photographs do not convey a very accurate impression of buildings of this class.[67]

IV

It is a fitting point from which to sum up. What survives is not a neutral document of working-class life but a composite text, sent to Parliament as part of an official submission, as evidence. What we have to ask is what that would mean. What conventional procedures, competences and techniques would have to be deployed to produce a truth from the photographic text? How were such procedures established and when did they become administrative habit? We are not dealing with photography alone but with its insertion into a cumulative network of documents, an intense and meticulous archive, a cluster of small disciplinary techniques of notation, registration, tabulation and filing. The Parliamentary Committees appear to have been uncertain as to what to make of the albums, but the lobby in favour of clearance seems to have anticipated a certain resistance. Or was it that they had to establish the necessary competences? Certainly, photography had been used as a means of record and evidence by the police, prisons, asylums, children's homes and hospitals before this date,[68] but in a haphazard fashion. The exact and confident techniques which codified the conditions under which photographs could be construed as evidence do not seem to have been established until the early decades of this century. What we have here is an instance of negotiation – a precedent of evidence.

But it is also evidence mustered in an argument, and the argument is part of a political struggle over housing policy. This is not just something which goes on *around* the images. The photographs are not just a *stake in* but also a *site of* that struggle: the point where powers converge but are also produced. We may not know the photographer – the person who released the shutter – but, in a sense, this may not be an issue. We can investigate the

into these other Forms

author not as an individual but as a complex entity, as, for example, the department of the Medical Officer of Health which played a constitutive role not only in instigating but also in making and interpreting the photographs. Nor was this the first time that the lobby for public health reform in Leeds had taken up the most advanced means of representation of the day. Before photography there was cartography. Five years before the first large-scale Ordnance Survey, in 1842, the first sanitary map of the district was prepared by town councillor and factory inspector Robert Baker for presentation to a House of Lords inquiry into an appalling outbreak of cholera in the town.[69] What Baker sought to mark out in his map was the correlation of the disease with areas deficient in sewering, drainage and paving; prominent among such areas was Quarry Hill, though at that time much of its property was newly built. Baker's object, like Cameron's, was to describe a situation meticulously, to grasp it, to control it.

This, then, was part of the intention. But authorship does not determine meaning. The meaning of a photograph or sequence of photographs always remains relatively open to a range of possibilities – hence the arguments which go on in the records about the exact construction to be put on the images. The opposition – the landlords, the *laissez faire* politicians, those seeking compensation – produce meanings of their own, but they fail to expose the processes of photographic construction. Central to this are the technical constraints of the available photographic technology. Recognition of these limitations might have acted as a counter-weight to unargued assumptions about the semiotic transparency of the mechanical image – assumptions which have a history longer than that of photography itself. Yet technical constraints are not some pre-given limit. They are present only when the available camera equipment is set to work in a particular way. They then become visible in the photographs not as a boundary but as a meaning: the alleys are underexposed, dark, *dingy*; the spaces are foreshortened, compressed, *cramped*; the compositions are repetitious, bare, and *brutal*. In the albums as a whole, the limits of the technology are traced as an absence. Certain places are not shown and there are no interiors, though these were not beyond the capacity of the available equipment, as Willie Swift's photograph published in 1897 shows.[70] But the Medical Officer of Health, never at a loss, retrieves this: there were

alleys and ginnels so dark and narrow, interiors so strait and gloomy that photographs could not even be made there. What does the absence signify? Can it be appropriated in this way by one side or another? The argument goes on. Before, during and after the making of the photographs, it invests their meaning.

Plate 30. Willie Swift, *Interior of Cellar Dwelling, Mushroom Court* from D. B. Foster, *Leeds Slumdom. Illustrated with Photographs of Slum Property by W. Swift,* Leeds 1897. (Leeds City Libraries, Local History Department)

The camera is never merely an instrument. Its technical limitations and the resultant distortions register as meaning; its representations are highly coded; and it wields a power that is never its own. It arrives on the scene vested with a particular authority; authority to arrest, picture and transform daily life. This is not the authority of the camera but of the apparatus of the local state which deploys it and guarantees the authority of its images to stand as evidence or register a truth. The streets are cleared. Street life is not an issue in these representations, whereas it is for social reformers like Swift. It is not just that moving figures do not register on the slow plates. Exactly as in the earlier slaughteryard

photographs, it is the written report and the verbal account which bear the burden of emotion and are left to evoke the sounds, the smells, the life. Space and light are what the negatives measure. The locals are posed only for scale or extra detail. But the sombre presence of the inspectors signals a dismal, philanthropic power. It is the power to see and record, a power of surveillance that effects an entire reversal of the political axis of representation which has confused so many labourist historians. The squalid slum displaces the country seat, but its presence in representation is no longer a mark of celebration but now a mark of subjection. The very clutteredness and obscurity of the images argues for another space: a clear space, a healthy space, a space of unobstructed lines of sight, open to vision and supervision. It is a space that will appeal to the police as much as to Medical Officers of Health and philanthropists; a desirable space in which people will be changed – changed into disease-free, orderly, docile and disciplined subjects; a space, in Foucault's sense, of a new strategy of power-knowledge. For this is what is at stake in town planning and in the photography

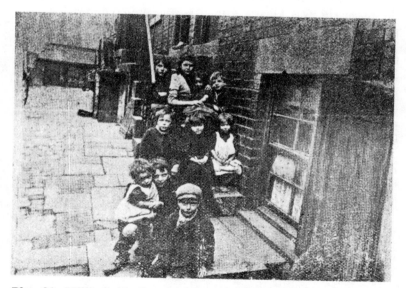

Plate 31. Willie Swift, *Group of Slum Children in Court Off Charlotte Street, Holbeck* from D. B. Foster, *Leeds Slumdom*, Leeds 1897. (Leeds City Libraries, Local History Department)

which furnished a technique central to it from the start. The same could be said of Riis's more famous photographs of Mulberry Bend in New York – that breeding ground of criminality and immorality, that warren of alleys and yards, a no-go area for the police, a space of resistance – which was pictured and pulled down, and replaced by the sterile, supervised paths and lawns of Jacob Riis Park.[71]

In Leeds, the Council spent £718,456 and was decidedly reluctant to demolish more of its newly acquired purchase than was required for road-widening schemes. Rents brought in the city's newest and largest slum landlord an income of £22,500 per annum. The suspicion seemed well-founded that:

> the scheme was not a sanitary one at all but a street improvement scheme for the purpose of which the corporation desired to acquire property cheaply by calling it unhealthy.[72]

Less than half the Quarry Hill area was cleared before 1914 and even by 1933, 754 condemned houses were still standing. It was the election of the city's first Labour Council in that year which swept away the last traces of the stagnating slum. What was put up on the razed site was Quarry Hill flats, the prototype for Labour's postwar plans – 938 ordered, clean-lined, modernistic units for 3,280 people.[73] It took another Labour Council in 1973 to schedule it, like its 1960s progeny at Hunslet Grange, for demolition. It has taken a third Labour Council to produce plans to replace the present-day car park with a prestigious cultural complex. The city's interior is stripped now of industry and the bustle of class ghetto life. The Quarry Hill photographs have taken on an after-life as tourist promotions and forgetful evocations of the quaintness of 'Old Leeds'. Cameron's dream of a reshaped and repopulated urban landscape has become the inheritance of speculators armed with inner-city grants. We might look at the photographs and ask again, where have the working-class slum dwellers gone?

Chapter 6

The Currency of the Photograph: New Deal Reformism and Documentary Rhetoric[1]

I

On 6 October 1951 Berenice Abbott took part in a conference on photography at the Aspen Institute, Colorado. There, she put forward her view that photography has a strong affinity to writing and that, in the USA, this is to 'a glorious tradition of unsurpassed realist writers'.[2] In the course of her argument she reminded her audience that: 'Jack London in his powerful novel *Martin Eden* pleads not only for realism but impassioned realism, shot through with human aspirations and faith, life as it is, real characters in a real world – real conditions.' She asked: 'Is this not exactly what photography is meant to do with the sharp, realistic, image-forming lens?' And a little later, as if in answer, she concluded: 'Photography cannot ignore the great challenge to reveal and celebrate reality.'[3]

The comparison with the author of 'proletarian' and 'revolutionary' fiction is surely a surprising one for a former pupil and assistant of Man Ray to draw. The same might be said for other references in the lecture: to the communist writer Theodore Dreiser, and the painter of the 'Ash Can School', John Sloan, though the latter's 'Hairdresser's Window' of 1907 prefigures the many shop-fronts documented by Abbott thirty years later. Clearly, it is important. Abbott deliberately sites her work within an

153

American tradition but, more than this, she identifies this tradition as *realist*.

We must, of course, be careful to establish what exactly Berenice Abbott meant by 'realism'. It is not just a question of subject-matter. Undoubtedly, she believed realism – or 'documentary value' – to be inherent in the photographic process itself and present in every 'good photograph' whose image had not been falsified by exaggerated technical manipulation. Yet, in her reference to Jack London, Abbott also introduced the themes of tendency literature: of a realism which focuses on 'real characters' and is 'shot through' with 'aspirations and faith' which belong both to them and to the author. Again, this seems to introduce a thematic not obvious in Abbott's work. Yet Abbott wrote that the objectivity of the photographer was 'not the objectiveness of a machine, but of a sensible human being with the mystery of personal selection at the heart of it'.[4] Elsewhere, writing about documentary photography in New York, she urged:

> The work must be done deliberately, in order that the artist actually will set down in the sensitive and delicate photographic emulsion the soul of the city . . . sufficient time must be taken to produce an expressive result in which moving details must coincide with balance of design and significance of subject.[5]

Here, then, is not the careless style and ranging view of London, but certainly a conception of realism which is not incompatible with Abbott's emphasis on 'personal expression' and 'creative development'. It also introduces the idea that, far from being a neutral presentation of pre-existing facts, realism may involve certain essential formal strategies. As Abbott saw it, 'The second challenge [for the photographer] has been to impose order onto the things seen and to supply the visual context and the intellectual framework – that to me is the art of photography.'[6] It is in this sense that what she called the 'aesthetic factor' in photography was not at odds with its documentary or realist purpose.[7] This should be sufficient to convince us of the complexity of the 'internal' features of Abbott's 'realism'. We must see that here, as generally, realism is defined *at the level of signification*, as the outcome of an elaborate constitutive process. We cannot quantify the realism of a representation simply through a comparison of the representation with a 'reality' somehow known prior to its realisation. The reality

of the realist representation does not correspond in any direct or simple way to anything present to us 'before' representation. It is, rather, the product of a complex process involving the motivated and selective employment of determinate *means of representation*. As Max Raphael majestically put it:

Language presses us, even against our will, to compare the finished work of art with its model in nature, and thus diverts us from the fundamental fact that the work of art has come about through a dialectical interaction between the creative forming spirit and a situation that is given to begin with. Therefore we must sharply distinguish between the given situation (nature), the methodical process (the mind), and the total configuration (the work of art). The given situation is itself highly complex, for in addition to being a component of nature it contains a personal. psychic experience and a socio-historical condition: nature, history and the individual do not tend to coincide, to be harmonious, but conflict with each other and so accentuate their differences. The artist seizes upon this conflict and thereby divests it of its factual character, transforms it into a problem – a task which consists in bringing these three factors into a new relatedness, merging or fusing them into a new unity with a new, internally necessary form. Mere existence is thus made into a process, and the result of this process is another existent, an existent of a special kind, founded upon a new unity of the conflicting elements as perceived by man and embodied in matter. To the viewer of the work of art this man-made yet 'autonomous' (i.e. self-sufficient) reality is immediately accessible. When he tries to analyse it into its components in order to gain insight into the process that brought it into being, it is not enough for him to note the differences between the finished work of art and the given model. He must also know how the respective data of nature, history, and the artist's personality were creatively combined, as a problem to be solved – and how, thus, the work of art came about – in so far as this creative process was not a mere matter of psychological accident but was governed by laws.[8]

There is a tendency in Raphael to believe that the constitutive process of creation and the various unfolding stages of its realisation are a historically determined representation, at a particular level, of

the 'deep structure' given for all time and defined in epistemology or the 'theory of intellectual creation'.[9] The creative process and its progressive stages are mirrored, therefore, in a critical procedure which is similarly 'outside' history. However, while Raphael correctly shows that it is for the historian to locate in the specific historical context of the particular image the means of figuration, the mode of their deployment and the specific motivation of their use, and to reconstitute the *method* by which the image was realised, the historian must do more than this. It is not enough to reconstitute the complex conditions, means and processes of production. The same analysis must be brought to bear on the mode of reception of the work. We must *historicise the spectator*, or, to make this more precise by returning to Berenice Abbott, we must also take care to specify *to whom* and under what conditions she thought her photographic images would *appear* 'realistic'.

In her essay 'Changing New York' – written, admittedly, to represent the Photographic Division, of which Abbott was supervisor, in a national report compiled in 1936 to throw a favourable light on the work of the Federal Art Project section of the Works Progress Administration – Berenice Abbott claimed that public response to her exhibits proved there was 'a real popular demand for such a photographic record':[10] one, that is, which would 'preserve for the future an accurate and faithful chronicle in photographs of the changing aspect of the world's greatest metropolis'.[11] On the basis of this conviction and having failed to procure the requisite private patronage, Abbott welcomed the practical social support afforded by government sponsorship under the Works Progress Administration. In return, she argued, there were many immediate and longer-term public uses to which her documentary photography might be put, besides that of adding to the permanent collections of the Museum of the City of New York and similar historical depositories. Her prints were exhibited in demonstration galleries in southern states, in historical museum and in 'numerous community centres in the five boroughs' of New York City.'[12] They were allotted to various High Schools and to the University of Wisconsin. They appeared in the New York City guidebook, in newspapers, government reports and publications ranging from *Life, House and Garden* and *Town and Country*, to social work dossiers and religious periodicals. Yet if we look at her list of exhibitions, we see that, aside from individual shows in such

private galleries as the Julien Levy Gallery in New York, it is exhibitions at the Museum of the City of New York and the relatively new Museum of Modern Art, New York, which predominate. Furthermore, we may note that many of the exhibitions in which she participated were not devoted to social or environmental issues but to 'Art'. I am thinking of such exhibitions as 'New Horizons in American Art' of 1936, or 'Art in Our Time' of 1939, both of which were held in the Museum of Modern Art. To understand the public meaning of such exhibits we would, in turn, have to site them within the general policies, purposes and discourse of the management of the privately funded Museum and understand the role within the state that the Museum was beginning to define and assume.

In general, although responsibility for the national and international presentation of American achievements in the sphere of the visual arts had not yet devolved to the Museum of Modern Art, the Museum had already begun to attempt, in its exhibitions, a definition of the character and tradition of a specifically American art. As far as contemporary work was concerned, the policy in the 1930s tended to neglect American abstract art in favour of the very 'realist' figurative work which, by the early 1950s, the director Alfred H. Barr had come to equate with 'totalitarianism'.[13] This must have affected the selection and reception of Berenice Abbott's documentary work – as must the fact that, even at this early date, the Museum had begun that appropriation of photography to Art which brought Walker Evans his one-man show in 1938 and which continues to this day.

The detailed examination of these institutional trends and the rigorous analysis of Abbott's 'realism' are outside the scope of this paper. Its actual destination is a discussion of *the prerequisites of realism*. However, the terrain we shall have to cross is precisely that of the problems raised by Abbott: the relationship of photography to the real; the processes and procedures which constitute meaning in the photograph; the social utility of photographs; and the institutional frameworks within which they are produced and consumed. I shall try to treat these problems under three headings – or in three stages: the currency of the photograph; the régime of truth; and the conditions of realism. I shall attempt to give an adequate account of the first, but my treatment of the latter two will be necessarily truncated.

II

Let us begin by looking at two images. In appearance, they are close enough to us in history, culture and the development of photographic rhetoric to be readily identifiable. They represent two interiors, two groups of people, two collections of furniture and ornaments. It seems 'natural' to identify the pairs of figures as couples, as families; the interiors as homes; their furnishings as the trappings of two social groupings. One (Plate 32) shows an elderly

Plate 32. Jack Delano, *Union Point, Georgia*, 1941. (Library of Congress, Prints and Photographs Division)

Plate 33. Russell Lee, *Hidalgo County, Texas,* 1939. (Library of Congress, Prints and Photographs Division)

middle-class couple from Union Point, Georgia, in 1941; the other (Plate 33) recipients of government aid from the Farm Security Administration, at home in Hidalgo County, Texas, in 1939.

The photographs are dense with connotations, as every detail – of flesh, clothes, posture, of fabric, furniture and decoration – is brought, fully lit, to the surface and presented. Just as we see each detail within the meaning of the total photographic image which they themselves compose, so we see every object both singly and coming together to form an ensemble: an apparently seamless ideological structure called a *home*. We are aware of significant differences, but also of striking similarities: of individual objects, possessions, and of their relations; of the way they come together to constitute what is common in the two images – the concepts of *family* and *home*. What we experience is a double movement which typifies ideological discourse. On the one hand, the ideological construction put on the objects and events concretises a general mythical scheme by incorporating it in the reality of these specific historical moments. At the same time, however, the very conjuncture

of the objects and events and the mythical schema dehistoricises the same objects and events by displacing the ideological connection to the archetypal level of the *natural and universal* in order to conceal its specifically *ideological nature*. What the mythic schema gains in concreteness is paid for by a loss of historical specificity on the part of the objects and events.

It has been argued that this insertion of the 'natural and universal' in the photograph is particularly forceful because of photography's privileged status as a guaranteed witness of the actuality of the events it represents.[14] The photograph seems to declare: 'This really happened. The camera was there. See for yourself.' However, if this *binding* quality of the photograph is partly enforced at the level of 'internal relations' by the degree of definition, it is also produced and reproduced by certain privileged ideological apparatuses, such as scientific establishments, government departments, the police and the law courts. This power to bestow authority and privilege on photographic representations is not given to other apparatuses, even within the same social formation – such as amateur photography or 'Art photography' – and it is only partially held by photo-journalism. Ask yourself, under what conditions would a photograph of the Loch Ness Monster or an Unidentified Flying Object become acceptable as proof of their existence?

It is only where this functioning of photography within certain ideological apparatuses is ignored that the question of privileged status can be transferred to the alleged 'intrinsic nature' of photography. Thus, even where it is accepted that the choices of event, aspect, angle, composition and depth represent a whole complex chain of ideologically significant and determinate procedures, it has been maintained that the 'binding quality' of photographs is rooted in a pre-manipulative, a-rhetorical level which exists ideally. Roland Barthes imagined a 'natural', 'innocent' or 'Edenic' state of the photograph: 'as if there was at the beginning (even Utopian) a brute photo (frontal and clear) on which man disposed, thanks to certain techniques, signs drawn from a cultural code'.[15] The very word 'natural' should alert us to a conception that is precisely ideological. Looking at these two photographs, and remembering the images of Atget, Abbott and Evans, we must also be aware that the hypothetical 'brute photo (frontal and clear)' is itself locatable within a historical typology of photographic

configurations: it is the characteristic format of photographs in official papers and documents, and also predominates in that purer strain of pedigree photographs – 'straight photography' – said by so many critics and ideologues to embody 'universal truths' about existence, about 'being-ness', about the 'stasis-in-continuum'.

Let us return to the problem of the 'double movement' within ideological discourse. While this process is seen at its most explicit in the 'family structure' of the exhibition 'The Family of Man', what it means here is that the ideological conceptions of 'family' and 'home' are both 'proven' and fleshed out in the reality of these two disparate settings. On the other hand, our very acceptance of these ideological conceptions leads us to see these 'families' and 'homes' as participating in certain universal, fundamental truths so that the two groups of figures and the two settings are effectively removed from history and we are no longer able or inclined to see, question or account for their very differences. However, we are in danger of overstating the case. We should remember that, whereas ideology presents itself and imposes on our consciousness a well-constructed, coherent and systematic totality which contains our thought within its apparent consistency, it produces this coherence as an *effect*. As Macherey says, 'ideology is essentially contradictory, riddled with all sorts of conflicts which it attempts to conceal. All kinds of devices are constructed in order to conceal these contradictions; but by concealing them, they somehow reveal them.'[16] If the discrepancies in these two photographed rooms clearly signify that the difference between the two is a difference of *class*, then it is equally clear that the one has been realised *within the dominant form* of the other and that this dominant form is an *ideological form* constituted in the form of life and by the realisation of the values, beliefs and modes of thought of the dominant class. It is the existence of the differences – the discrepancies – of the one within the identity of the other that gives the juxtaposition its poignancy: a poignancy in which we *see* and *feel* the reality of the ideological field of this social formation at this historical moment – middle America 1939, 1941 – revealed, not by 'unmasking', but by its strategies of concealment of its own internal flaws. As Walter Benjamin wrote, ten years before either couple sat for the camera:

However skillful the photographer, however carefully he poses his model, the spectactor feels an irresistible compulsion to look

for the tiny spark of chance, of the here and now, with which
reality has, as it were, seared the character in the picture; to find
that imperceptible point at which, in the immediacy of that long-
past moment, the future so persuasively inserts itself that, looking
back, we may rediscover it.[17]

For the moment, let us isolate two details from the dense mat of
signifying strands. On the rear wall of each room we find a
tapestry. One depicts a Moorish dance in an exotic setting
reminiscent of Delacroix's 'Women of Algiers'. The other shows the
scene of an eighteenth-century chamber concert, again reminding
us of French art, of conversation pieces, though here the style and
gestures of the figures do not cohere and the method of figuration
and composition do not connote or make reference to any particular
style or works of art. In this, it falls short of the pastoral scenes on
the tapestry cushion covers in the other room, in the other
photograph.

What meanings could such images have for American couples
like these? Did the one bring to mind the refined culture of a more
secure class in a pre-industrial society where luxury could be
conspicuously consumed? Did the other, as in nineteenth-century
France, where we may find many such scenes in Romantic
paintings, suggest an escape: something exotic, a primitive culture
now reachable within French possessions through the expanding
tourist industry? Did it hint at something tinged with the erotic,
and with risk? And why tapestries – woven woollen pictures? Did
tapestry itself allude to some special meaning: carry, however
hidden, some reference to a history of furnishings and homes? And
did this allusion diminish with the actual size of the woven image?
Was all this on the walls of these private American dwellings,
overlayed by the memory of the very cultures of those social strata
which consumed such images in the American past? Did, in fact,
these meanings matter? Were the tapestries looked at, studied and
admired? Were they hung in special vantage points, with care or
indifference? Were their meanings as images separable from their
functions as colourful decorations, motifs on a wall, parts of a
decorative whole? Were they bought or made? Invented or copied?
Were they valuable or worthless? Valued or neglected? Will we
discover the answers to these questions by staring very hard at the
material items, at these pieces of cloth to be hung on a wall? Will

we even recover the meanings of the images depicted on them by patiently analysing their internal features alone? Or must we seek to discover the processes by which these meanings are constituted within definite and specific social practices and rituals at given levels in the precise historical social formation? Here, we are able to see these 'minor works of art' in their actual settings, in the living context of their social uses. Were we to meet them in a museum – whether of 'fine art' or 'decorative art' – we would know only that / they had lost their function, however tenuous this might have been, and had left the social relations which once determined their cost and price, their material and 'spiritual' values, to enter a strange 'after-life' as art and art alone./Would art historians then have to talk about their forms and techniques and iconography, and find some place for them in the history and hierarchy of art as art? Stranger transformations have occurred. As Hans Hess has pointed out:

> If we look at a coin of Hadrian or Constantine, we look at it as a work of art, a finely modelled portrait head, a very useful document for art historians, a thing of rarity and beauty. If we look at a 50p piece, we do not think of it as a work of art because it is currency and still functions as money, but it is as much a work of art as the coin of Hadrian which was also used as money in its own day. If, however, our coin is taken out of circulation and goes to a numismatic collection in Japan, let us say, it loses its function and becomes an *objet d'art*.[18]

It is precisely this transformation that we must reverse if we are to understand that the metal die-cast of an academic bas-relief and the coloured cloth woven to form an image once had a use, a value, an objective social validity, in short had *currency*. We must also understand that, as Marx saw it, this 'currency' could only take force as a 'compulsory action of the State' and this, in turn, could 'take effect only within that inner sphere of circulation which is coterminous with the territories of the community'.[19]

Now I wish to carry this concept of 'currency' to another level. Let us imagine we have to remind ourselves again that we are not in the presence of tapestries and furnishings but only of two photographs, or rather, in this case, of photo-mechanical reproductions of two images. The theme of photography is subtly introduced within each of the pictures: in the one, by the album at

which the couple are looking but which we cannot see; and in the other, by the photographic portraits on the radiogram which echo the arrangement of the 'real' figures and introduce a historical, as well as a representational, displacement into the heart of the picture. If we had the actual photographs, however, we would have – and perhaps this is so obvious it needs stating – two pieces of special paper, tokens, images, exactly like the tapestries: items produced by a certain elaborate mode of production and distributed, circulated and consumed within a given set of social relations; pieces of paper that changed hands, found a use, a meaning and a value, in certain social rituals. We would have two pieces of paper bearing images constituted by a material process, according to real and definite choices constrained by the repertoire of choices available to their specific, individual or collective producers within the moment of their production: images made meaningful and understood within the very relations of their production and sited within a wider ideological complex which must, in turn, be related to the practical and social problems which sustained and shaped it. As Susan Sontag has stressed, photographs are objects of manipulation:

> They age, plagued by the usual ills of other objects made of paper. They are lost, or become valuable, are bought and sold; they are reproduced ... They are stuck in albums, tacked on walls, printed in newspapers, collected in books. Cops alphabetise them; museums exhibit them.[20]

They can be taken as evidence. They can incriminate. They can be aids to masturbation or trophies of conquest. They can be emblems of a symbolic exchange in kinship rituals or vicarious tokens of a world of potential possessions. Through that democratised form of imperialism known as *tourism*, they can exert a power to colonise new experiences and capture subjects across a range never envisaged in painting. They are on our tables at breakfast. They are in our wallets and stood on our desks and dressing tables. Photographs and photographic practice appear as essential ingredients in so many social rituals – from customs checks to wedding ceremonies, from the public committal of judicial evidence to the private receipt of sexual pleasure – that it has become difficult to imagine what such rituals were like and how they could be conducted before photographs became widely available. It is difficult precisely

because the internal stability of a society is preserved at one level through the naturalisation of beliefs and practices which are, on the contrary, historically produced and historically specific. It is in this light that we must see photographs and the <u>various practices of photography</u>.

I am not trying to avoid such questions as how, in these photographs, the simplicity of pictorial means, corresponding to the uncluttered nature of the subjects, carries into the construction of the photographs, on the one hand, the proud and puritan sparseness of poverty, and, on the other, the elegant bareness of 'good taste'; or how a slight asymmetry and a quiet play of light softens the image of the middle-class couple, and how the difference of eye-level between the two photographs changes our relation to the subjects and alters the meaning of the apparently identical images. To make an analysis at this level is exactly to observe what Foucault calls the 'capillary form' of the existence of power: 'at the point where power returns into the very grain of individuals, touches their bodies, and comes to insert itself into their gestures and attitudes, their discourses, apprenticeships and daily lives'.[21] We see it in the individual determinations of the photographs. We see it in the rooms which existed as iconic systems before the photographers began their transformations. When, elsewhere, I characterised these as 'internal' as opposed to 'external' relations, I was trying to locate an unresolved stage in the *method of art history* and to define the level at which an adequate analysis must operate.[22] I was not trying to open up a rift in the complex process of constitution of individual images. What I am trying to stress here is the absolute continuity of the photographs' ideological existence with their existence as material objects whose 'currency' and 'value' arise in certain distinct and historically specific social practices and are ultimately a function of the state.

Photography is a mode of production consuming raw materials, refining its instruments, reproducing the skills and submissiveness of its labour force, and pouring on to the market a prodigious quantity of commodities. By this mode of production it constitutes images or representations, consuming the world of sight as its raw material. These take their place among and within those more or less coherent systems of ideas and representations in which the thought of individuals and social groups is contained and through which is procured the reproduction of submissive labour power and

acquiescence to the system of relations within which production takes place. In this sense, while it is also used as a tool in the major educational, cultural and communications apparatuses, photography is itself an apparatus of ideological control under the central 'harmonising' authority of the ideology of the class which, openly or through alliance, holds state power and wields the state apparatus. As Louis Althusser has said, 'No class can hold state power over a long period without at the same time exercising its hegemony over and in the State Ideological Apparatuses.'[23] In the modern bourgeois state the ruling class cannot constitute the state as an apparatus of class repression alone; the necessity for any state to extend its power beyond the level of coercion is reduplicated under capitalism:

> once capitalism had [physically] put invested wealth in popular hands, in the form of raw materials and the means of production, it became absolutely essential to protect this wealth. Because industrial society requires that wealth could be directly in the hands not of those who own it, but those whose labour, by putting it to work, enables a profit to be drawn from it.[24]

The state must therefore be elaborated in the domain of what Gramsci has called 'civil society'. It must install 'a certain number of realities which present themselves to the immediate observer in the form of distinct and specialised institutions'[25] whose function, together with that of the predominantly coercive state apparatuses, is to secure the reproduction of the political conditions within which the means of production may themselves be reproduced. It is the more explicitly repressive state apparatuses – the government, the administration, the army, the courts, the police and the prisons – that both encompass and create the conditions for the effective working of the complex of ideological apparatuses which act as behind a 'shield', yet constitute a real strength. As Gramsci put it:

> In the West, there was a proper relation between State and civil society, and when the State trembled a sturdy structure of civil society was at once revealed. The State was only an outer ditch, behind which there stood a powerful system of fortresses and earthworks: more or less numerous from one state to the next.[26]

It is through the ideological apparatuses that the ideology of the ruling class must necessarily be realised and within them that the ideology of the ruled class must be measured and confronted. Thus the ideological apparatuses both express the general and delimited levels of class struggle in the society and demarcate the sites of such a struggle whose ultimate repercussions go far beyond them. None the less, ideologies do not merely *represent* class interests or forces properly located at the economic level. Such 'interests' or 'forces' are constituted at the level of representation (politics and ideology) by definite means of representation and have no prior existence. In consequence representations are not reducible to class identities pre-given at the economic level. Properly understood, the concept of *representation* entails a rejection both of reductionist readings and of the idea that class interests or forces exist fully formed but somehow unrealised pior to their representation.

This is not, however, to imply, as Paul Hirst seems to do in his otherwise cogent criticisms of Althusser's reflectionist theory of representation, either that what is represented, in the sense of the source-of-the-represented, has no existence, or that the relationship between this source-of-the-represented and the representation is entirely arbitrary.[27] The means of representation may exist distinct from the source-of-the-represented – they may have their 'relative autonomy' – but, if the complex process of constitution of the representation neither allows us to identify the content of the representation and the source-of-the-represented nor to compare the representation and this source, no more does it lead us to the view that the represented has 'no existence beyond the process which represents it'.[28] This is too reminiscent of the formalism of those painters and critics who, recognising that painting had a mode of existence distinct from that which it represented, deduced that painting was entirely autonomous and that the presence of 'external' references was an intrusion of alien and inessential elements. There is no simple correspondence between classes at the economic level and classes as social forces constituted on the political and ideological planes. But neither is the connection accidental and arbitrary. What relates them is a process of representation, properly understood, in which a representation of the one is produced at the other distinct and 'relatively autonomous' levels.

Perhaps I am straying too far. The point to which I want to

return and lend real emphasis is that when we deal with photography as ideology we are not dealing with something 'outside' reality: a looking-glass world related to the real world by laws of reflection and reversal. According to Althusser, 'An ideology always exists in an apparatus, and its practice, or practices. This existence is material.'[29] 'Therefore,' as Pierre Macherey has argued, 'to study the ideology of a society is not to analyse the system of ideas, thoughts and representations (the "history of ideas" approach). It is to study the material operation of ideological apparatuses – to which correspond a certain number of specific practices.'[30]

III

If you wished to find the two prints we have been discussing (Plates 32 and 33), you would discover them, filed and indexed, in the US Library of Congress. The story of how they came there is itself an encapsulated history of US government departments between 1935 and 1943. If this initial and important fact seems surprising, then remember that Matthew Brady's civil war negatives were stored in the vaults of the US Signal Corps; William Henry Jackson's plates of the Far West were kept in the Bureau of Reclamation; and great collections of photographs of the unbridled exploitation of the timber lands and of the condition of agriculture before the First World War languished in the files of the Forest Service and the Extension Service respectively. The representation of this material in 'coffee-table books' is a recent phenomenon. Both the photographers responsible for these images were employed by the Historical Section of the Farm Security Administration (FSA), a Federal government department of the USA set up in 1935 as part of the 'New Deal' administration to lend support to its programme by documenting the effects of the 'Depression' on the land and the agricultural labour force. The Historical Section was directed from a government office in Washington DC by Roy Stryker and served to supply pictures to New Dealers in various departments, to reports and exhibits, to newspapers and to the flourishing photographically illustrated magazines. But it was also open to individuals, as a story from Stryker shows. Some months after a picture by Walker Evans was issued ('Bethlehem,

Pennsylvania'; see Plate 34), a woman came into Stryker's office and asked for a copy:

> We gave it to her and when I asked her what she wanted it for, she said, 'I want to give it to my brother who's a steel executive. I want to write on it, "*Your* cemeteries, *your* streets, *your* buildings, *your* steel mills. But *our* souls, God damn you."'[31]

In some senses, the photographers Jack Delano and Russell Lee were only co-authors of the pictures, for Stryker, whose original conception it was to go beyond his narrow brief and begin to accumulate 'a pictorial encyclopedia of American agriculture',[32] issued regular and detailed shooting scripts to all his photographers. It was Stryker who was the first to see the contact sheets. It was he, too, who categorised, filed and selected the work the photographers sent in and who is said to have 'killed', by punching holes in the negatives, 100,000 of the 270,000 pictures taken at a cost of nearly one million dollars in the eight years of the Department's existence.

Plate 34. Walker Evans, *Bethlehem, Pennsylvania*, 1935. (Library of Congress, Prints and Photographs Division)

The total 'world view' of the FSA file was, therefore, predominantly Stryker's. Of these two photographers, Russell Lee, who made the picture of the FSA clients, had a particularly close relationship with Stryker. Stryker has said: 'When his photographs would come in, I always felt that Russell was saying, "Now here is a fellow who is having a hard time but with a little help he's going to be all right." And that's what gave me courage.'[33]

In a shooting script issued to all FSA photographers in 1936, we find Stryker suggesting as subjects: 'Relationship between density of population and income of such things as: pressed clothes; polished shoes and so on.' And more particularly: 'The wall decorations in homes as an index to the different income groups and their reactions.'[34] A year after the later picture was taken, under pressure from Departmental and Congressional criticism in the period following Pearl Harbour, Stryker was calling for 'Pictures of men, women and children who appear as if they really believed in the US. Get people with a little spirit. Too many in our file now paint the US as an old person's home and that just about everyone is too old to work and too malnourished to care much what happens.' He went on to ask for 'More contented-looking old couples – woman sewing, man reading.'[35] Clearly, we must have as our aim the analysis of the specific discourse of the scripts and the correspondences of this written discourse with that of the individual photographs and, more important still, the whole range of filed and captioned images. As Stryker has written, 'The total volume, and it's a staggering volume, has a richness and distinction that simply cannot be drawn from the individual pictures themselves.'[36] We shall want to relate this to Stryker's individual and idiosyncratic character whose ideological framework belonged to that 'lost America' of small rural towns, prior to the effects of urbanisation consequent on the massive expansion of industry in the postwar era and the accelerated industrialisation of agriculture. For Stryker, the picture files exactly represented life as he had known it and wished it to be.

Then, too, there is the question of direct Federal and Congressional interference in the Department which, by 1941, was beginning to succumb to the effects of financial and staffing cutbacks, bureaucratic interference, and the general Congressional assault on the Farm Security Administration. More than this, the specific economic and political processes which created the need for

the Historical Section, presented it with its subject-matter and the transmutations it underwent, and fed on its products, suffered significant and far-reaching changes in the period of the build-up to war and after. These changes ultimately determined a general transition in American social life: a transition which not only governed changes in the patterns of patronage and the function of intellectuals having a direct bearing on the practice of photography, but also involved, at the most general level, changes in the mode of social perception. As I have argued elsewhere, we are not concerned with political and economic events alone, but with

> one of those moments of transformation which render the roots of social experience socially visible or invisible. We are concerned with a set of circumstances in which the 'logics', by means of which social reality can be signified, collapse inwardly and are usurped by new logics of social perception which become established within public discourse and receive expression inside the hegemonic institutions. What we must explain is the formation and disintegration of socially structured 'ways of seeing' and the specific genres of image-making in which they are realised.[37]

IV

Earlier, I spoke of the 'binding quality' of photographs and said that, rather than look to the supposedly intrinsic nature of the photographic process, we must account for this by an analysis of the operation of certain privileged apparatuses within the given social formation. I also said that I wished to consider the question of *truth*, which concerns not only the truth function of photographs and what Sontag has called 'the usually shady commerce between art and truth',[38] but also the specific premium put on 'truth' in realist works. Here we can see that our analyses converge and coincide.

The French philosopher and historian Michel Foucault has argued that there is a constant articulation of power on knowledge and knowledge on power. The exercise of power itself creates and causes to emerge new objects of knowledge and accumulates new bodies of information: 'The exercise of power is perpetually creating

knowledge and, conversely, knowledge constantly induces effects of power.'[39] The truth of this knowledge, therefore, is neither outside power nor deprived of power. It is, rather, the product of a multiplicity of constraints, which, in turn, induce the regular effects of power. It is not a question of the struggle for 'truth' but, rather, of a struggle around the status of truth and the economic and political role it plays. What defines and creates 'truth' in any society is a system of more or less ordered procedures for the production, regulation, distribution and circulation of statements. Through these procedures 'truth' is bound in a circular relation to systems of power which produce and sustain it, and to the effects of power which it induces and which, in turn, redirect it. It is this *dialectical* relation which constitutes what Foucault calls 'a régime of truth':

> Each society has its régime of truth, its 'general politics' of truth: that is, the types of discourse it harbours and causes to function as true; the mechanisms and instances which enable one to distinguish true from false statements, the way in which each is sanctioned; the techniques and procedures which are valorised for obtaining truth; the status of those who are charged with saying what counts as true. In societies like ours the 'political economy' of truth is characterised by five historically important traits: 'truth' is centred on the form of scientific discourse and the institutions which produce it; it is subject to a constant economic and political incitation (the demand for truth, as much for economic production as for political power); it is the object, under diverse forms, of an immense diffusion and consumption (it circulates in apparatuses of education and information whose extent is relatively wide within the social body, notwithstanding certain strict limitations); it is produced and transmitted under the control, dominant if not exclusive, of a few great political and economic apparatuses (university, army, writing, media . . .); lastly, it is the stake of a whole political debate and social confrontation ('ideological' struggles).[40]

This brings Foucault to the view that the problem is one of changing not people's 'consciousness' but the political, economic and institutional régime of the production of truth – or, at least, of showing that it is possible to construct a new politics of truth. This does not mean emancipating truth from every system of power;

such an emancipation could never be attained because truth itself is already power. In politics what must be our aim is to detach the power of truth from the specific forms of hegemony in the economic, social and cultural domains within which it operates at the present time. For the historian, however, the problem is to *reinsert* the forms of knowledge under examination within the specific régime of truth and the regulating institutions of the social formation which produced them as 'true'. It would, of course, take much detailed and lengthy work to situate the photographs of the Farm Security Administration in this way, and this is something I cannot undertake here. However, the general importance of the concepts to their proper analysis must be evident.

The 'truth' of these individual photographs may be said to be a function of several intersecting discourses: that of government departments, that of journalism, more especially documentarism, and that of aesthetics, for example: each of them at a determinate stage of historical development; each of them incited and sustained by highly evolved social institutions. The photographs, as I have already pointed out, also participate in the wider 'truth' of the file itself, as a composite picture of rural America in the late 1930s and early 1940s, conceived apparently by one man, but called into being, administered and employed by specific government agencies. (These agencies, being subject to historical mutation, could equally withdraw their validation: towards the end of the life of the Historical Department there was strong pressure from the government to destroy the entire file, negatives included. It was not until the early 1960s that the photographs were re-evaluated and submitted to renewed circulation, this time through the museum and university apparatuses.)

However, if we are to understand how the organisation of photography under the FSA could function as an apparatus of control through the production of 'truth' and as a channel of power for the distribution of 'truth', we must be careful not to formulate the problem either as a crude 'conspiracy' or as a problem of state intervention, however, mediated, in a pre-existent, pre-defined domain of 'social problems'. It is not just a question of the exertions of power on the Historical Department through the various 'coercive' and hegemonic apparatuses of the state. It is also a question of the constitution within the state of the photographic record itself as a deep-seated apparatus of surveillance,

transformation and control. Nancy Wood reports that the photographers 'began to function as reporters, feeding back to Stryker graphic descriptions of why and where unrest and injustices were building up. And he, in turn, would see that the information worked its way into the right channels for government action.'[41] But this is only the most observable manifestation. Foucault warns us that 'The relations of power are perhaps among the best hidden things in the social body.'[42] We must go beyond the idea of 'regulation' and 'manipulation' to conceive of the very designation of 'social problems', taking place within specific apparatuses, as itself a *grasping* of the problems by the state by which points of contradiction in the social complex and areas of real or potential social conflict are articulated and commanded. This takes us back to the nature and function of representation.

What we must be aware of in our analysis of FSA photography is the constitution, at a moment of profound social crisis, of 'poverty and deprivation' – of what Herbert Hoover called 'Depression' – as both the target and the instrument of a new kind of discourse which became, though fleetingly, as production and mobilisation for war brought immense changes in the historical forces, a formidable tool of control and power. We must ask how it was in the power of this 'Depression' to produce the 'true' discourse of the FSA photographs. What was the political history of this 'truth'? How was it produced and circulated? We must also consider the wider question of Realism, emerging within the newly formed hegemony of nineteenth-century bourgeois democratic states in apparent opposition – as resistance – to the dominant and atavistic ideology. How should we account for this insistent concern with 'Reality' and the constant political and economic incitement of the search for it? Is 'Realism' to be feared by power, or is it, more subtly, a channel through which power drains into the social body? Does power operate only by repression? Foucault again has argued that 'the interdiction, the refusal, the prohibition, far from being essential forms of power, are only its limits, power in its frustrated or extreme forms. The relations of power are, above all, productive.'[43] What is the function, the *office*, of 'realistic' representations of 'misery' in the bourgeois state?

I shall remind you again that we are not concerned with exposing the manipulation of a pristine 'truth', or with unmasking some conspiracy, but rather with the analysis of the specific 'political

economy' within which the 'mode of production' of 'truth' is operative: that is, not with something motivated on the personal plane, necessarily, but with relations and forces which are pervasive and diffuse throughout the social structure. Such a reading is not, therefore, incompatible with Arthur Rothstein's assertion that 'the Farm Security file would never have been created if we hadn't the freedom to photograph anything, anywhere in the United States – anything that we came across that seemed interesting, and vital'.[44]

V

I have tried to bring into view one aspect of the problem of realism, and it is on the further reaches of this problem that I wish to focus in the final phase of my argument.

The status of truth in the photographs with which we began (Plates 32 and 33) is evidently related to the problem of their 'realism'. Just as I have have rejected the analysis of photography as a general category but have considered it as a specific apparatus in definite historically determined forms, and just as I have deployed Foucault's arguments for a political, economic and institutional analysis of the social production of 'truth', so it is with my approach to realism. It is a consequence of my line of argument that we must cease to use 'realism' as a universal and a-historical conception, or as a pre-given recipe for practice. The indispensable conditions for realism have to be located in the particular conjuncture, as T. J. Clark has done for the components or constitutive stages of Courbet's realism.[45] Clark shows that it is not only the 'content' that is located in the constitutive forces of the historical conjuncture, for this cannot make its way into artistic imagery directly. Nor is it enough to say that something intervenes, that a 'technique' is required to 'translate' the historical 'content' into the terms of the particular medium. What we have is a variety of levels – or indices of determination – which represent stages in a continuous process of constitution through which the means of production, in the fullest sense, are set to work within a specific apparatus and at a particular moment in the evolution of the social formation to produce the concrete work of art, and produce it as 'real'.

In Clark's account the means are patiently mustered. There are

the forms of popular iconography, the codes and sub-codes, which already articulate an historical reality but which are subject to a new appropriation reflecting the needs of an ascendant bourgeoisie in the towns to efface and repress their recent emergence from the countryside through the processes of capitalist accumulation. There are the techniques, forms and styles of the past which serve as models but are far from neutral mediators since they retain and connote the residues of older contents. There are the skills and motivations of a certain type of intellectual at a certain moment in the socio-economic development of town and countryside. There is the political arrival of a particular social class in the aftermath of the defeat of the 1848 revolution in Paris and the emergence of a rural, oppositional 'Red France'. Finally, there is the constitution, *by* and *for* the work, of a public, itself rent by the class conflicts inherent in the historical moment which find their codified expression in a determinate range of discourses and modes of behaviour.

Not only are these moments made available by the confluence of historical forces, but their meaning and effectivity – that is, whether or not the work will be constituted as 'realist' in the consciousness of its spectators – are determined or circumscribed by the same cross-flow of currents. The opportunity, the means, the effect, are all to be sought in the constitution of the unique and fragile historical moment. In the sense that we have to see the work as an assemblage of 'very disparate materials',[46] we have to make a radical break with the idea of the work as an organic, complete and ordered whole. The very notion of a definable boundary between 'internal' and 'external' relations is called into question. Yet we do discover a 'unity' that is precisely historical and ideological, for the multiplicity of codes which make up the work is focused in the very historical conjuncture within which it is delivered. A further consequence of this analysis of realism is that we must also question the idea that works 'endure' in any simple sense. The example of Courbet can no longer be regarded as a model to be imitated. Rather, it stands – as Marx and Engels saw the work of Balzac, and as Lenin saw the work of Tolstoy – as a lesson in the need to work through the complex and unique structural possibilities inherent in our own concrete historical situation. We must reject the idea of timeless models and, indeed, the question 'What is realism?' for its implications that 'realism' is a thing and, moreover,

one thing, rather than a practical mode of material transformation which is constituted at a particular historical moment and is subject to definite historical *transformations*.

It has to be said that this seems to go against the classical Marxist treatment of realism which seems to be, precisely, a formula. The term 'realism' does not appear in any text by Marx, and we cannot proceed very far on the basis that he once in a letter praised the scenery of a dull ballet as 'beautiful . . . everything being represented with photographical truth'.[47] But the problem of definition is taken up by Engels in letters written in 1885 and 1888 to two novelists: Minna Kautsky, author of many novels and stories published in social-democratic periodicals and mother of Karl Kautsky, and Margaret Harkness, a friend of Eleanor Marx and member of the Social Democratic Federation who wrote under the pseudonym John Law.

To Minna Kautsky, Engels stressed the necessity of 'a faithful portrayal of the real conditions' which 'dispels the dominant conventional illusions concerning them, shakes the optimism of the bourgeois world, and inevitably instils doubt as to the eternal validity of that which exists'.[48] This 'faithful portrayal' took definite precedence over the author's display of a 'tendency': that is, over the 'merely ideological', which Engels went so far as to equate with the 'unartistic'. 'The more the opinions of the author remain hidden,' he wrote to Margaret Harkness, 'the better for the work of art. The realism I allude to, may crop out even in spite of the author's opinions.'[49] Where Marx would certainly have agreed with Engels was in the view that the greatest exponent of this form of literature was Balzac:

> That Balzac was thus compelled to go against his own class sympathies and political prejudices, that he *saw* the necessity of the downfall of his favourite nobles, and described them as deserving no better fate; and that he *saw* the real men of the future where, for the time being, they were alone to be found – that I consider one of the greatest triumphs of Realism.[50]

For Engels, therefore, the elements of realism were located in the existing social formation and its constituent forces, rather than in the author's allegiances, whether progressive or reactionary. The author was not, however, a mere passive reflector of social conditions. In perhaps his most important single theoretical

formulation on the subject, Engels wrote: 'Realism, to my mind, implies, besides truth of detail, the truthful reproduction of typical characters under typical circumstances.'[51] This has at least two important consequences. First, it requires of the author an *active intervention* in creating a hierarchy of social phenomena founded on an understanding of the *dialectical totality* of history. Second, it entails that realism, as Brecht has also argued, is not to be derived from particular existing works of art but is, in Stefan Morawski's words, to be judged by 'the expression of a cognitive equivalent: specifically, the dominant and typical traits of socially conflicted life in a particular place and time. *Typicality* is thus a key consideration.'[52] This 'typicality' must be grounded in the specific, individual character of the historical moment. There can be no single transhistorical model.

It might also be said at this point that Engels's account demonstrates that Roman Jakobson's characterisation of realism as connected to a 'metonymic' bias in the use of a signifying system is not adequate.[53] While 'truth of detail' implies an inclination to synechdoche – a defining feature of the metonymic pole – this, Engels says, is not enough. This alone would constitute *naturalism*. The importance of the 'typical' in realism implies, on the one hand, a disposition to select the part which stands for the whole, but, on the other hand, an ability to identify similarity and to substitute, that is, a *metaphoric* tendency. Therefore, realism in Engels's terms must be defined not as a metonymic bias in opposition to the dominance of metaphor in Romanticism and Symbolism, but rather as a fusion and active equilibrium of metaphoric and metonymic poles.

The problem of 'typicality' in Realism and the precise level within the work at which it may be said to operate was taken up by Lenin in a series of articles on Tolstoy, published between 1908 and 1911. In 'Lev Tolstoy as the Mirror of the Russian Revolution', Lenin uses the phrase 'most sober realism'[54] to refer to *specific elements* in Tolstoy's work:

> Merciless criticism of capitalist exploitation, exposure of government outrages, the farcical courts and the state administration, and unmasking of the profound contradictions between the growth of wealth and achievements of civilisation and the growth of poverty, degradation and misery among the working masses.[55]

These *elements*, however, stand in contradiction to other elements:

> Tolstoy's point of view was that of the patriarchal, naive peasant, whose psychology Tolstoy introduced into his criticism and his doctrine. Tolstoy mirrored their sentiments so faithfully that he imported their naivete into his own doctrine, their alienation from political life, their mysticism – their desire to keep aloof from the world, 'non-resistance to evil', their impotent imprecations against capitalism and the 'power of money'.[56]

Tolstoy's resolution of these *opposed elements* into an aesthetic whole cannot be taken as a solution to their deep-lying contradictions, which remain the central conflict within his writings. As Pierre Macherey has said of literary works in general, Tolstoy's novels 'appear "healthy", almost perfect, so that all one can do is to accept them and admire them. But in fact their reality does not accord with their self-presentation.'[57] On the contrary, one must see them as 'something which doesn't work very well'.[58] Thus Lenin saw that 'The very thing that Tolstoy did not succeed in finding, or rather could not find, either in the philosophical foundations of his world outlook or in his social-political doctrine, is a synthesis.'[59] It was going beyond this point, however, that Lenin made his most innovatory contribution to the Marxist theory of realism. He argued it is specifically *this contradiction of elements* which 'mirrors' or 'expresses' the contradictory conditions of Russian life in Tolstoy's period:

> the contradiction in Tolstoy's views are indeed a mirror of those contradictory conditions in which the peasantry had to play their historical part in our revolution.[60]

> The contradictions in Tolstoy's views are not contradictions inherent in his personal views alone, but are a reflection of the extremely complex, contradictory conditions, social influences and historical traditions which determined the psychology of various classes and various sectors of Russian society in the *post*-Reform, but *pre*-revolutionary era.[61]

> Tolstoy is original, because the *sum total* of his views, *taken as a whole*, happens to express the specific features of our revolution as a peasant bourgeois revolution.[62]

Reflection takes place, therefore, at a *structural* level in which 'all the distinguishing features of Tolstoy's work'[63] correspond to the

transitional nature of the epoch. Reflection is a function precisely of what Lenin calls Tolstoy's 'deviations from integrality'.[64] It is this lack of *integrality* which reflects or embodies the contradictions inherent in the peasant-bourgeois revolution, and it can only be explained by reinserting the works within the historical and economic conditions in which these contradictions were real. The possibility of such an explanation in turn becomes real only through a process of change involving two kinds of displacement. In the first place, there is an historical shift. The year 1905 marked

> the end of an epoch that could give rise to Tolstoy's teachings and in which they were inevitable, not as something individual, not as a caprice or fad, but as the ideology of the conditions of life under which millions and millions actually found themselves for a certain period of time.[65]

In the second place, it is a change of class perspective which reveals the lack of 'integrality' in the ideological object:

> That is why a correct appraisal of Tolstoy can be made only from the viewpoint of the class which has proved, by its political role and its struggle during the first dénouement of these contradictions, at a time of revolution, that it is destined to be the leader in the struggle for the people's liberty and for the emancipation of the masses from exploitation.[66]

That is to say, more specifically, the correct appraisal can be made 'only from the viewpoint of the Social-Democratic proletariat'.[67]

Tolstoy's novels endure, not as models to be imitated, but because they 'embodied in amazingly bold relief the specific historical features of the entire first Russian revolution, its strength and its weakness.'[68] Yet, for all this:

> The Russian people will secure their emancipation only when they realize that it is not from Tolstoy they must learn to win a better life but from the class the significance of which Tolstoy did not understand, and which alone is capable of destroying the old world which Tolstoy hated. That class is the proletariat.[69]

Here, then, is a classical Marxist view of realism that is expressly *conjunctural* and can have nothing to do with ideas of 'photographical truth' or 'universal and enduring human values'. From the point of view of analysis, it sends us back to the dense and disparate

materials of history. From the point of view of production, it directs us to the complex and contradictory conditions of class conflict within society and to the representational levels at which this conflict is ideologically present. If the account leaves untheorised what T. J. Clark has called the 'concrete transactions . . . hidden behind the mechanical image of reflection'[70] – if it is unable to specify the representational processes of conversion and relation which are themselves 'historically formed and historically altered'[71] – then neither does it lay down prescriptions for form, style or 'human content'.

This must offer little comfort to those who would revive what they take to be the documentary realism of Abbott, Evans and the rest. Although mass unemployment and deep-rooted economic crisis are with us again, few of the requisite determinations are present in our own conjuncture. The variously inflected documentary realism of the FSA photo-file was born of a complex of events and conditions which ranged from the technical and aesthetic to the economic, political and social. Photography, at this time, was emerging fast as a major tool of mass communications. Flash units and small-format cameras were becoming more generally available. Rotogravure was dying and the first big picture magazines which would take its place were already being roughed out for a public unused to such lavish use of photographic imagery. New forms and techniques were being evolved to keep pace with the possibilities of the new equipment and outlets and to create new needs. A whole new territory of themes and contents was added to the range of legitimated subjects. The 'documentary' was constituted as a distinct genre and category. 'In a year or so,' Stryker remarks, 'and with a suddenness matched only by the introduction of television twelve years later, picture-taking became a national industry.'[72] All this took place in a 'Depression' which characterised not only an economic condition but also a national mood. Yet, set against this, was the genuine exhilaration of the 'New Deal' Administration in Washington, engendering what Stryker described as 'a feeling that things were being mended, that great wrongs were being corrected, that there were no problems so big they wouldn't yield to the application of good sense and hard work'.[73]

Whether 'wrongs' were corrected may be open to doubt, but, at this lowest point, a new economic upsurge was being prepared which would again transform the structure of American society.

Already, the subjects of the documentary record were the source of reverie and nostalgia. As Stryker said of a picture of a small town railroad by Walker Evans ('Edwards, Mississippi'; see Plate 35):

> The empty station platform, the station thermometer, the idle baggage carts, the quiet stores, the people talking together, and beyond them, the weather beaten houses where they lived, all this reminded me of the town where I had grown up. I would look at pictures like that and long for a time when the world was safer more peaceful. I'd think back to the days before radio and television when all there was to do was to go down to the tracks and watch the flyer go through.[74]

We cannot be innocent of the values which inhere in the 'realism' of these phtographs. We cannot afford to neglect an analysis of the apparatuses at work in the bringing to light of all this 'documentary' material and in its recirculation. We may follow Stryker's gaze: up the dirt path between the tracks, past the carts and talking men,

Plate 35. Walker Evans, *Edwards, Mississippi*, 1936. (Library of Congress, Prints and Photographs Division)

past the stores whose names we cannot see and the silent houses of timber and stone. We may live the space of the picture, its 'reality', its ideological field. But as the picture draws us in, we are drawn into its orbit, into the gravitational field of its 'realism'. There it holds us by the force of 'the Past' as successfully as it once exerted the force of 'the Present'. If the majority of photographs raise barriers to their close inspection, making protracted analysis seem 'excessive', then these photographs invite a closer and closer view. The further one penetrates, the more one is rewarded by the minutiae of detail suspended in the seemingly transparent emulsion. We seem to experience a loss of our own reality; a flow of light from the picture to us and from ourselves into the picture. Like Stryker, we are invited to dream in the ideological space of the photograph. It is now that we should remember that 'dreams really have a meaning and are far from being the expression of a fragmentary activity of the brain, as the authorities have claimed. When the work of interpretation has been completed, we perceive that a dream is a fulfilment of a wish.'[75]

Chapter 7

Contacts/Worksheets:
Notes on Photography,
History and Representation

Reading for pleasure

Working in the library, I find a reproduction of a little-known photograph by Lewis Hine, taken around 1936 for the National Research Project of the Works Progress Administration. It shows two young people in what we may take to be their sitting room: he, on one side, in a wooden-armed upright; she, to his left, in a padded armchair with bulging, curving lines and elaborate wooden feet; they sit opposite each other. The man does a crossword. The woman reads. Something that may be a paper knife is held in her right hand. Both are smiling, half flattered, half afraid. He wears a short-sleeved shirt and holds his pen with confidence but, nervously perhaps, his other hand fingers his collar and the base of his neck.

To his right is a small side table and on its top lies what could be an ashtray with a special device for holding matches. On the stand beneath is another object but it is not possible to make it out. Next to the table, moving left, is a metal standard lamp, strangely wrought, on a square-legged base and supporting a large fringed shade whose decoration shows a stylised hunting scene: the hound is on the right, the stag in the centre and, to its left, in the direction it is running, is a clump of grass. Each motif occupies one face of the hexagonal shade. On its other sides, if the pattern continues, it is not visible to us, though it would be to the man in the chair were he to look up.

Plate 36. Lewis Hine, *Young Couple*, 1936. (WPA National Research Project, National Archives, Washington, DC)

Diagonally in front of him, but parallel to the picture plane, is a square pouffe on cabriole legs, and between him and the woman, though to the rear of the room and set across a corner so as to obstruct a dark painted door with a round white handle, someone has set a wardrobe or cupboard on which stands a small table lamp fitted, like the standard lamp, with an hexagonal shade. The wardrobe or cupboard avoids being parallel to the camera plane so that, although it marks a caesura, not quite the furthest plane in depth, it mediates between the plane of the pouffe and the diagonally receding wall in which the dark painted door would open and which meets the other visible wall at ninety degrees in a corner the wardrobe obscures. The image must be overexposed at this point or else it has lost too much in definition in the process of being reproduced, but we may guess that the plane of intersection of the two visible walls would be in line on the picture plane with the vertical axis of the cupboard or wardrobe, at the junction of its two closed doors.

The floor covering may be rush matting, but it is difficult to tell from the suggested texture of the image and the regular squares

whose closely abutting edges recede parallel to the walls of the room. Rush matting or not, the people seem comfortably off: he wears a watch and a signet ring; her hand relaxes without difficulty on the arm of her chair and her eyes are not reading the magazine in her lap. Yet the room cannot be serving the use for which it was planned. Perhaps it is a room in a house divided into flats. Perhaps the photographer moved them here, arranging the furniture in a plain, deflected symmetry.

We are invited to speculate: is this their first home? (He finds himself dreaming into the picture – sliding into the picture beneath this assemblage of objects and meanings – a look, his self, a reconstituted world.) They are young, nice folks; clean, hair neatly brushed; making a start. The connotations hang without seeming to find an object: have these things been brought here or is this a home? These things – the personal jewellery, the furnishings, the room or 'home', their ankles which seem to be touching (she supposedly needing reassurance, he the sense of command), his bare arms unmarked by labour, her stockingless legs, their unglancing awareness of each other, scarcely absorbed in their carefully divided but inconsequential domestic pursuits (he doesn't read for learning, she doesn't sew or knit) – these things are so many moments, retrievable only with difficulty, instated here as Hine's young couple: the generation of the New Deal, healthy, leisured, free from the factory, ignorant of child labour, assembling the signifiers of family and home, stabilising society in its fundamental unit, content, hopeful, shut in by the cupboard up against the door. Perhaps, however, it is a wardrobe. Though that would be unlikely in a sitting room. Something is not right. Some flaw in the ensemble. 1936: seven years after the Wall Street Crash and a year before the 'Roosevelt Depression'. The style of the furniture undatable; perhaps second-hand. The image unplaceable; perhaps Hine's 'late period'. Unexpected. Unreliable.

How many tracks converge on this point and seem at once to have petered out at their nodal point? Does Hine's personal disappointment cut across his reformist script and its public, political enactment: a sudden movement of light over these few objects and this closed stage? The flash that lit this image and set the shadow of the standard lamp on the pale, receptive surface of the wall beyond, revealed too much and the pleasure of the ideology is spoilt.

Notes for a panel discussion at Nottingham

In his essay 'Understanding a Photograph', written in 1968, John Berger has argued that 'photographs are records of things seen', an 'automatic record'. 'Photography', he has added, 'has no language of its own.' 'There is no transforming in photography.' The only decision is the choice of moment to record and isolate.

Clearly the pursuit of such views has put Berger on a collision course with a growing number of other writers on photography. It has been said, for example by Umberto Eco, that if photography is to be likened to perception, this is not because the former is a 'natural' process but because the latter is also *coded.*

The photographer turns his or her camera on a world of objects already constructed as a world of uses, values and meanings, though in the perceptual process these may not appear as such but only as qualities discerned in a 'natural' recognition of 'what is there'. By more or less conscious adjustment of an infinite field of significant determinations ranging from the arrangement and lighting of this 'world of objects' to the mechanics and field of view of the camera and the sensitivity of the film, paper and chemicals, the photographer abstracts from the distribution of reflected light from the objects to procure a pattern of light and dark on paper which can in no way be regarded as a replication of the 'given' subject. This pattern on paper is, in turn, the object of a perception – or reading – in which it is constituted as a meaningful image according to learned schemas.

The meaning of the photographic image is built up by an interaction of such schemas or codes, which vary greatly in their degree of schematisation. The image is therefore to be seen as a composite of signs, more to be compared with a complex sentence than a single word. Its meanings are multiple, concrete and, most important, *constructed.* In common, too, with other language-like systems, photographs may be exhaustively analysed as projections of a limited number of rhetorical forms in which a society's values and beliefs are naturalised and which may not be dispelled simply by analysis since, following Freud's discussion of desire and censure, we may see rhetorical forms as mock transgressions of notional, simple, underlying propositions which may be rejected but which still provide, through their very rejection, a source of unpunished satisfaction.

It is the underestimation of the degree to which the photographic image itself already needs to be read as a rhetorical construction which gives rise to the idea that the meaning of the photograph is too imprecise in itself and needs to be anchored by a caption, if it is not to drift in ambiguity. The same underestimation gives rise to the rigid separation of verbal and visual which semiotics, by revealing the complex interpenetration of visual and verbal codes, has shown to be spurious: the purely visual image is nothing but an Edenic fiction.

If there cannot be found any ontological or semiological basis for the privileging of photography as a means of representation which renders a direct transcription of the real, how are we to account for the real force which photography exerts in modern social life? In the first place, the production and attribution of photographic meanings is not an arbitrary or voluntaristic process. Encoding and decoding in photographs is the product of work by concrete historical individuals who are themselves reciprocally constituted as the subjects of ideology in the unfolding historical process. Moreover, this work takes place within specific social and institutional contexts. Photographs are not ideas. They are material items produced by a certain elaborate mode of production and distributed, circulated and consumed within a given set of social relations; images made meaningful and understood within the very relations of their production and sited within a wider ideological complex which must, in turn, be related to the practical and social problems which sustain and shape it.

What I am trying to stress here is the absolute continuity of the photograph's ideological existence – its coalescence and codification of value-filled meanings – with its existence as a material object whose 'currency' and 'value' arise in certain distinct and historically specific social practices. When we deal with photography as ideology, we are not dealing with something 'outside' reality – a looking-glass world related to the real world by laws of reflection and reversal. As Louis Althusser has argued, 'an ideology always exists in an apparatus, and its practice or practices. This existence is material.' Therefore, as Pierre Macherey has shown, to study the ideology of a society is not to analyse the system of ideas, thought and representations (the 'history of ideas' approach) or to produce a new metaphysics of the image. It is to study the material operation of ideological apparatuses, to which correspond a certain number of specific practices.

We are now in a position to displace the question about photography's privileged status as a guaranteed witness of the actuality of the objects or events it represents from the level of internal relations – the alleged intrinsic nature of the photographic process – to the level of the operation of certain privileged apparatuses within the given social formation, such as, in our case, scientific establishments, government departments, the police and the law courts. This power to bestow authority and privilege on photographic representations is not given to other apparatuses within the same social formation – such as amateur photography or 'art photography' – and it is only partially held by photojournalism. Ask yourself, under what conditions would a photograph of the Loch Ness Monster or a UFO become acceptable as proof of their existence. Not if they were 'frontal and clear', to use Barthes' term, that is, if they deployed the allegedly 'natural' rhetoric of documentary images.

Here we pass into the area of the constant articulation of power on knowledge and knowledge on power which the French philosopher and historian Michel Foucault has explored. Foucault argues that each society establishes what he calls its 'régime of truth': 'its "general politics" of truth: that is, the types of discourse it harbours and causes to function as true; the mechanisms and instances which enable one to distinguish true from false statements . . . the techniques and procedures which are valorized for obtaining truth; the status of those who are charged with saying what counts as true.'

It is within this 'regime of truth' that we must situate the photograph if we are to understand not how photographic truth may be emancipated from every system of power, but how we may construct a *new politics of truth* by detaching its power from the specific forms of hegemony in the economic, social and cultural domains within which it operates at the present time. This, I think, is very different from the development of a 'world historical consciousness' which John Berger has called for.

Part of a proposal for study

The work will involve a reconsideration of how representations are articulated, circulated and consumed within certain specified social apparatuses; how they have an effect; and what it means to say

that, in this circulation, the ideological level is constituted. This, in turn, entails a critique of the conception of ideology as 'false consciousness' but also of the notion of ideology as a mode of vision (thought, value) whose boundaries do not constitute part of (appear within) the field of sight. What these theories share is a conception of ideology as an internally consistent, if not coherent, system which may be 'unmasked' by the revelation of the ideology's non-correspondence with a pre-given reality, or by confronting it with some other ideology, reflecting an opposed class outlook.

This work, by contrast, will attempt to construct a theory of ideology which will accommodate the non-conflictual coexistence and interpenetration of divergent ideological elements and representations, and which will give an account of ideology as something 'seen through' yet whose enforcement stabilises contradictions between the existing social order and the conflicting projection of desires by a double effect in which it simultaneously installs the idea of a prior, 'normal' level which constitutes 'truth', while allowing a release of phantasy in a pretended transgression of this 'truth' which because it is only pretence, yields unpunished – because unrealised – gratification. From this point of view, ideology will be seen as a mode of accommodation between the regime of truth and the domain of prohibited desires, whose effectivity lies in the manner in which it can bring both into play: on the one hand, naturalising the regime of truth and, on the other, ameliorating the disruptive effects of desire, the sources of whose prohibition is, in the process, completely erased. It is this form of collusion of power and the unconscious which remains entirely unmoved by 'rational' analysis.

Addendum on Hine's photograph and Russell Lee's picture of FSA clients in Hidalgo County, Texas

Where would one begin one's analysis of the constitution of 'family' and 'home' in these photographs? Before the photographic phase? With the marking out of the landscape by the designation, through the complex codes and relations of power of urban planning, of a regular hierarchy of 'residential' areas? With the division of these areas by the further elaboration of related codes and the constitution of an orderly sequence of plots or 'private sites' along the avenues

of a continuous and unobserved surveillance? With the subdivision of these sites and the articulation, in architecture, of a set of domestic functions, together with their relations: the 'sitting' room, 'lounge' or 'living' room marked out in separation from the functions of cooking, eating, washing, sleeping, excreting, as clearly as the house itself marks out the domain of 'family life' from that of work? This is the 'living room', the centre-piece of the 'family home', the supposed arena of its life, a space of leisure, recreation and interpersonal relationships, uncluttered by social functions and work on the one hand, or bodily functions on the other. (The woman, wife-and-mother, for whom the 'home' is arena of being and place of work is, of course, the exception in this. How often in such photographs she sits sewing or knitting or engaged in some other 'homely' labour.) With the elaboration, extension and refinement of these architecturally defined functions in the subcodes of decor and furnishing: two chairs which face each other, the radiogram between them, the lamp arranged for reading or sewing, the identically framed photographs restating the symmetry and duality of the entire arrangement; this appalling topography of the 'family'; this production and marriage of an hierarchy of needs and gratifications within a single setting?

Only now, on this *mise en scène*, does the photographer begin to act, deploying a whole set of skills and techniques, the entire power of an artistic method and the apparatus or apparatuses within which it is inscribed, to inflect, reveal, conceal, draw out or curtail the densely overlaid discourses of the 'family home' which become 'what was there', a second 'nature', the 'truth' of the photograph.)

13.vii

What Tim Clark argues is that the question of a Realist representation concerns not only the confluence of crucial and necessary conditions and codes of the Realist work, but also the outlawing, the refusal of signification, of certain 'realities' in the dominant and dominated discourses of the same historical moment. Therefore, the possibility of a conjuncturally Realist discourse is dependent not only on the assemblage of the disparate elements of a new code at the point of historical conflict, but also a double entry into the regime of discourse: an assault on the ruling codes

and a replenishing of those dissident or disengaged codes which survive or coexist within the dominant and dominated formation.

The goal of Clark's argument is a Realism that is constructed as a specific artistic or representational reality, not that spurious after-the-event realism which is embedded in the ruling discursive formation and which in no way merits the name 'socialist'. The moment he scrutinises is that of the historical failure of this enterprise in painting and of the emergence of a modernism, critical on the level of the sign alone, within the very work that seems to reinstate the Realist challenge: Manet's 'Olympia'.

(But Foucault might challenge that the realism of a representation is not just a matter of codes or of their insertion in and traversal of a ruling formation of discourses. No more has it solely to do with the function of the definite apparatuses or institutions within which it is inscribed, but it is incited by a whole technology through which power is accrued, transmitted and exercised in the social body. What is poignant about the assertion of 'Realism' in nineteenth-century painting is that it occurs at the very moment when painting was losing its role within the technology of power which determined the regime of truth in Western European countries and in the USA. It was 'technologically' superseded by the camera in more than the literal sense. Though it played some part in the early elaboration of this new technology of power, it was already stretched and already assuming a different function, leaving the field for photography to dominate, for a time, the image production of 'panoptic' societies as the first medium of surveillance.)

Lewis Hine at the Side Gallery, Newcastle

(i) Consider Hine as a photographer who, in his earlier work, completely avoids 'humanism' in his representations of people. He is neither humanist nor anti-humanist; neither empathetic nor alienated. Is this why Stryker ultimately rejected him as a photographer for the FSA, because there is no 'positive' element; because he doesn't show people with a potential to recover? (How could they, from causes beyond their effective reach as unorganised immigrants, homeworkers, children?)

Hine does not show a 'lost' rural America with its simple, homely ways – the America of Stryker's childhood which he sought

to recall – even though he had in common with Stryker a utopian, social democratic idea of a perfectable capitalism: reformed, free from injustice and social inequalities. For Stryker, this reform was to be achieved by the release or restoration of capabilities vested in all people.For Hine, before the Roosevelt era of state intervention, it seemed that these capabilities would only be found among the skilled workers. The others – children, women, immigrants from peasant economies – seemed entirely dependent upon enlightened reformers who might 'rescue' them. In themselves, these groups were represented as entirely helpless.

(How different is Marx's view of poverty and exploitation, being neither sentimental and humanist, like Stryker's, nor paternalistic and reformist, like Hine's. From the point of view of Marx's analysis, Hine and Stryker want to retain the categories which express bourgeois relations, without the antagonism which constitutes them and is inseparable from them. They have failed to comprehend that 'An oppressed class is the vital condition for every society founded on the antagonism of classes. The emancipation of the oppressed class thus implies necessarily the creation of a new society.' Like Proudhon, they are beset by the 'illusion of seeing in poverty nothing but poverty, instead of seeing in it the revolutionary subversive side which will overthrow the old society.')

(How should one see Hine's photographs of the construction of the Empire State Building in this light? Are they an exception?)

(ii) In the catalogue essay, Valerie Lloyd argues that Hine transformed accepted notions of what constituted a 'picture', drawing on the mode of the 'traditional commercial photographer', to produce images of an unprecedented systematic power and a new kind of aesthetic consciousness. What Lloyd misses is the *class content* of the frontal, symmetrically posed picture.

It would be entirely wrong to regard it as an unsophisticated genre or device without rhetoric. It draws, in fact, on a tradition going back, at least, to the painter Le Brun's treatise on expressions. One of its constituent elements is a social history of posture and the 'language of gestures'. Hogarth employed it in the contract scene of 'Marriage à la Mode', in which the gout-infected, bankrupt Earl disports himself in elegant, mannered, asymmetrical pose, in contrast to the mean-minded, aspiring middle-class merchant with

whom he has to barter, who sits square on, his feet and limbs
parallel, in a squat and cramped posture. This is the choreography
of the great English social contract.

Daumier was well versed in the same depictive codes and used
them in his telling contrast of 'natural' and 'civilised' man; though,
in his two caricatures, the confident possessor of 'culture', who
arranges himself decorously against a table and stool, clearly
belongs to the higher bourgeoisie, while the glowering, Neanderthal

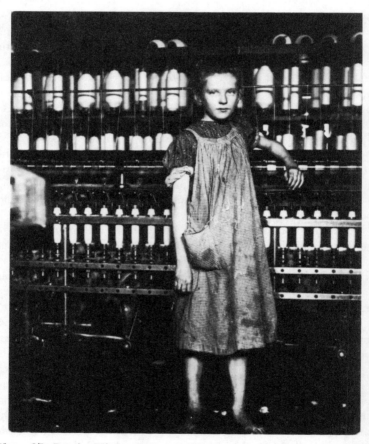

**Plate 37. Lewis Hine, *Cotton Mill Worker*, 1912. (International
Museum of Photography at George Eastman House, Rochester, New
York)**

figure in the frontal pose emanates from the lowest stratum of the petty bourgeoisie from the edge of the town, where it meets the country. These modes of behaviour, these clichés of portrayal of types, and the demand for unaffected depiction – 'warts and all' – are vehicles of meaning which cluster together at the disputed boundary between two class territories. But Daumier had more than this in mind. The target of his satire is also the booming photographic trade. It is not only the two class stereotypes who are present. We are also shown the picture maker: the photographer. What we see is not only a comedy of class manners, but also the way representatives of different classes are imagined to present themselves to the camera. The significant differences which Daumier observed and drew still inform the photo-snapshot.

We must, of course, go on to ask why this frontal, symmetrical presentation of the subject to the camera is coupled with the desire for an unmediated and unadorned record. Here we are concerned not only with the class co-ordinates of the search for realism but also with a certain view of the ontology of the photograph. This is the point at which we may return to Hine, who said that if he could have told the story in words, he would not have needed to lug a camera around. He saw the camera as a means to 'vivify' empirical, scientific facts; to flesh them out, to prove them. The camera, for Hine, was fundamentally a source of truth. The photograph was an unmediated reflection of the world 'outside', a true record of the subject stood before it. Technique was therefore an 'intervention' which only falsified. However modified by secondary effects of light, balance, composition and contrast, the photographic image asserted itself as a primary fact: proof of the existence of a subject; an unshakeable witness bound to its subject by physical laws of chemistry and optics. The invention of the half-tone block further enabled the transference of these qualities directly on to the pages of magazines and newspapers, without the intervention of the interpreting engraver.

Daumier had clearly seen beyond this 'naive' view, yet, within its limits, Hine elevated and refined a photographic language which was to be deployed across a spectrum of self-conscious photography ranging from the 'fine art' of Evans and Strand, through the work of what was later called a documentary genre, to the imagery of corporate advertising. We might still ask, however, whether Hine's achievement is any greater than that of Charles Van Schaick and

countless other unremembered high street photographers. Doubtless, there are important departures in Hine's approach. Like Sander, in those of his images which portray the working class, he exchanged the fictive painted backdrop for the background of the actual setting, although a problem with Hine's work is that it remains, precisely, a background, against which the figure is set. What may be looked on as a primarily aesthetic departure was, for Hine, simply a consequence of the fact that, following the tracks of Jacob Riis, he had to get out to find his subject, to record it on location often under the suspicion of the owners of the site. Any other strategy would have detracted from the evidential value of his photographs which was his primary concern and governed the way in which he used his images.

But this is not enough to explain why Hine should have sought to rehabilitate dissident or underprivileged signifying conventions. Hine's was an assumed naivety. He had to shed the pictorialism he learnt with his early photography in order to command a new rhetoric in keeping with the obdurate, intransigent nature of the problems he wished to picture. Contrary to the current misconception, Hine was a photographer first and had to learn his sociology later – the reverse of the case with the social reformer Jacob Riis, whose photographs of the conditions of work and life in New York's tenements were published in his book *How The Other Half Lives* in 1890. Hine was undoubtedly a campaigner, but we must be sceptical about the idea that his overriding concern with his theme simply presented him with a ready-made form.

Perhaps this also begins to explain the development of Hine's postwar photography, in which he wished to present those positive features of the 'toiling classes': strength, skill, physique and courage; 'positive features' characteristically marked as male. To realise his conception, Hine brought into play an elaborate pictorial code of heroism, familiar from nineteenth-century academic classicism and genre painting. Not that his images are crude and ineffective. The writer of the catalogue notes dismisses them too easily. Hine's skill at manipulating art historical models should not be underestimated. His prewar photograph of a Chicago man, bed-ridden through tuberculosis, is as solid in its sharply illuminated forms, yet as ambiguous as a De La Tour. Where the loss of effectivity of his later work lies is not in his resort to an old, though still current rhetoric – this is the basis, too, of all his 'documentary' work – but in his

return to a humanistic and sentimental view of skilled working people which, for reasons not always progressive, had had no place in the representational conventions through which he constructed his picture of child workers, immigrants and homeworkers.

A fragment

My historical researches seem always to be fragmentary and incomplete; not just like a series of sketches of a landscape, but like a series of sitings, authenticated reports, rumours, glimpses, prolonged observations, and second-hand accounts which are evaluated and re-evaluated, categorised and re-categorised, brought to some kind of order in which the contradictions are suppressed, then broken up and reformed into unexpected configurations. All through this process, the concepts and theories with which the records and accounts are to be articulated are themselves refined, adjusted or replaced.

But for all the provisional nature of the work, certain categories and concepts remain as those which reveal more in the material on which they are brought to bear, which allow more questions to be asked, which expose more passages of half light and suggest more far-reaching spaces beyond; in short, which exert a greater power to produce representations dense with meanings disclosed and undisclosed. The concepts and theories which emerge and re-emerge are those of the tradition of Marxist thought and the representations of history which are tentatively and partially formed in this manner are, I believe, fragments of an historical materialist view.

17 vii

If we say that the mechanisms of control in a society, in which the respective capacities for action of social classes are established and measured, arise from specific struggles in specific arenas which have their own particular given conditions for action, how are we to account for and analyse the presence of certain regularities in a number of social institutions which, if they do not constitute an

organic system, at least constitute a cluster of apparatuses somehow related, somehow functioning towards the same or a convergent end?

The terms in which this question is raised do not entail the positing of an Hegelian essence working itself out in the forms of an organic social structure. But they do problematise the relations of coexisting apparatuses or institutions: How does action in one affect the others? Does action in one infect the others? In what way may they be said to constitute collectively a *technology of power*? And if the apparatuses interlock, interact or interfunction in some way, does this not raise difficulties for a political practice which confines itself to establishing and intervening in the specific conditions of struggle in specific arenas?

If the institutions or apparatuses which constitute the technology of power in a particular society form a cluster, not an organic system, then an intervention in one apparatus, or around the conditions of possibility of struggle within it, does not threaten to collapse the whole structure nor necessarily entail any effects in the other apparatuses or mechanisms which make up that structure. This is not to say, however, that such an intervention *may* not affect the others, which may be non-continuously directed towards some common or convergent, emerging or incoherently defined end, without sharing a common ruling and prior-existent 'purpose' in the Hegelian sense, even where a consciously arrived at 'plan' may exist.

The hegemony of socialism will have to emerge in general conditions comparable to those which governed the emergence of the capitalist class's capacity to exert control, in a diverse and fluctuating topography of arenas of conflict and struggle. The capitalist class had to construct its 'interests' in an incoherent and episodic fashion in which its success was not guaranteed from one domain to another, where the conditions of action applying might be very different. The 'homology' of the apparatuses elaborated by the emergent class and in which that class emerged, was not one of 'essence' and 'form'; nor was the historical fact, moment or order of their elaboration strictly determined.

What is opened up is the *possibility* of the emergence, construction, restructuring or re-orientation of the various apparatuses. What is given are the conditions or preconditions. But what cannot be given is the guarantee of realisation: the accomplishment of the

emergence, construction, restructuring or re-orientation of each apparatus.

Each apparatus or its terrain becomes the object of a specific struggle whose possibilities and limitations are set by the conditions particularly to the apparatus or terrain in question or by the particular form certain general conditions take in relation to this apparatus or terrain. Nor are such struggles merely the unfolding or realisation of 'interests' preformed and present before the struggles themselves, as a 'formless content' waiting to be poured into the particular apparatus as into a vessel. Rather, these interests are themselves constituted only in the process of struggle.

(What this solution seems to leave hanging is the original question. Yet to say that the conditions of possibility of struggle in a given arena are particular to it does not exclude the possibility of their having much in common with those governing other arenas. It says nothing about the existence or non-existence of common or dissimilar features. Such a topography cannot be given in theory. Theory can only describe the spectrum of possibilities. To establish what is the case, one must 'look and see', that is, trace the topography of concrete institutions in the geography of the specific conjuncture.)

(But this again leaves in suspension the question of whether there are any necessary common features. Are there any highly general preconditions governing the possibilities of struggle in all arenas? Or is history discontinuous on the plane of synchrony?)

10 vii

All the time, it seems that I am trying to stem the flow of phantasy. Not because I wish to suppress it but the reverse: because I do not want to dissipate it by resorting to it too directly. I do not want to lose that proximity of phantasy which puts pressure on conscious thought, causing it to be suddenly diverted, making it run desperate risks for avoidance. It is almost as if the telling of the dream would sap its strength and dispel the strange force it exerts over the day. It is there to be savoured but not explained. (Yet the dream conceals a wish.)

I look at an image and it is flooded with a half-forgotten dream, bulking out its figures with the forms of desire, opening up its vistas

to a physically sensed space and presence. Now it can emerge, exciting my interest, inciting my curiosity for this very different object.

29 vi

'A dreary exhibition of students' photographs.' We leave and hail a cab. In the one we choose, the driver has two photographs fixed to his dashboard, in front of the windscreen and vertically below his rear-view mirror. One shows a young girl; the other a naked baby, perhaps another girl, in its bath. They are not for show but are positioned so that *he can see them at all times.*

Why does he need them whilst he drives? What reflections of the past do they provide? What fragments of his life fall in their frames? What does he see *in* them? Or *through* them?

. . . the screen, the mirror, the photograph.

6 vii

He studied the images of the naked woman very carefully. He thought he knew the girl. Crouching over the light box, it was hard to tell. What was her body like? What kind of nipples did she have? What sort of breasts and thighs? How strangely light and bold the tuft of pubic hair. He has a predatory curiosity which directs his look but what he is offered remain pictures of a girl he thinks he knows. They do not gain entry to the genre of the erotic, least of all its sub-form, the pornographic. As in Bellocq's portraits of New Orleans prostitutes, which remain pictures of working women posed out of context like Hine's workers set alongside their machines or the tools of their trade, so, in these pictures, the ensemble is not completely articulated, not unfolded. The realisation (the photographer's? the viewer's?) falls short of *suture*: desire does not fuse the discrepant elements of the image, even for a moment, in the orgasmic pleasure of illusory wholeness. There is no response on the level of the body, so easily deceived yet so constantly awake to stimulation. The masculine gaze (to which the body has been reduced) is denied satisfaction.

Perhaps, even in the most fully realised erotic image, suture cannot be sustained since the contradiction of the flat actuality of the paper and the fullness of the body of desire is too great. There must be a mechanism to re-immerse the distanced subject. Either the image must cleave to the sadistic first-person captions characteristic of hard pornography or else it must give itself over to the excitation of delay; it must, as in the Japanese print, intertwine the disavowal of the printed image in the courtesanship of style, the formal etiquette of sexual foreplay: the invitation in art that is never consummated.

And yet, the solution to this problem in art – accepting entirely (but why?) the look which is sexed as male – has been to turn away from the insistence of bodies, to embrace and penetrate space, to give oneself up to the illusion of recession, the flawless conduit of suture, to find oneself again in the unfolding of the image, opening on an endless vista of wholeness and harmony, passing like an insatiable longing beyond the capabilities of the eye to infinity. And, as our passage is uninterrupted, flowing into the picture, so is the illusion we enter without disharmony or contradiction. For the moment, we accept everything and do not wish to see beyond it; we cannot see beyond it; it is the limits of our vision and the co-ordinates of our space.

(What happens in the 'Rape of Europa', which Titian painted for Philip II of Spain, is that the amplitude of the woman's body is set against an infinite, atmospheric space – mediated at their junction by the varying degrees of realisation of the bull's obliquely thrusting body – a space that is also entirely abstract, resolved into a colour circle whose centre is the white of Europa's body; a mythological space possessed only of extension, emanating from specific locations, revolving around specific actions of bodies. In this way, Titian binds the unfolding of the mythological events to the unfolding of space and of bodies, moving from an unbounded background, through increasing degrees of emergence, to the fullest bodying forth of the woman: the object of myth and *rape*; the culmination of 'our' phantasies; the physical climax for the male owner/viewer.)

But this is a moment far removed from those – in Italy in the Quattrocento, in Holland in the seventeenth century, in France in the mid-nineteenth century – in which, most typically in landscape painting, release was sought from all bodily bounds through the

infinite recession of central vanishing point perspective: the path or road which leads from the lower edge of the frame to a point on the depicted horizon. This is also the mode of representation deployed so often in 'road pictures' in American photography from the 1930s on, though here too, as in Dutch landscape painting or the paintings of the Barbizon and Impressionist schools, the schema is capable of variation:

. . . As we look at Evans's post office, here at Sprott, Alabama, we find ourselves at a crossroads. Beyond the symmetrical front of the wooden frame building, with its tin plaques and single petrol pump, the dusty road stretches, curving slightly and cut by the unflinching shadows of solitary trees. Some way down the track, it bends again. We cannot see as yet which way it will turn but, before we go on, we may pause to look again at the spare-lined post office. We may pause and feel the temptation to move round – round the simple gabled frontage and the pitched-roofed block behind. The invitation is there, to pass round its plain solidity laid bare for our inspection in the flat, bright light.

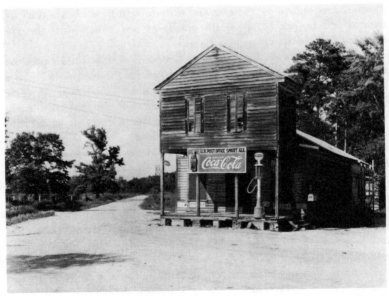

Plate 38. Walker Evans, *Post Office at Sprott, Alabama*, 1936. (Library of Congress, Prints and Photographs Division)

It is this pause, this moment of choosing, that we are offered: on the one hand, the post office with its satisfying symmetry and unadorned forms; on the other, the road beyond, running away from us and turning out of sight. For a moment, we pause – here at the crossroads – an unmeasurable moment of longing. As we do so our longing is displaced: to the place, to the time, to the vision of the man whose gaze is, we believe, constructed in the camera viewfinder. Still we cannot choose, and the longer we wait the more the picture seems to see us, drawing us into its space, holding us there, filling us with a doubtful contentment, offering us over to the dangerous 'inexhaustibility of art'.

In our dream, which passes for the timelessness of art, the site, the picture, the artist seem beyond doubt. They appear so 'real' and in their 'reality' we find the consolation of a confirmation of ourselves. If there is pleasure in ideology, then there is also the nostalgia of self-enjoyment.

Bodies and space

Imagine a history of photography as an insistent practice, inserted into the very heart of the modern social order and characterised by a double momentum: an ever more intimate and exacting attention to bodies, dividing them, apportioning them, observing them, supervising them and, in the same movement, exerting a control over them; and a diverse constitution of space as itself a realm of phantasy and control, submission and consent, a space of the Imaginary and the Ideological. On one side, time and motion studies, criminal records, sociological dossiers, humanist documentaries, medical photography, ethnographic records, reportage, sports pictures, pornography, identikit faces, all kinds of portraiture, and photographs in official documents, papers and files. On the other, the landscape tradition, aerial surveys, astronomical photography, micro-photography, topographical records, certain kinds of advertising images, and so on. Two kinds of longing. Two kinds of subjection. (The gaze has both passion and perspective.)

(no date)

For Barthes, the writer uses words the way a tourist handles money: not entirely blind to its value but with a pleasurable unfamiliarity, for its strangeness, its foreign-ness; for the pleasure of its passing through the hands; with a *delay* in value. But not at all like the miser, that is without any trace of fetishism.

In everyday life, this pleasure is squeezed out by the drive of desire, the ceaseless to and fro of exchange. But as a tourist, one has no regularised place in the social structure, though one's presence is now entirely necessary to the economy: a place at the 'base' but none at all in the co-extensive structures?

Folies Bergère

What Berger and Sontag have in common, stylistically, is that their prose moves by a series of sudden, dramatic and epigrammatic assertions. These pithy statements, which are neither supported historically nor developed theoretically, spurt the argument forwards, carrying the reader with them by the force of their flat conviction. This gives their style an illusion of a 'profundity' modestly born within a readily intelligible prose.

The first step in breaking with the pretentious role of critical overseer and commentator must be to undertake real historical research. The conceptual and descriptive demands this makes of themselves render the assertive style redundant. (And here?) More than this, they erode the entire ground on which a certain critical stance has set itself and, with that, goes a view of history and a view of the process of social change.

What Berger appeals to is a 'future' which serves both as a hope, a profession of faith, and a standard by which present actions may be judged. What historical research produces is no such grand plan but a constantly changing ground of tactical actions whose strategy may be stated only in terms so generalised as to be of little analytical use, though they may have a function in political rhetoric. What such historical analysis offers practitioners is not the heroic chance to measure themselves against the future, but a multiplicity of points of intervention, limited objectives, courses of action open now, ends that can be achieved through struggle: an

unremitting 'war of position' in which the smallest gain may hold significance for a chain of related struggles. The sexist macro-image of the 'Big Push' is abandoned for a spectrum of specific interventions in a microphysics of power.

Such a prospectus for action may lack the emotional appeal and attraction of the Utopian projection. It may not offer the guarantees of historicism. But it does have the incomparable advantage that it begins in the present, in the topography of existing apparatuses and institutions, in a concrete analysis of the uneven terrain in which the struggles must be waged. Its 'revolution' is not to be put off till the millennium. Its forces are not to be gathered for the 'moment of becoming'. Its 'revolution' is a potential now and everywhere.

18.ix.78

I began my work on the emergence of the USA from the Second World War into global, neo-imperial power, as a result of a series of compulsory steps back. The project came out of a need to understand the origins of the American painting and sculpture which still dominated the remodelled art education I began to receive in British art schools in the late 1960s. It was pursued through a study of the emergence of a coherent east-coast American school of modernist painting which provided the platform for the unerring push into the heartland of European art, for which Britain itself was a staging base. This, in turn, opened out on to the whole question of the massive insertion of US mass culture into European life and the effective re-culturation of Western Europe which was bound up with the effects of Marshall Plan 'aid' and the spread both of US military bases and US-controlled multinational corporations. The re-examination of the economic growth, political fluctuations and cultural transformation this entailed was itself a retracing of uncertain recollections and distorted images from the years of my own childhood and primary education through the 1950s. What kept the project alive was this direct connection with my own formative life, together with the need constantly to gauge and regauge the relationship of representations of this period to an always changing, elusive and incoherent historical present.

But the problem which began to be formulated in my mind as *the*

problem to be solved was how to describe, to follow, to plot and explain the emergence of American cultural hegemony, the process of transformation of American power and American life, this period of passage in American history which saw the disappearance of the goals and beliefs of the 1930s and their mutation into the hysterically militarised and hysterically privatised society of the 1950s. Here began a phantasy track which led back, beyond the New York of the Eight Street Club and the Cedar Tavern, the Greyhound bus queues of recently demobilised young men, Kerouac and Cassady's disorganised pads, smoke-filled jazz clubs, Harlem brothels, Greenwich Village and the slow drift uptown. Further and further beyond the bounds of my memory and childhood on Tyneside; deeper and deeper into what I did not know, but all the time staying here, in the years of my own life; moving away from an account of myself to an encounter with the life of another, but finding with a shock that Kerouac was born in the same year as my father.

26.x

There is something morbid about looking at pictures, something frigid, and something furtive. We shuffle from one image to the next like the buyers of old books. Once I imagined a collective looking, argued out aloud. But the exhibiting institutions allow no space for such a practice. Now, like the other johns, I move from one picture to another, alone. Sometimes I make a transaction, out in the open, here in this public space. But to the moment of intimacy, the image is entirely indifferent and I am alone once more. (My friends tell me it is because intellectuals have lost contact with the Movement. 'The Movement' – as if to conjure up the strict but forgiving Mother was a solution.)

There is a scene, familiar from a certain type of sentimental movie and from television advertisements for cigarettes, proprietary pills or diamond rings: it is on the road and she (never he) is coming towards me (always a he). Suddenly, she begins to run. Now, she is coming towards me, running, her arms outstretched. (We must repress the memory of that child, running on a road in Vietnam, arms outstretched, napalm burning her skin.) I feel myself move. This is the final dénouement. I feel myself moving

towards her and we are both running. The hoped for moment when I shall truly enter the picture, or whatever the picture promises, and be immersed within it – when I shall find myself in its space, embraced by it – closes upon me as if some memory of an ideal Mother stirred. But it never comes. The running never stops. The moment never arrives. Always the promise, never that moment of joining: real wholeness; distance gone.

In the overblown image is something of what it is to look at pictures; something of why they leave one listless, inadequate and incomplete yet, strangely, with an appetite for them uncloyed. This is why they find one so ready to be deceived. This is the source of their ideological effectivity which the world of real actions and effects could never enjoy. It is precisely what is lacking in them that prolongs their influence; precisely their disavowal of the desires which they incite and which remain unchecked and unreproached, ready to be excited again.

(There is something unhealthy about looking at pictures and the kind of dependence they produce. Yet our way of looking is neither universal nor eternal. Rather, it is installed in the particular modes and apparatuses of exhibition in our culture. It has not always been the same.)

Two pictures of women in 'men's' clothing

A photograph by Dorothea Lange from around 1937 shows a migrant labourer pausing from work in a field and leaning on a hoe. The format is vertical and the figure fills the frame with a softened roundness and solidity reminiscent of Millet. Behind this standing figure, the furrows of a ploughed field recede to a low horizon and the light sheet of the sky, which throws forward the darkened upper forms of the labourer's body. The dress is familiar from other photographs: battered, stitched and patched-up dungarees, an outsize denim jacket, boots and a cap. But looking closely, we see that the figure is a woman, or possibly a woman. It is not that the body is de-sexed. The more we look, the more clues we gather: breasts perhaps rounding the cotton plaid shirt; the stance; the face – worn and creased like a man's, or like a woman's.

What we have in this image is a theme to which Lange was to return. Here it is social conditions of poverty and unemployment

which have degraded bodies to a uniform appearance; though, in
the work of other contemporary photographers, the different sexual
significations of dress remain evident. There is, however, another
image by Lange from another moment, showing two wartime
workers having just left a supermarket, stopping for the camera,
still wearing their workplace dungarees and helmets, their I-D
buttons pinned to their clothing, each clutching a well-packed
paper grocery bag. One is a woman. The other is a man. The usual
cues are removed – removed by a situation as dramatic in its effect
as the Depression. In this case, what we see is the result of a
wartime shortage of labour which necessitated the absorption of
women into better-paid, skilled industrial jobs which had never
before been open to them. In poverty and wartime, Depression and

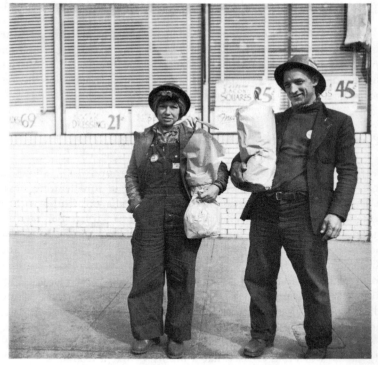

**Plate 39. Dorothea Lange, *Workers, Richmond, California*, 1942.
(Oakland Museum)**

Boom, the sexual division of labour and its significations in dress, in places, broke down and Lange saw it.

Yet she was not immediately concerned to make a general point. She was interested, as always in the warmth of these people: women, in relative affluence or depression, somehow freed from stereotyping, wearing 'men's' clothing from necessity but also from a seeming desire to lay hold on a production of meanings, doing 'men's' work and temporarily, rupturing that restrictive social categorisation.

In the case of the wartime worker, she is pictured alongside a man. He is taller than she and further to the fore of the picture space but he leans back on his heels with an elegant swagger, as if to reduce his size and to allow her to advance. Despite the ample evidence of the hostility of the unions and male workers to the employment of women in heavy industry, there is something in their expressions which suggests a pleasure in their sameness, a mutual enrichment and enjoyment of this moment of ambiguity; a rediscovery of sexuality, not a loss of it.

Lange: Oklahoma, June 1938

The picture renews itself in dreams. This is its dream life, that it erects so many barriers to the shock of waking. We turn but we are pushed back into its imagery. A wash of memories and expectations always hanging on the present: this couple will always be walking on the road, the children always running. The tension with which I fill them, drawn from the waking world in which I dream, gives their actions a real and vivid poignancy, for behind them is the knowledge I must refuse: that this picture of people walking is only a still.

10.x

So much 'marxist' art history has been caught in the circular trap of trying to explain the image production of a society by reference to a 'mental outlook' or 'world view' which is itself only present in the *representational activity* of that society. These 'world views' are

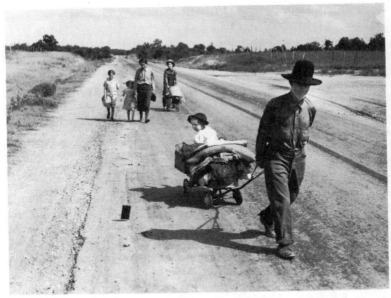

Plate 40. Dorothea Lange, *Family Bound for Krebs, Oklahoma, from Idabel, Oklahoma*, 1939. (Library of Congress, Prints and Photographs Division)

then allotted to social 'classes', defined in the most general terms; the only progression over the view that history is the enactment of racial or national mentalities being that natural cultures are seen as divided and heterogeneous – the sites of contention between rival 'world views' in which one is dominant.

Just as the development of cultures cannot be explained as the conflict of 'mainline' traditions or tendencies (aristocratic v. bourgeois; agrarian v. mercantile; peasant v. urban) but must be seen as the product of conflict and interaction within a hierarchy of heterodox and overlaid (sub)cultures, each with its characteristic institutions, each catering for a more or less defined and distinct 'public'; so, the complex topography of these 'publics' cannot be *reduced* to a simple 'class' map. Nor can the kinds of image production sustained and consumed by these 'publics' be explained away by reference to 'outlooks', 'mentalities' or 'world views' somehow present at another level.

We must forget these imaginary entities, these thought-bubbles floating above the heads of the supposed 'real actors' of history. We must not allow ourselves the expedient of imagining something existing 'before' representation by which we may conveniently explain the representation away. Where we must start is with concrete material activity and what it produces. We must begin to analyse the real representational practices that go on in a society and the concrete institutions and apparatuses within which they take place. We must plot the network of material, political and ideological constraints which bear on these institutions and constitute their conditions of existence and operation. We must describe the function of 'specific' individuals within them and their production of 'operatives' to staff them. We must establish the material, social and symbolic contexts in which they are sited, in which they operate and in which they intervene.

Only in this way will we come to understand how ideologies are produced in real representational practices, in material apparatuses; how these representations are disseminated, consumed, elaborated, modified and sustained; how they are meaningful; how they affect and are affected by other productive activities within the same social complex. And all this is to be done by studying actual material entities and processes, entirely without the need for pre-given mental or spiritual phenomena. This, then, would be the beginnings of a materialist account.

Notes and References

Introduction

1. Roland Barthes, *Camera Lucida*, Jonathan Cape, London, 1981, pp. 76, 87.
2. *Ibid.*, p. 70.
3. *Ibid.*, pp. 88–9.
4. Alphonse Bertillon, *La photographie judiciare*, Gauthier-Villars, Paris, 1890. See also Allan Sekula, 'The Body and the Archive: Criminal Identification and Criminal Typology in the Late Nineteenth Century', paper delivered to the annual meeting of the College Art Association of America, February 1986, forthcoming in *October*.
5. Michel Foucault, *Discipline and Punish. Birth of the Prison*, Allen Lane, London, 1977; and *Power/Knowledge*, Colin Gordon (ed.), Harvester Press, Brighton, 1980.
6. 'Photographs of Criminals. Summary of the Return from the County and Borough Prisons', *Parliamentary Papers*, 1873, (289), LIV, p. 788.
7. Gareth Stedman Jones, *Languages of Class. Studies in English Working Class History 1832–1982*, Cambridge University Press, Cambridge, 1983, p. 16.
8. See William Stott, *Documentary Expression and Thirties America*, Oxford University Press, Oxford and New York, 1973, p. 9.
9. John Collier Jr, *Visual Anthropology: Photography as a Research Method*, Holt, Reinhart and Winston, New York, 1967.
10. This analysis comes close, in certain respects, to that of Stuart Hall's 'The Social Eye of Picture Post', *Working Papers in Cultural Studies*, Birmingham Centre for Cultural Studies, No. 2, Spring 1972, pp. 71–120. In this essay, however, while developing a comparable conjunctural analysis of the currency and limits of documentary rhetoric and practice, Stuart Hall argues that conditions of mass mobilisation for war in Britain constituted a moment of social and symbolic 'transparency' in which the documentary mode of the 1930s (then being displaced in the USA) was revivified and crystallised into a national popular expression – an innovatory 'way of seeing' or 'social eye':

Picture Post was one of the means – the medium – by which this *social* transparency was transformed into a *visual* and *symbolic* transparency: for a moment, the conditions were created which enabled a historical experience directly to inform a style. (p. 89)

It is the notions of a prior determining 'social experience' and of the 'transparency' of representation – replicating, as they do, the rhetoric of documentary itself – that I have been at pains to avoid here.

11. Writing on 'Robert Frank' in T. Maloney (ed.), *US Camera 1958*, US Camera Publishing Corporation, New York, 1957, Walker Evans declared:

He shows high irony towards a nation that generally speaking has it not; adult detachment towards the more-or-less juvenile section of the population that comes into his view. This bracing, almost stinging manner is seldom seen in a sustained collection of photographs. It is a far cry from all the woolly, successful 'photo-sentiments' about human familyhood, from the mindless pictorial salestalk around fashionable, guilty and therefore bogus heartfeeling. (p. 90)

Compare this with the editor Tom Maloney's comment:

Robert Frank's vision of America certainly isn't everyone's picture of the country we live in. This is hardly the inspirational school of photography. It is also not a new school, but a throwback to the documentary that was so important to photography in the thirties. (p. 89)

12. Christopher Lasch, 'The Cultural Cold War', in *The Agony of the American Left: One Hundred Years of Radicalism*, Penguin, Harmondsworth, 1973, p. 81.

13. John Szarkowski, *Walker Evans*, Museum of Modern Art, New York, 1971. See also John Szarkowski, A. C. Quintavalle, and M. Mussini, *New Photography USA*, Università di Parma and the Museum of Modern Art, New York, 1971; and *The Presence of Walker Evans: Diane Arbus, William Christenberry, Robert Frank, Lee Friedlander, Helen Levitt, Aston Purvis, John Szarkowski, Jerry Thompson*, The Institute of Contemporary Art, Boston, 1978.

14. For a discussion of 'post-market institutions', see Raymond Williams, *Culture*, Fontana, Glasgow, 1981, pp. 54–6.

15. The term 'proletariat of creation' comes from Bernard Edelman, *The Ownership of the Image. Elements of a Marxist Theory of Law*, E. Kingdom (trans.), Routledge & Kegan Paul, London, 1979, p. 45; see below, Chapter 4.

16. See T. J. Clark, *The Absolute Bourgeois: Artists and Politics in France 1848–1851*, Thames and Hudson, London, 1973; and *Image of the People: Gustave Courbet and the 1848 Revolution*, Thames & Hudson, London, 1973.

17. *Ibid.*; see also T. J. Clark, *The Painting of Modern Life: Paris in the Art of Manet and His Followers*, Alfred Knopf, New York, 1985.

18. Cf. Perry Anderson, 'Components of the National Culture', *New Left Review*, No. 50, 1968. For the emphasis on art historical methodology, see T. J. Clark, 'The Conditions of Artistic Creation', *Times Literary Supplement*, 24 May 1974, pp. 562–3; and also my essay, 'Marxism and Art History', *Marxism Today*, Vol. 21, No. 6, June 1977, pp. 183–92.

19. For a discussion of this, see my essays: 'Art History and Difference', *Block*, No. 10, 1985, pp. 45–7; reprinted in A. L. Rees and F. Borzello (eds), *The New Art History*, Camden Press, London, 1986, pp. 164–71; and 'Should Art Historians Know Their Place?', *New Formations*, No. 1, 1986.

20. Louis Althusser, 'Ideology and Ideological State Apparatuses (Notes Towards an Investigation)', in *Lenin and Philosophy and Other Essays*, B. Brewster (trans.), New Left Books, London, 1971, pp. 121–73. For a penetrating critique on which this analysis draws heavily, see Paul Q. Hirst, 'On Ideology' and 'Althusser and the Theory of Ideology', in *On Law and Ideology*, Macmillan, London, 1979, pp. 1–21, 40–74.

21. For Althusser's criticisms of the concept of an expressive totality, see especially his essay, 'Contradiction and Overdetermination', in *For Marx*, B. Brewster (trans.), Penguin, Harmondsworth, 1969, pp. 87–128.

22. Laura Mulvey, 'Visual Pleasure and Narrative Cinema', *Screen*, Vol. 16, No. 3, Autumn 1975, pp. 6–18. Elizabeth Cowie, 'Woman As Sign', *m/f*, No. 1, 1978, pp. 49–63.

23. Stedman-Jones, *Languages of Class*, p. 18.

24. See Foucault, *Discipline and Punish*, pp. 26, 213–14; and 'Prison Talk', 'Truth and Power', and 'Powers and Strategies', in *Power/Knowledge*, pp. 37–54, 109–45.

25. Cf. Victor Burgin, 'The End of Art Theory', in *The End of Art Theory. Criticism and Postmodernity*, Macmillan, London, 1986, pp. 140–204.

1 A Democracy of the Image: Photographic Portraiture and Commodity Production

1. It is a salutary fact that, excepting Alois Riegl's famous study, *Das Holländische Gruppenporträt*, of which still only a fragment has been translated, there is nowhere in the art historical literature any adequate theorisation of the nature and function of the portrait. The provisional account of photographic portraiture I develop here tries to follow certain interlacing and inseparable histories: a history of portraits as commodities and possessions produced by a rapidly developing technology within definite forms and relations of production; and a history of portraits as a history of signs mobilising representational codes whose meanings are embedded within historical fields of discourse. I am not suggesting that there could be a single, unified history of portraiture, for other histories converge upon and veer away

from these. A different sense of technology, for example, might be gleaned from the writings of Foucault; one which, as I suggest in conclusion, would direct us to the forms of power and knowledge generated within new institutions of social transformation and control emerging during the nineteenth century, contemporaneous with the development of photographic production.

2. G. Freund, *Photography and Society*, Gordon Fraser, London, 1980, pp. 10–11.

3. Broadside published by Daguerre in 1838, Collection of George Eastman House; quoted in B. Newhall, *The History of Photography*, Museum of Modern Art, New York, 1964, p. 17.

4. *Leipziger Stadtanzeiger*, quoted in W. Benjamin, 'A Small History of Photography', in *One-Way Street and Other Writings*, New Left Books, London, 1979, p. 241.

5. See R. Rudisill, *Mirror Image, The Influence of the Daguerreotype on American Society*, University of New Mexico, 1972.

6. Abraham Bogardus, *Anthony's Photographic Bulletin*, February, 1884, p. 65; quoted in Newhall, *The History of Photography*, p. 50.

7. Nadar, for example, charged one hundred francs for a 10 × 8 inch print, compared with Disdéri's price of twenty francs a dozen for *cartes-de-visite*.

8. W. Benjamin, 'The Work of Art in the Age of Mechanical Reproduction', in *Illuminations*, Fontana, Glasgow, 1973, p. 228.

9. See Chapter 3 below.

2 Evidence, Truth and Order: Photographic Records and the Growth of the State

1. The argument in this chapter is both an introduction to and a highly compressed version of that made at greater length in the chapters which follow. For a closely related study of photography and the labour process, see Alan Sekula, 'Photography Between Labour and Capital', in B. H. D. Buchloh and R. Wilkie (eds), *Mining Photographs and Other Pictures 1948–1968*, Nova Scotia College of Art and Design, Halifax/Cape Breton, Nova Scotia, 1983.

3 A Means of Surveillance: The Photograph as Evidence in Law

1. This chapter is based on a lecture given, as part of a series on photography, at the Institute of Contemporary Arts, London, in February 1979.

2. M. Foucault, 'Power and Sex: An Interview with Michel Foucault', *Telos*, No. 32, Summer, 1977, p. 157.

3. F. Nietzsche, *The Will To Power*, (trans.) W. Kaufmann, Random, New York, 1967, para. 717, p. 382.

4. A. Gramsci, 'State and Civil Society', in Q. Hoare and G. Nowell-Smith (eds), *Selections from the Prison Notebooks*, Lawrence & Wishart, London, 1971, p. 210ff.

5. L. Althusser, 'Ideology and Ideological State Apparatuses (Notes Towards an Investigation)', in *Lenin and Philosophy and Other Essays*, B. Brewster (trans.), New Left Books, London, 1971, p. 139.

6. *Ibid.*, p. 156.

7. Foucault, *op. cit.*, p. 158. For Foucault's relation to Althusser, see R. Bellour, 'Deuxième Entretien avec Michel Foucault', in *Le Livre des Autres*, Union générale d'éditions, Paris, 1971, pp. 191–2. For the concept of the 'technology of power', see M. Foucault, *Discipline and Punish. The Birth of the Prison*, A. Sheridan (trans.), Allen Lane, London, 1977, pp. 23–4, 131, 215.

8. Foucault, *Discipline and Punish*, pp. 26, 213–14; and 'Prison Talk: An Interview with Michel Foucault', *Radical Philosophy*, No. 16, Spring, 1977, p. 10.

9. Foucault, *Discipline and Punish*, pp. 200–1.

10. J. P. Smith, quoted in E. P. Thompson, *The Making of the English Working Class*, Penguin, Harmondsworth, 1968, p. 89.

11. *Ibid.*, p. 89. See also C. Wegg-Prosser, *The Police and the Law*, London, 1973; and D. Philips, *Crime and Authority in Victorian England. The Black Country 1835–1860*, Croom Helm, London, 1977, chapter 3, 'The Old and New Police'.

12. H. W. Diamond, 'On the Application of Photography to the Physiognomic and Mental Phenomena of Insanity', S. L. Gilman (ed.) *The Face of Madness. Hugh W. Diamond and the Origin of Psychiatric Photography*, Brunner-Mazel, Secaucus, New Jersey 1976, pp. 17–24. The paper was summarised in the *Saturday Review*, No. 2, 24 May 1856, p. 81; and this summary was reprinted in *The Photographic Journal*, No. 3, 21 July 1856, pp. 88–9.

13. Diamond, *op. cit.*, p. 21.

14. *Ibid.*, p. 20.

15. *Lancet*, 22 January 1859, p. 89, quoted in S. L. Gilman, 'Hugh W. Diamond and Psychiatric Photography', in S. L. Gilman (ed.), *The Face of Madness*, p. 5.

16. Diamond, *op. cit.*, p. 24.

17. *Ibid.*, p. 19.

18. *Ibid.*, pp. 20–1.

19. *Ibid.*, p. 23–4.

20. *The Photographic Journal*, No. 3, 1857, p. 289, quoted in S. L. Gilman, *op. cit.*, p. 9.

21. H. W. Berend, 'Uber die Benützung der Lichtbilder für Heilwissenschaftliche Zwerke', *Wein.med.Wischr*, No. 5, 1855, p. 291.

22. W. Keiller, *New York Medical Journal*, No. 59, 1894, p. 788. See also R. Ollerenshaw, 'Medical Illustration in the Past', in E. F. Linssen (ed.) *Medical Photography in Practice*, London, 1971.

23. Quoted in V. Lloyd and G. Wagner, *The Camera and Dr Barnardo*, Hertford, 1974, p. 14.

24. *Ibid.*, p. 14.
25. *Ibid.*, p. 12.
26. On the Panopticon, see Foucault, *Discipline and Punish*, pp. 200–9; and Foucault, 'The Eye of Power', *Semiotexte*, Vol. 3, No. 2, 1978, pp. 6–19.
27. Foucault, 'Power and Sex', p. 157. See also *Discipline and Punish*, p. 194; and Foucault, *La Volonté de Savoir*, Paris, 1976, pp. 18–21, 121ff.
28. Foucault, *Discipline and Punish*, pp. 23, 131, 215.
29. *Ibid.*, p. 185.
30. *Ibid.*, pp. 191–2.
31. John Thomson, Fellow of the Royal Geographical Society, travelled extensively in the Far East, publishing four volumes of *Illustrations of China and its People* (1873–4). With Adolphe Smith he co-authored *Street Life in London*, which appeared in monthly instalments from February 1877.

Thomas Annan photographed in and around Glasgow between 1867 and 1877 for the Glasgow City Improvement Trust, publishing *The Old Closes and Streets of Glasgow* in 1868 – the first commissioned work of its kind.

Arthur Munby recorded details of his encounters with working women from the 1850s on and championed women's right to work at and wear what they wished. He bought and commissioned an extensive collection of photographs of labouring women.

Jacob Riis's work as a police reporter in New York led him to take up photography in 1887 to further his personal crusade against slums such as Mulberry Bend. Half-tone reproductions of his photographs illustrated his book, *How the Other Half Lives* (1890).

Willoughby Wallace Hooper served with the 4th Regiment of the Madras Light Cavalry from 1858 to 1896 and photographed the victims of the Madras famine of 1876–7.
32. Foucault, *Discipline and Punish*, p. 191.
33. Foucault, *La Volonté de Savoir*, p. 123.
34. See J. Tagg, 'A Socialist Perspective on Photographic Practice', in P. Hill, A. Kelly and J. Tagg, *Three Perspectives on Photography*, Arts Council, London, 1979, pp. 70–1.
35. M. Foucault, 'The Political Function of the Intellectual', *Radical Philosophy*, No. 17, Summer, 1977, pp. 13–14. See also *Discipline and Punish*, pp. 27–8.
36. H. Pountney, *Police Photography*, London, 1971, p. 3.
37. *Ibid.*, pp. 3–4.
38. *Ibid.*, p. 4.
39. *Ibid.*, p. 5.
40. S. G. Ehrlich, *Photographic Evidence. The Preparation and Use of Photography in Civil and Criminal Cases*, London, 1967, p. 10.
41. *Ibid.*, pp. 26–7.
42. See the analysis of the structuration of the 'classic' realist text in R. Barthes, *S/Z*, Jonathan Cape, London, 1975; and Chapter 4 of R. Coward and J. Ellis, *Language and Materialism, Developments in Semiology and the Theory of the Subject*, Routledge, London, 1977, pp. 45–60.

43. F. Nietzsche, *The Gay Science*, W. Kaufmann (trans.), Random, New York, 1974, para. 110, pp. 169–71.
44. See Coward and Ellis, p. 47.
45. T. J. Clark, 'Un realisme du corps: *Olympia* et ses critiques en 1865', *Histoire et Critique des arts*, No. 4/5, Mai 1978, pp. 148–9.
46. F. Nietzsche, 'On Truth and Falsehood in an Extra-Moral Sense', quoted in J. P. Stern, *Nietzsche*, Fontana, Glasgow, 1978, p. 143.

4 A Legal Reality: The Photograph as Property Law

1. Charles Baudelaire, 'The Salon of 1859 II: The Modern Public and Photography', in *Art in Paris 1845–1862. Salons and Other Exhibitions*, J. Mayne (trans.), Phaidon, London, 1965, p. 153.
2. Bernard Edelman, *Ownership of the Image. Elements for a Marxist Theory of Law*, E. Kingdom (trans.), Routledge & Kegan Paul, London, 1979, p. 33.
3. Planiol and Ripert, *Traité de droit civil. Librairie général de droit et de jurisprudence*, Vol. 1, No. 6, quoted in Edelman, pp. 28–9.
4. Edelman, p. 52.
5. *Ibid.*, p. 38.
6. *Ibid.*
7. Tribunal de grande instance, Paris, 6 January 1969, *Revue internationale des droits d'auteur*, July 1970, p. 148; quoted in Edelman, p. 43.
8. *Ibid.*, p. 45.
9. Lamartine, *Cours familier de litérature. Entretiens sur Léopold Robert*, Vol. VI, 1848, p. 140; quoted *ibid.*, p. 45.
10. Quoted *ibid.*, p. 45.
11. Baudelaire, *op. cit.*, p. 153.
12. *Ibid.*, p. 154.
13. Tribunal de commerce, Turin, 25 October 1861; quoted in Edelman, p. 46.
14. Tribunal de commerce, Seine, 7 March 1861; quoted *ibid.*, p. 46.
15. Findings of the *avocat impérial* Thomas, in *Annales de la propr. ind.*, 1855, p. 405; quoted *ibid.*, p. 46.
16. Tribunal de commerce, Turin, quoted *ibid.*, p. 46.
17. Tribunal de commerce, Seine; and Tribunal de commerce, Paris, 10 April 1862; quoted *ibid.*, pp. 46–7.
18. Cours de cassation, chambre civil, 1, 23 June 1959; quoted *ibid.*, p. 51.
19. *Ibid.*, p. 50.
20. *Ibid.*, p. 52; Edelman quotes Karl Marx, *Capital*, Vol. III, Lawrence and Wishart, London, 1962, p. 601, note 26.
21. *Ibid.*, p. 97.
22. *Ibid.*
23. P. Q. Hirst, 'Introduction' to Edelman, *op. cit.*, p. 17. For a discussion of copyright protection of artistic property in the USA, especially concerned with its effect on competition between entertainment industries, see Jeanne Allen, 'Copyright Protection in Theatre,

Vaudeville and Early Cinema', *Screen*, Vol. 21, No. 2, Summer 1980, pp. 79–91.

5 God's Sanitary Law: Slum Clearance and Photography in Late Nineteenth-Century Leeds

I should like to thank the staff of the Leeds Local History Library and also, especially, Janet Douglas who first drew my attention to the Quarry Hill photographs and on whose knowledge of Leeds' history I have extensively drawn. This essay is dedicated to Tom Steele, without whose support it would not have been written.

1. G. Pollock, 'Vision, Voice and Power. Feminist Art History and Marxism', *Block*, No. 6, 1982, pp. 2–21.
2. P. Hill, A. Kelly, and J. Tagg, *Three Perspectives on Photography*, Arts Council of Great Britain, London, 1979; T. Dennet, D. Evans, S. Gohl, and J. Spence (eds) *Photography/Politics: One*, Photography Workshop, London, 1979.
3. M. Foucault, *Language, Counter-Memory, Practice*, (ed.) D. F. Bouchard, Blackwell, Oxford, 1977, p. 200.
4. *The British Worker. Photographs of Working Life 1839–1939*, London, 1981.
5. *Leeds Mercury*, 14 October 1862; quoted in D. Linstrum, *West Yorkshire Architects and Architecture*, Lund Humphries, London, 1978, p. 145. On the history of working-class housing in Leeds, see M. W. Beresford's essays: 'Prosperity Street and Others: An Essay in Visible Urban History', in M. W. Beresford, and G. R. J. Jones (eds), *Leeds and Its Region*, Leeds, 1967, pp. 186–97; 'The Face of Leeds, 1780–1914,' in D. Fraser (ed.) *A History of Modern Leeds*, Manchester University Press, 1980, pp. 72–112; and 'The Back-to-Back House in Leeds 1787–1937', in S. D. Chapman (ed.) *The History of Working Class Housing: A Symposium*, Newton Abbot, 1971, pp. 93–132. Also chapter 2 of A. Ravetz, *Model Estate. Planned Housing at Quarry Hill, Leeds*, Croom Helm, London, 1974.
6. James Spottiswoode Cameron, for example, expressed before Parliament his opposition to the continued sanctioning of back-to-back housing in Leeds under the 1893 Improvement Act.
7. R. Baker, 'Report on the State and Condition of Leeds' in *Local Report*, 23, of Chadwick's *Sanitary Inquiry*, PP (1842), XXVII. The Privy Council investigations occurred in 1858, 1865, 1870 and 1874.
8. Sir John Simon, *Eighth Report of the Medical Officer of the Privy Council*, PP (1866), XXXIII, (3645), p. 23; cited in A. J. Taylor, 'Victorian Leeds: An Overview', in Fraser, *op. cit.*, pp. 393–4. See also B. J. Barber, 'Aspects of Municipal Government, 1835–1914', *ibid.*, p. 302.
9. C. J. Morgan, 'Demographic Change, 1771–1911', *ibid.*, pp. 63–9.
10. *Leeds Mercury*, 25 September 1852; cited in Beresford, 'The Face of Leeds', pp. 83–4.
11. Local Government Board's Provisional Orders Confirmation (Housing

of the Working Classes) Act, 1896, PP (1896), V; and (No. 2) Act, 1901, PP (1901), III. See also *House of Commons Select Committee on the Local Government Provisional Orders (Housing of the Working Classes) (No. 2) [Leeds Order] Bill*, 2 July 1901, pp. 4–5. Estimates of population are given *ibid.*, 3 July 1901, p. 83; and a full list of residents' occupations is in the *Quarry Hill Unhealthy Area. Book of Reference*, November 1900, in the West Yorkshire Archive, Leeds (LC/TC, Bin 21, Box 3).

12. R. H. Bicknell, evidence to the *House of Commons Select Committee*, 5 July 1901, (1619), p. 170. See also the report in the *Yorkshire Post*, 6 July 1901. For Sheffield MOH, Dr John Robertson's evidence see *House of Commons Select Committee*, 4 July 1901, (868), p. 108.

13. *Leeds Medical Officer of Health Annual Reports to the Urban Sanitary Authority of the Borough of Leeds*, 1894, 1895, 1896. See also Cameron's evidence in the *House of Commons Minutes of Proceedings taken before the Select Committee on Private Bills (Group F) on the Local Government Provisional Orders (Housing of the Working Classes) [Leeds Order] Bill*, 15 July 1896, (166), p. 22.

14. Cf. Barber, *op. cit.*

15. W. L. Jackson to the *House of Lords Select Committee*, 1 August 1896, (125), p. 13.

16. *Abstract of Monies Received and Expended in Municipal Boroughs, 1870*, PP (1871), LVIII, (453), pp. 4–5; cited in Taylor, *op. cit.*, p. 394.

17. 'The Liberal Programme', *Leeds Mercury*, 27 September 1893. For commentary, see also *Leeds Mercury*, 14 October 1893 and 2 November 1893; and A. T. Marles, 'On Sleepy Hollow', in A. T. Marles (ed.) *Hypnotic Leeds: Being Essays on the Social Condition of the Town*, Leeds, 1894, p. 58.

18. 'The Health of Leeds. Is It Not Time?' by Our Special Commissioner, *Leeds Mercury*, 26 September 1891; 'The Health of Leeds – II. Back-to-Back Houses: Are They Healthy?', *ibid.*, 3 October 1891; 'The Health of Leeds – III. How The Poor Live', *ibid.*, 9 October 1891; 'The Health of Leeds – IV. More Disclosures', *ibid.*, 16 October 1891; 'The Health of Leeds – V. The Need of Improved Sanitary Administration', *ibid.*, 23 October 1891; 'The Health of Leeds – VII. Liverpool's Example', *ibid.*, 7 November 1891; 'The Health of Leeds. Artisans' Dwellings in Liverpool', *ibid.*, 14 November 1891; 'The Sanitary Condition of Worsted Mills', *ibid.*, 19 November 1891; 'The Health of Leeds. The Manchester Scheme', *ibid.*, 21 November 1891; 'The Health of Leeds. Back-to-Back v. Through Houses', *ibid.*, 24 November 1891. See also the report of the annual meeting of the Society of Medical Officers of Health in Leeds, *Leeds Mercury*, 5 October 1891; and the interview with Alderman Ward, Chairman of the Sanitary Committee, *ibid.*, 27 October 1891.

19. See the Preface to J. S. Cameron, *Is My House Healthy? How To Find Out*, Leeds and London, 1892. Cameron had taken the degrees of MD and BSc at Edinburgh University and, by the time of the 1901 inquiry, was a member of the Royal College of Surgeons. He was also a member of the Council of the Thoresby Society and Chairman of

Section C, 'The History and Nomenclature of Leeds Streets and Buildings and Collection of Ancient Maps of Leeds and District'.

20. See the discussion of the paper by G. F. Carter (Assistant Engineer, Insanitary Areas, Leeds) on the 'Operation of the Housing of the Working Classes Act in Leeds', at the Sanitary Institute Congress held in Leeds in 1897: *The Journal of the Sanitary Institute*, Vol. XVIII, Pt IV, p. 472.

21. Cf. F. M. Lupton (Chairman of the Unhealthy Areas Sub-Committee), *Housing Improvement: A Summary of Ten Years' Work in Leeds*, Leeds, 1906, p. 3.

22. See especially chapters 4 to 7 of *Is My House Healthy?*, *op. cit.*

23. J. S. Cameron, 'Sanitary Progress During the Last Twenty-Five Years – and in the Next', *Public Health*, November 1902. The phrase 'God's sanitary law' comes from the Introductory to *Is My House Healthy?*, p. 3. See also B. Richardson, *Hygeia – A City of Health*, London, 1876.

24. Baker, *op. cit.*; also *Report to the Leeds Board of Health*, 1833, and 'Report upon the Condition of the Town of Leeds and Its Inhabitants' in the *Journal of the Statistical Society of London*, II, 1839–1840. Cameron and other officials were even careful to avoid the temperance aspect of the question: *House of Commons Select Committee*, 14 July 1896, p. 19; 15 July 1896, (255), p. 34.

25. E. Wilson, 'The Housing of the Working Classes', *Journal of the Society of Arts*, Vol. 48, 9 February 1900, p. 253ff.

26. See Morgan, *op. cit.*; and D. Fraser, 'Modern Leeds: A Postscript', in Fraser, *A History of Modern Leeds*, *op. cit.*, pp. 466–70.

27. For a reading of slum-life literature employing this imagery, see G. Stedman Jones, *Outcast London*, Penguin, Harmondsworth, 1984, Part III, p. 237ff; and R. Williams, *The Country and the City*, Paladin, London, 1975, chapter 19. In the course of the 1901 Parliamentary inquiry, counsel for the Corporation, Balfour Browne, was to make the astonishing claim: 'The lighting is exceedingly bad and I am right in saying that in recent days the importance of light as an agent of health has become more than prominent; we know that light kills all forms of germs both in air and water' (*House of Commons Select Committee*, 2 July 1901, p. 4).

28. D. B. Foster, *Leeds Slumdom*, Leeds 1897, p. 8. By contrast, in a collection of dissident essays published by the Leeds and County Cooperative Newspaper Society in 1894, Joseph Clayton wrote bitterly about middle-class attitudes to housing the poor:

> It is an interesting problem to those who live at Headingley and Chapeltown, and discussions and mutual conferences on it help to pass the time; if you are a person too who works amongst the poor, or feels an interest in social questions, you can make a good long speech about it – without giving any solution. ('Housing of the Poor', in Marles, *Hypnotic Leeds*, *op. cit.*, p. 14)

'Slums', he added, 'afford much occupation (with salary), for clergymen, doctors, policemen, and magistrates who don't live in them (*ibid.*, p. 16). Yet, dramatically turning the image of light in a radical way, he concluded:

> Nevertheless in slums and workmen's dwellings there is life yet; our friends and comrades inhabit them. We are poisoned, choked, dragged down by our surroundings, but not dead. The Light which penetrates the darkest, foulest spots; invincible, unlimited, flashes on the dwellers in condemned areas. Foul smells will not keep it out as subtlely as venetian blinds and drawing room curtains. (*ibid.*)

29. Cf. G. Stedman Jones, 'Working Class Culture and Working Class Politics in London, 1870–1900: Notes on the Remaking of a Working Class', in *Languages of Class*, Cambridge University Press, 1983, pp. 179–238, especially pp. 189–91.
30. G. Goldie, evidence to the *Royal Commission on the Housing of the Working Classes*, PP (1885), XXXI, p. 325; cited in T. Woodhouse, 'The Working Class', in Fraser, *A History of Modern Leeds*, p. 354.
31. National Society, letters in school files dated 1844 and 1848; cited in W. B. Stephens, 'Elementary Education and Literacy, 1770–1870', *ibid.*, pp. 232–3.
32. Quoted by Stephens, *ibid.*, p. 245.
33. See Morgan, *op. cit.*, pp. 49, 62–3.
34. See E. Krausz, *Leeds Jewry. Its History and Social Structure*, Cambridge, 1964; and E. E. Burgess, 'The Soul of the Leeds Ghetto', *Yorkshire Evening News*, January–February 1925. Anti-semiticism leaves its trace in an exchange between the Select Committee Chairman and F. M. Lupton, Chairman of the Unhealthy Areas Sub-Committee:

> (*Lord Robert Cecil*) What do you say about the inhabitants – (*Lupton*) Most of the inhabitants are Jews, and their habits are said to be very cleanly, so far as their persons go; but certainly the courts outside their houses are –
> *The Chairman.* Eastern in character? – Yes, that is so, exactly.
> (*House of Commons Select Committee*, 2 July 1901, (239–240), pp. 22–3)

Earlier, Cameron had explained the difficulty his department experienced in dealing with Jewish residents – difficulty which led to the printing of handbills in Yiddish and English and to the appointment of a special officer who spoke Yiddish.

35. E. D. Steele, 'Imperialism and Leeds Politics, c. 1850–1914', in Fraser, *A History of Modern Leeds*, pp. 342–3, 348–9. In 1901, it was Irish Nationalist MPs who, in what the *Yorkshire Post* called the 'Irish Intervention', voiced the most concerted opposition to the clearance in Parliament (*Yorkshire Post*, 15 June 1901).
36. Woodhouse, *op. cit.*, p. 385, n. 34.
37. *Ibid.*, pp. 369–70. For example, one of the leaders of the Gas Workers' and General Labourers' Union, Walter Wood, became involved with

Leeds socialists in 1890 when he was a gas stoker at York Road gasworks (*ibid.*, p. 373). See also E. P. Thompson, 'Homage to Tom Maguire', in A. Briggs and J. Saville (eds) *Essays in Labour History*, London, 1960.

38. *House of Lords Select Committee*, 31 July 1896, p. 2.
39. A list of ownerships and rentals of properties in Quarry Hill is in the West Yorkshire Archive, Leeds (LC/TC, Bin 21, Box 6). See also Lupton, *op. cit.*, pp. 2–3; and the contribution to the correspondence on 'The Health of Leeds' from Rex, 'a working man', *Leeds Mercury*, 22 October 1891. During the debate on the second reading of the 1901 Bill, complaint was made that the working-class inhabitants had not been consulted, though 'a deputation of working men' had gone to the Sanitary Committee to argue that, before pulling down an enormous number of low rented houses, they ought first to undertake and complete the building of others (*Hansard Parliamentary Debates* (1901), XCV, 396).
40. Barber, *op. cit.*, p. 316.
41. F. Engels, 'The Housing Question' (1872–3), in K. Marx and F. Engels, *Selected Works* (3 vols), Vol. 2, Progress Publishers, Moscow, 1969, p. 352. In another context, it is interesting to find Engels making the military assessment that 'in very densely populated counties, e.g. in the almost continuous labyrinth of buildings in Lancashire and West Yorkshire, guerrilla warfare can be rather effective' ('England' (1852), in Marx and Engels, *Collected Works*, Vol. 11, London, 1979, p. 204.)
42. Wilson, *op. cit.* For the debate, see *Hansard* (1901), XCV, 388–402.
43. In approving the York Street scheme, the Local Government Board specified that it was to be carried out in four stages, with a proportion of the inhabitants rehoused after each, so that none would be homeless on its completion. The Bill for the second phase proposed rehousing by stages 700 residents for every 1,000 homes demolished, though this was later modified to 2,000 in 1906 and 4,000 in 1908. The Council, however, could not effectively comply with these orders because it refused to intervene on any significant scale in the housing market in competition with private traders. Led by Alderman Lupton, it argued that it could be left to the private sector to absorb the homeless, and the rents of the houses it did build, on the Ivy Lodge Estate, were known to be beyond the reach of the inhabitants of the insanitary area. The Council's only solution was to petition the Local Government Board in 1898 for permission to build back-to-back houses on the York Street site. The Board predictably refused and, by 1900, realistic alternative accommodation had been provided for only 198 tenants in two tenement blocks (Barber, *op. cit.*, pp. 314–16).
44. *House of Commons Minutes of Proceedings taken before the Select Committee on Private Bills (Group F) on the Local Government Provisional Orders (Housing of the Working Classes) [Leeds Order] Bill, 13 July–15 July 1896; House of Lords Select Committee, 29 July–1 August 1896; House of Commons Select Committee on the Local Government Provisional Orders (Housing of the Working*

Classes) (No. 2) [Leeds Order] Bill, 2 July–5 July, 9 July 1901; *House of Lords Select Committee*, 26 July 1901.

45. The photographs exist in a number of forms: Leeds City Reference Library possesses five volumes of *Photographs of Unhealthy Areas* from the Leeds City Council, City Engineer's Department. They contain 215 photographs of sites in both the York Street and Quarry Hill areas and are modern copy prints taken from the original seven illustrated volumes of the Leeds Order Bill of 1901. Two large volumes of *Views of Old Leeds. Being Photographs of Properties Demolished by the Corporation in their Schemes for the Improvement of Unhealthy Areas in the City* were donated to the Leeds Public Free Library by the Sanitary Committee of Leeds Corporation, and to the Thoresby Society by Cllr E. E. Lawson, by resolution of the Sanitary Committee, on 13 March 1902. They each contain 154 photographs covering the area of both schemes, and were bound by the Leeds photographic firm of Charles R. H. Pickard. The University of Leeds Brotherton Library has four albums. Two of these are duplicates of *Photographs of Properties Situated in the Quarry Hill Unhealth Area, Taken Dec 1900 and Jan 1901*. They were presented to the University by E. E. Lawson and each contain 100 photographs of the second clearance scheme, with the exception that Album C includes five additional photographs of the building of a subway in York Street in December 1920. The other two albums appear to belong to those which were tabled in Parliament. Album A, *In Parliament, Session 1901. Photographs of Properties of Petitioners in the Quarry Hill Unhealthy Area* contains 44 plates. Album B has the title, '*City of Leeds, Insanitary Areas.* 5–12 In the area originally represented; 13–48 In "York Street" Section'. It bears the stamp of the City Engineer's Office Leeds, Unhealthy Areas Dept, and contains 44 photographs clearly related to the 1896 clearance scheme. The numbers of the photographs also correspond to those quoted by Cameron in the Select Committee minutes (*House of Lords Select Committee*, 31 July 1896, (41), p. 4). In plate no. 6, 'Nelson Street Looking East', a poster for the opening of the Birmingham Race Course Station shows the dates March 9 and 10, 1896.

It is interesting to note that, by 1901, Cameron had also had glass slides made from the photographs in order to illustrate his public lectures in support of clearance, such as the one he gave for the Leeds Industrial Cooperative Society Education Committee on the day after the Local Government Board inquiry had ended, on 23 March 1901.

46. *The British Worker, op. cit.*

47. *Ibid.* See also the report of the Leeds Photographic Society in the *British Journal of Photography*, 27 September 1895, p. 615.

48. *The British Worker, op. cit.*

48. *Manchester Guardian*, 21 January 1890; cited in H. Milligan, 'The Manchester Photographic Survey Record', *The Manchester Review*, Vol. VII, Autumn 1958, pp. 193–204. See also A. Budge, *Early Photography in Leeds 1839–1870*, Leeds City Art Gallery, Leeds, 1981.

50. *Report of the Unhealthy Areas Sub-Committee*, 31 March 1902–1903, p. 11.

51. *Reports of Dr (Edward) Ballard to the Local Government Board; the Medical Officer of Health to the Markets Committee; and the Markets Committee to the Council, upon the Slaughter-Houses and Slaughter-Yards in the Borough, and as to the Establishment of a public Abbattoir*, 28 June 1880.

52. The Medical Officer of Health notes:

> At the request of the Visiting Committee I have obtained photographs of all the seven slaughteryards, and they will be found very useful to those members who have not yet visited the yards. The photographs are numbered and briefly explained by foot note on each. They will show fairly the condition of the slaughter-yards. (*Ibid.*, p. 19)

Though Ballard comments:

> between the time of my visit and of the taking of the photographs the lime brush and the scrubbing brush had been freely used in order to render these places as presentable as was practicable. (*Ibid.*, p. 7)

View No. 13 is titled 'Interior of Higgins Yard. The View speaks for itself'.

53. Leeds City Reference Library possesses a number of such photographs by Wormald, for example: 'Slaughter-House Looking Towards Entrance, Vicar Lane', c.1893; 'Slaughter-House, Wood Street, c.1890 – near Boy and Barrel'; and 'J. R. Smith's Slaughter-Yard, Briggate'. See also Budge, *op. cit.*

54. D. B. Foster, *Leeds Slumdom. Illustrated with Photographs of Slum Property by W. Swift*, Leeds, 1897. The cover of the pamphlet advertises: 'The Shadows of a Great City. A Lime-Light Lecture by D. B. Foster, giving over 100 Sunny and Shady Views of Leeds photographed by W. Swift. A startling exhibition of the fearful conditions of slum life.' In *Socialism and The Christ: My Two Great Discoveries in a Long and Painful Search for Truth*, Leeds, 1921, Foster recounts:

> My work in conjunction with the Holbeck Social Reform Union and my efforts to shed light on slum life in the city had brought me a very valuable helper in the person of my now old friend, Willie Swift. He was great on slum photographs, and clever at converting these photographs into lantern slides. With the aid of my two daughters, who sang suitable solos for us, we went up and down showing the dark places of the city, and helping to create that healthy public opinion which eventually demanded the clearance of many of the places shown.
>
> As an outcome of, and a fitting climax to, this work *Leeds Slumdom* was published in 1897, and had considerable influence in strengthening the anti-slum movement. (p. 37)

Charles R. H. Pickard (1877–1979) worked as a commercial photographer and engraver in Leeds from around 1897, carrying out several public commissions such as photographing munitions work

during the 1914–18 war and recording buildings about to be demolished along Park Lane and the Headrow for the City Engineer's Department in 1928. Alfred Mattison (1868–1944) was an active local socialist who took up photography at the turn of the century to illustrate his lectures and writings on local history. Cf. A. Mattison, *The Romance of Old Leeds: A Series of Descriptive Sketches*, Bradford, 1908.

55. Alfred Ernest Matthewman (1868–?) was born in Leeds and educated at Leeds Grammar School and the University of London. From 1895 till 1903, when he took up the position of Town Clerk of Bridlington, he was a solicitor in Leeds Town Hall. In the absence of the Town Clerk, he represented the Corporation at a Local Government Board inquiry into the rehousing of displaced York Street tenants in 1897 (*Leeds Mercury*, 5 March 1897) and he may have acquired the photographs in this way. Several of his collections of materials on Leeds history and municipal affairs are held in Leeds City Reference Library, in whose files photographs of Cherry Tree Yard, Kirkgate, and Wilson's Yard, Duke Street, both (wrongly) dated 1899, are attributed to him.

56. See Cameron's evidence to the *House of Lords Select Committee*, 31 July 1896, p. 2; the report of the Local Government Board inquiry, *Leeds Mercury*, 2 March 1901; and the evidence of R. H. Bicknell to the *House of Commons Select Committee*, 5 July 1901, (1619), p. 170.

57. *House of Commons Select Committee*, 15 July 1896, (234), p. 33.

58. *Ibid.*, (235).

59. *Ibid.*, (236).

60. *Ibid.*, (228), p. 32; the photograph in question is No. 17 in the Brotherton Library's Album B, and reproduced here as Plate 28.

61. Cameron's typescript proof for his evidence to the House of Commons Select Committee of 1901, in the West Yorkshire Archive, Leeds (LC/TC, Bin 21, Box 2), p. 6. The yard in question was off Regent Street.

62. *Ibid.*

63. 1890 Housing of the Working Classes Act, Part I, Section 4. See also Cameron's evidence to the *House of Lords Select Committee*, 31 July 1896, p. 2.

64. Thomas Middleton to the *House of Commons Select Committee*, 4 July 1901, (1098), p. 126.

65. *Ibid.*, (812–823), pp. 104–5.

66. For example, those tabled by the estate agent J. W. Heeles, *ibid.*, 5 July 1901, (1331–1337), pp. 145–6; and *House of Lords Select Committee*, 26 July 1901, (438), p. 37.

67. *Ibid.*, (459), p. 39.

68. See Chapter 3.

69. *Sanitary Condition of the Labouring Population . . . Local Reports (England and Wales)*, PP (1842), XXVII. See also Beresford, 'Prosperity Street and Others', *op. cit.*, pp. 193, 195.

70. 'Interior of Cellar Dwelling, Mushroom Court', in Foster, *Leeds Slumdom*, p. 21, reproduced here as Plate 30.

71. See J. A. Riis, *How The Other Half Lives*, New York, 1890; *The Children of the Poor*, New York, 1892; and *The Battle with the Slum*, London and New York, 1902.

72. Wilson, *op. cit.* See also Ravetz, *op. cit.*, p. 42.

73. Ravetz, *op. cit.* See also Linstrum, *op. cit.*, pp. 148–9. Quarry Hill flats were designed by Leeds' newly created Housing Department under R. A. H. Livett and were consciously modelled on the 'superblocks' built by the socialist municipality of Vienna during the 1920s. In Edgar Anstey and Sir Arthur Elton's documentary film, *Housing Problems*, they figure in the optimistic conclusion as the solution to social ills. However, criticism of the scheme markedly increased when, following Dolfuss's *coup d'état* in Austria in 1934, the British press and newsreels carried images of 'communist' and 'anarchist' resistance in Vienna's 'fortress' housing schemes, under artillery fire from the fascists.

6 The Currency of the Photograph: New Deal Reformism and Documentary Rhetoric

1. This chapter is based on a lecture given at the Midland Group Gallery in August 1977.

2. Berenice Abbott, 'From a Talk Given at the Aspen Institute, Conference on Photography, 6 October, 1951' in *New York in the Thirties: The Photographs of Berenice Abbott*, Side Gallery, Newcastle, 1977, p. 23.

3. *Ibid.*

4. Quoted in Valerie Lloyd, 'Introduction', in *New York in the Thirties*, p. 4.

5. Berenice Abbott, 'Changing New York', in *Art for the Millions: Essays from the 1930s by Artists and Administrators of the WPA Federal Art Project*, (ed.) Francis V. O'Connor, New York Graphic Society, Boston, 1975, p. 161.

6. Quoted in Lloyd, 'Introduction', p. 160.

7. Abbott, 'Changing New York', p. 160.

8. Max Raphael, *The Demands of Art*, Routledge & Kegan Paul, London, 1968, pp. 11–12.

9. Cf. Max Raphael, *Theorie des geistigen Schaffens auf marxistischer Grundlage*, Fischer Vorlag, Frankfurt am Main, 1974. What Max Raphael argues in *Proudhon–Marx–Picasso: Trois études sur la sociologie de l'art*, Excelsior, Paris, 1933, is that certain categories and laws are realised in the works of art of all peoples and all times: categories or laws such as symmetry and series, statics and dynamics, the separation and interpenetration of the three dimensions. These categories and laws are realised, however under different configurations, and the diversity of these configurations originates, in turn, in the diversity of natural environments against which people must struggle and of the concrete social structures within which this struggle (material production) takes

place. What is common to them all cannot be known by abstraction. It involves the entire biological and historical formation of human consciousness whose nature is *relatively* constant, compared with the variable phenomena of social life. But to make this *relative* constancy absolute is to ignore the historical genesis of consciousness and the necessity for its realisation.

10. Abbott, 'Changing New York', p. 160.
11. Quoted from the original plan for the photographic sub-project of the WPA/FAP, in *ibid.*, p. 158.
12. *Ibid.*, p. 161.
13. Alfred H. Barr, 'Is Modern Art Communistic', *New York Times Magazine*, 14 December 1952, pp. 22–3, 28–30. See also John Tagg, 'American Power and American Painting: The Development of Vanguard Painting in the US 1945', *Praxis*, Vol. 1, No. 2, Winter 1976, pp. 59–79.
14. Roland Barthes, 'Rhetoric of the Image', *Working Papers in Cultural Studies*, Spring 1971, pp. 45–6. See also Stuart Hall, 'The Determinations of News-photographs', *Working Papers in Cultural Studies*, Autumn 1972, p. 84.
15. Barthes, 'Rhetoric of the Image', p. 45.
16. 'An Interview with Pierre Macherey', (ed. and trans.) Colin Mercer and Jean Radford, *Red Letters*, Summer 1977, p. 5.
17. Walter Benjamin, 'A Short History of Photography', (trans.) Stanley Mitchell, *Screen*, Vol. 13, No. 1, Spring 1972, p. 7.
18. Hans Hess, 'Art as Social Function', *Marxism Today*, Vol. 20, No. 8, August 1976, p. 247.
19. Karl Marx, *Capital: A Critical Analysis of Capitalist Production*, Vol. 1, (trans.) Samuel Moore and Edward Aveling, Allen & Unwin, 1938, p. 105.
20. Susan Sontag, 'Photography', *New York Review of Books*, 18 October 1973.
21. 'Prison Talk: An Interview with Michel Foucault', *Radical Philosophy*, Spring 1977, p. 10.
22. See John Tagg, 'Marxism and Art History', *Marxism Today*, Vol. 21, No. 6, June 1977.
23. Louis Althusser, 'Ideology and Ideological State Apparatuses', in *Lenin and Philosophy*, New Left Books, London, 1971, p. 139.
24. 'Prison Talk: An Interview with Michel Foucault', p. 11.
25. Althusser, 'Ideology and Ideological State Apparatuses', p. 136.
26. Antonio Gramsci, *Selections from the Prison Notebooks*, (trans.) Quinton Hoare and Geoffrey Nowell Smith, Lawrence & Wishart, London, 1971, p. 238.
27. Paul Q. Hirst, 'Althusser and the Theory of Ideology', *Economy and Society*, Vol. 4, No. 5, November 1976, pp. 385–412.
28. *Ibid.*, p. 407.
29. Althusser, 'Ideology and Ideological State Apparatuses', p. 158.
30. 'An Interview with Pierre Macherey', p. 5.
31. Roy Emerson Stryker, 'The FSA Collection of Photographs', *In This*

Proud Land: America 1935–1943 As Seen by the FSA Photographers, Secker & Warburg, London, 1973, p. 7.

32. *Ibid.*
33. Quoted in Nancy Wood, 'Portrait of Stryker', *In This Proud Land*, p, 14.
34. 'Selected Shooting Scripts', *In This Proud Land*, p. 187.
35. 'From R. E. Stryker to Russell Lee, Arthur Rothstein, In particular. FSA 19 February 1942', *ibid.*, p. 188.
36. Stryker, 'The FSA Collection of Photographs', p. 7.
37. See John Tagg, 'The Image of America in Passage', unpublished essay, p. 7.
38. Sontag, 'Photography'.
39. 'Prison Talk: An Interview with Michel Foucault', p. 15.
40. Michel Foucault, 'The Political Function of the Intellectual', *Radical Philosophy*, Summer 1977, p. 13.
41. Wood, 'Portrait of Stryker', p. 16.
42. 'Power and Sex: An Interview with Michel Foucault', *Telos*, Summer 1977, p. 157.
43. *Ibid.*
44. Arthur Rothstein, in *Just Before the War: Urban America from 1935 to 1941 as Seen by the Photographers of the Farm Security Administration*, catalogue to an exhibition at the Newport Harbour Art Museum, October House, New York, 1968, p. 6.
45. T. J. Clark, *Image of the People: Gustave Courbet and the Revolution of 1848*, Thames & Hudson, London, 1973.
46. *Ibid.*, p. 81.
47. Karl Marx, 'Letter to Nannette Philips, March 24, 1861', in Marx and Engels, *On Literature and Art*, (eds) Lee Baxandall and Stefan Morawski, International General, New York, 1974, p. 113.
48. Engels, 'Letter to Minna Kautsky, London, November 26, 1885', in Marx and Engels, *On Literature and Art*, Progress Publishers, Moscow, 1976, p. 88.
49. Engels, 'Letter to Margaret Harkness. Beginning of April 1888 (draft)', in Marx and Engels, *On Literature and Art*, (eds) Baxandall and Morawski, p. 116.
50. *Ibid.*, p. 117.
51. *Ibid.*, p. 115.
52. Stefan Morawski, 'Introduction', *ibid.*, p. 31.
53. Cf. Roman Jakobson, 'Two Aspects of Language and Two Types of Aphasic Disturbances', in Roman Jakobson and Morris Halle, *Fundamentals of Language*, Janua Linguarum 1, Mouton, The Hague and Paris, 1971, pp. 67–96.
54. V. I. Lenin, 'Lev Tolstoy as the Mirror of the Russian Revolution', in *Articles on Tolstoy*, Progress Publishers, Moscow, 1971, p. 6.
55. *Ibid.*
56. 'L. N. Tolstoy and the Modern Labour Movement', *ibid.*, p. 20.
57. 'An Interview with Pierre Macherey', p. 5.
58. *Ibid.*, p. 5.
59. Lenin, 'Heroes of "Reservation"', in *Articles on Tolstoy*, p. 24.

60. Lenin, 'Lev Tolstoy as the Mirror of the Russian Revolution', p. 7.
61. Lenin, 'L. N. Tolstoy', p. 12.
62. Lenin, 'Lev Tolstoy as the Mirror of the Russian Revolution', p. 7 (my emphasis).
63. Lenin, 'Lev Tolstoy and his Epoch', in *Articles on Tolstoy*, p. 29.
64. Lenin, 'Heroes of "Reservation"', p. 27.
65. Lenin, 'Lev Tolstoy and his Epoch', p. 31.
66. Lenin, 'L. N. Tolstoy', p. 12.
67. *Ibid.*, p. 13.
68. *Ibid.*, p. 11.
69. Lenin, 'Tolstoy and the Proletarian Struggle', in *Articles on Tolstoy*, p. 22.
70. Clark, *Image of the People*, p. 12.
71. *Ibid.*
72. Stryker, 'The FSA Collection of Photographs', p. 7.
73. *Ibid.*, p. 9.
74. Quoted in Wood, 'Portrait of Stryker', p. 15.
75. Sigmund Freud, *The Interpretation of Dreams*, (trans.) James Strachey, Penguin, Harmondsworth, 1976, pp. 198–9.

Bibliography

James Agee and Walker Evans, *Let Us Now Praise Famous Men*, Houghton & Mifflin, Boston, 1980.

N. Allen and J. Snyder, 'Photography, Vision and Representation', *Critical Inquiry*, Vol. 2, No. 1, 1975.

Louis Althusser, *For Marx*, trans. B. Brewster, Penguin, Harmondsworth, 1969.

Louis Althusser, *Lenin and Philosophy and Other Essays*, trans. B. Brewster, New Left Books, London, 1971.

Fredric Antal, *Classicism and Romanticism*, Routledge and Kegan Paul, London, 1962.

Arts Council of Great Britain, *The British Worker, Photographs of Working Life 1839–1939*, Arts Council, London, 1981.

Roland Barthes, *Elements of Semiology*, trans. Annette Lavers and Colin Smith, Jonathan Cape, London, 1967.

Roland Barthes, *Mythologies*, trans. Annette Lavers, Paladin, London, 1973.

Roland Barthes, *S/Z*, trans. Richard Miller, Jonathan Cape, London, 1975.

Roland Barthes, *Image – Music – Text*, trans. Stephen Heath, Fontana, London, 1977.

Roland Barthes, *Roland Barthes by Roland Barthes*, trans. Richard Howard, Hill and Wang, New York, 1977.

Roland Barthes, *Camera Lucida*, trans. Richard Howard, Jonathan Cape, London, 1982.

Jean-Louis Baudry, 'Ideological Effects of the Basic Cinematographic Apparatus', *Film Quarterly*, Winter 1974–5.

Jean-Louis Baudry, 'The Apparatus', *Camera Obscura*, Autumn 1976.

Walter Benjamin, *Illuminations*, H. Arendt (ed.), trans. H. Zohn, Fontana, London, 1970.

Walter Benjamin, *Understanding Brecht*, New Left Books, London, 1973.

Walter Benjamin, *One-Way Street and Other Writings*, New Left Books, London, 1979.

T. Bennett, G. Martin, C. Mercer, and J. Woollacott (eds) *Culture, Ideology and Social Process*, Batsford, London, 1981.

R. Bernheimer, *The Nature of Representation: A Phenomenological Inquiry*, New York University Press, New York, 1961.

R. Blackburn (ed.) *Ideology in Social Science*, Fontana, London, 1972.

Norman Bryson, *Vision and Painting. The Logic of the Gaze*, Macmillan, London, 1983.

Victor Burgin (ed.) *Thinking Photography*, Macmillan, London, 1982.

Victor Burgin, *The End of Art Theory. Criticism and Postmodernity*, Macmillan, London, 1986.

T. J. Clark, *The Absolute Bourgeois. Artists and Politics in France 1848–1851*, Thames & Hudson, London, 1973.

T. J. Clark, *Image of the People. Gustave Courbet and the 1848 Revolution*, Thames & Hudson, London, 1973.

T. J. Clark, 'The Conditions of Artistic Creation', *Times Literary Supplement*, No. 3768, 24 May 1974.

T. J. Clark, *The Painting of Modern Life: Paris in the Art of Manet and His Followers*, Alfred Knopf, New York, 1985.

John Collier, Jr, *Visual Anthropology: Photography as a Research Method*, Holt, Rhinehart & Winston, New York, 1967.

R. Coward, 'Class, "Culture" and the Social Formation', *Screen*, Vol. 18, No. 1, 1977.

R. Coward and J. Ellis, *Language and Materialism. Developments in Semiology and the Theory of the Subject*, Routledge & Kegan Paul, London, 1977.

Elizabeth Cowie, 'Woman As Sign', *m/f*, No. 1, 1978.

T. Dennett, D. Evans, S. Gohl and J. Spence (eds) *Photography/Politics: One*, Photography Workshop, London, 1979.

J. Derrida, *Positions*, Athlone Press, London, 1981.

M. A. Doane, 'Film and the Masquerade: Theorising the Female Spectator', *Screen*, Vol. 23, Nos 3–4, September/October 1982.

H. Dyos and M. Wolff (eds) *The Victorian City: Image and Reality*, 2 vols, Routledge and Kegan Paul, London, 1976.

T. Eagleton, *Literary Theory*, Blackwell, Oxford, 1983.

Umberto Eco, *A Theory of Semiotics*, Indiana University Press, Bloomington, 1976.

Bernard Edelman, *The Ownership of the Image. Elements of a Marxist Theory of Law*, trans. E. Kingdom, Routledge & Kegan Paul, London, 1979.

S. Edwards, 'Disastrous Documents', *Ten:8*, No. 15, 1984.

K. Forster, 'Critical History of Art, Or Transfiguration of Values?', *New Literary History*, Vol. 3, No. 3, Spring 1972.

Michel Foucault, *The Archaeology of Knowledge*, trans. A. Sheridan Smith, Pantheon, New York, 1972.

Michel Foucault, *Discipline and Punish. Birth of the Prison*, trans. A. Sheridan, Allen Lane, London, 1977.

Michel Foucault, *Language, Counter-Memory, Practice. Selected Essays and Interviews*, D. F. Bouchard (ed.) Blackwell, Oxford, 1977.

Michel Foucault, *The History of Sexuality. Volume One: An Introduction*, trans. R. Hurley, Allen Lane, London, 1978.

Michel Foucault, *Power, Truth, Strategy*, M. Morris and P. Patton (eds) Feral Publications, Sydney, 1979.

Michel Foucault, *Power/Knowledge*, C. Gordon (ed.) Harvester, Brighton, 1980.

D. Fraser (ed.) *A History of Modern Leeds*, Manchester University Press, Manchester, 1980.

Sigmund Freud, *The Interpretation of Dreams*, trans. J. Strachey, Penguin, Harmondsworth, 1976.

Gisèle Freund, *Photography and Society*, Gordon Fraser, London, 1980.

H. and A. Gernsheim, *The History of Photography from the Camera Obscura to the Beginning of the Modern Era*, McGraw-Hill, New York, 1969.

S. L. Gilman (ed.) *The Face of Madness. Hugh W. Diamond and the Origin of Psychiatric Photography*, Brunner-Mazel, Secaucus, New Jersey, 1976.

W. Goetzmann, *Exploration and Empire: The Explorer and the Scientists in the Winning of the American West*, Norton, New York, 1966.

E. H. Gombrich, *In Search of a Cultural History*, Oxford University Press, Oxford, 1969.

Anonio Gramsci, *Selections from the Prison Notebooks*, Q. Hoare and G. Nowell-Smith (eds) Lawrence & Wishart, London, 1971.

D. Green, 'Classified Subjects', *Ten:8*, No. 14, 1984.

N. Green and F. Mort, 'Visual Representation and Cultural Politics', *Block*, No. 7, 1982.

Clement Greenberg, *Art and Culture*, Beacon Press, Boston, 1961.

P. B. Hales, *Silver Cities. The Photography of American Urbanisation, 1839–1915*, Temple University Press, Philadelphia, 1984.

Stuart Hall, 'The Social Eye of Picture Post', *Working Papers in Cultural Studies*, Birmingham Centre for Cultural Studies, No. 2, Spring 1972.

Stuart Hall, 'The Determinations of News Photographs', *Working Papers in Cultural Studies*, Birmingham Centre for Cultural Studies, No. 3, Autumn 1972.

Stuart Hall, 'Rethinking the Base-and-Superstructure Metaphor', in J. Bloomfield (ed) *Class, Hegemony and Party*, Lawrence & Wishart, London, 1977.

Stuart Hall, 'The "Political" and the "Economic" in Marx's Theory of Classes', in A. Hunt (ed.) *Class and Class Structure*, Lawrence & Wishart, London, 1977.

Stuart Hall, 'Cultural Studies: Two Paradigms', *Media, Culture and Society*, Vol. 2, No. 1, 1980.

A. L. Hamby (ed.) *The New Deal. Analysis and Interpretation*, Longman, New York, 1981.

S. Heath, 'Difference', *Screen*, Vol. 19, No. 3, Autumn 1978.

G. W. F. Hegel, *The Philosophy of Fine Art*, trans. F. P. B. Osmaston, London, 1916.

G. W. F. Hegel, *Philosophy of History*, Dover, New York, 1944.

Hans Hess, 'Art as Social Function', *Marxism Today*, Vol. 20, No. 8, August 1976.

P. Hill, A. Kelly and J. Tagg, *Three Perspectives on Photography*, Arts Council, London, 1979.

B. Hindess and P. Hirst, *Mode of Production and Social Formation*, Macmillan, London, 1977.

Paul Hirst, *On Law and Ideology*, Macmillan, London, 1979.
Eric Hobsbawn, *The Age of Capital 1848–1875*, Weidenfeld & Nicolson, London, 1975.
F. J. Hurley, *Portrait of a Decade. Roy Stryker and the Development of Documentary Photography in the Thirties*, Louisiana State University Press, Baton Rouge, 1972.
R. Jackobson and M. Halle, *Fundamentals of Language*, Janua Linguarum I, The Hague and Paris, 1971.
R. Krauss, 'Photography's Discursive Spaces: Landscape/View', *Art Journal*, Vol. 42, No. 4, Winter 1982.
J. Lacan, *The Four Fundamental Concepts of Psychoanalysis*, Routledge & Kegan Paul, London, 1977.
E. Laclau, *Politics and Ideology in Marxist Theory*, New Left Books, London, 1977.
C. Lasch, *The Agony of the American Left. One Hundred Years of Radicalism*, Penguin, Harmondsworth, 1973.
V. I. Lenin, *Articles on Tolstoy*, Progress Publishers, Moscow, 1971.
V. Lloyd and G. Wagner, *The Camera and Dr Barnado*, Hertford, 1974.
Pierre Macherey, *A Theory of Literary Production*, Routledge & Kegan Paul, London, 1978.
Karl Marx, *Grundrisse*, trans. M. Nicolaus, Penguin, Harmondsworth, 1973.
Karl Marx, *Capital*, Vol. 1, trans. B. Fowkes, Penguin, Harmondsworth, 1976.
K. Marx and F. Engels, *Selected Works*, 3 vols, Progress Publishers, Moscow, 1969–70.
K. Marx and F. Engels, *Collected Works*, Lawrence & Wishart, London, 1976on.
C. MacCabe, *Tracking the Signifier*, University of Minneapolis Press, Minneapolis, 1985.
R. McGrath, 'Medical Police', *Ten:8*, No. 14, 1984.
Christian Metz, *Psychoanalysis and Cinema. The Imaginary Signifier*, Macmillan, London, 1982.
Stefan Morawski, *Inquiries into the Fundamentals of Aesthetics*, MIT Press, Cambridge, Mass., 1974.
F. Mort, 'The Domain of the Sexual', *Screen Education*, No. 36, Autumn 1980.
F. Mulhern, 'Notes on Culture and Cultural Struggle', *Screen Education*, No. 34, Spring 1980.
Laura Mulvey, 'Visual Pleasure and Narrative Cinema', *Screen*, Vol. 16, No. 3, Autumn 1975.
Beaumont Newhall, *The History of Photography*, Museum of Modern Art, New York, 1964.
Friedrich Nietzsche, *The Will To Power*, trans. W. Kaufmann, Random, New York, 1967.
Friedrich Nietzsche, *The Gay Science*, trans. W. Kaufmann, Random, New York, 1974.

Griselda Pollock, 'What's Wrong with Images of Women?', *Screen Education*, No. 24, Autumn 1977.

Griselda Pollock, 'Vision, Voice and Power. Feminist Art History and Marxism', *Block*, No. 6, 1982.

Karl Popper, *The Poverty of Historicism*, Routledge & Kegan Paul, London, 1957.

G. Procacci, 'Social Economy and the Government of Poverty', *Ideology and Consciousness*, No. 4, Autumn 1978.

Max Raphael, *The Demands of Art*, Routledge & Kegan Paul, London, 1968.

Max Raphael, *Proudhon, Marx, Picasso. Three Studies in the Sociology of Art*, J. Tagg (ed.) Lawrence & Wishart, London, 1980.

A. Rouillé, *L'Empire de la photographie. Photographie et pouvoir bourgeois 1839– 1870*, Le Sycomore, Paris, 1982.

R. Rudishill, *Mirror Image. The Influence of the Daguerreotype on American Society*, Albuquerque, 1972.

Ferdinand de Saussure, *Course in General Linguistics*, trans. W. Baskin, McGraw, London, 1974.

Meyer Schapiro, 'The Social Bases of Art', in D. Shapiro (ed.) *Social Realism. Art as a Weapon*, Ungar, New York, 1973.

Meyer Schapiro, *Modern Art, 19th and 20th Centuries*, Braziller, New York, 1978.

Allan Sekula, 'Photography Between Labor and Capital', in Leslie Shedden, *Mining Photographs and Other Pictures 1948–1968*, B. Buchloh and R. Wilkie (eds) Nova Scotia College of Art and Design, Halifax/Cape Breton, Nova Scotia, 1983.

Allan Sekula, *Photography Against The Grain*, Nova Scotia College of Art and Design, Halifax, Nova Scotia, 1984.

Susan Sontag, *On Photography*, Penguin, Harmondsworth, 1978.

Gareth Stedman-Jones, *Languages of Class. Studies in English Working Class History 1832–1982*, Cambridge University Press, Cambridge, 1983.

Gareth Stedman-Jones, *Outcast London*, Penguin, Harmondsworth, 1984.

William Stott, *Documentary Expression and Thirties America*, Oxford University Press, Oxford and New York, 1973.

William Stott, 'Walker Evans, Robert Frank and the Landscape of Dissociation', *Arts Canada*, December, 1974.

Roy Stryker and Nancy Wood, *In This Proud Land: America 1935–1943 as Seen by the FSA Photographers*, Secker & Warburg, London, 1973.

J. Sturrock (ed.) *Structuralism and Since*, Oxford University Press, Oxford, 1979.

John Tagg, 'Marxism and Art History', *Marxism Today*, Vol. 21, No. 6, June 1977.

John Tagg, 'Art History and Difference', in A. L. Rees and F. Borzello (eds) *The New Art History*, Camden Press, London, 1986.

John Tagg, 'Should Art Historians Know Their Place?', *New Formations*, No. 1, 1987.

A. Trachtenberg, 'Ever – The Human Document', in *America and Lewis Hine: Photographs 1904–1940*, Aperture, New York, 1977.

B. Wallis (ed.) *Art After Modernism: Rethinking Representation*, Godine, New York, 1984.

J. Weinstein, *Ambiguous Legacy. The Left in American Politics*, New Viewpoints, New York, 1975.

Raymond Williams, *The Country and the City*, Oxford University Press, 1973.

Raymond Williams, *Problems in Materialism and Culture*, Verso, London, 1980.

Raymond Williams, *Culture*, Fontana, London, 1981.

Raymond Williams, 'Marxism, Structuralism and Literary Analysis', *New Left Review*, No. 129, September/October 1981.

Judith Williamson, *Decoding Advertisements*, Boyars, London, 1978.

Index